On My Way
The Arts of Sarah Albritton

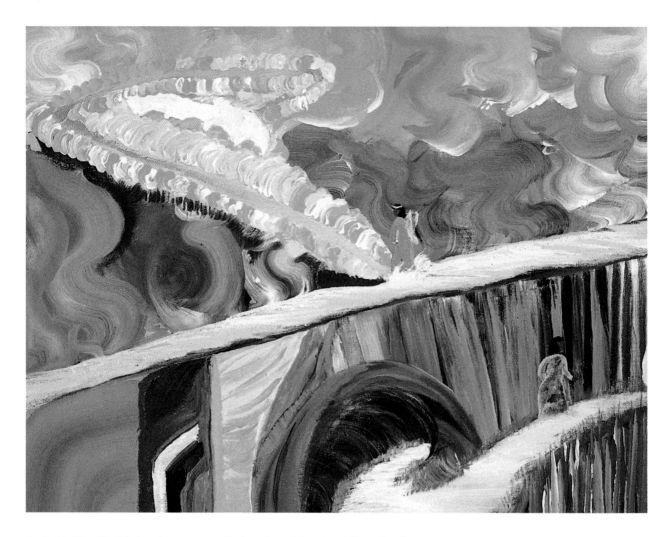

1. *On My Way*, 16 x 20, Acrylic on canvas, On loan from Edward and Karen Jacobs

On My Way

It's a story; I am on my way to heaven. I was baptized when I was six years old, but I was not converted. The only reason I was baptized was my sisters and the older girls told me that if I would be baptized, they would stop taking me out in the woods to pray—that's what they did then; they would take you out in the woods to pray over you, so they pulled me behind the house this Friday night and said, "Here's what we want you to say, `I feel like the Lord has forgiven me for my sins, and I want to be baptized.'" And so I told the story, and I was baptized, but I was re-baptized when I was nineteen, and I'm on my way to heaven. That's a vision; I'm working on that vision, and I know that's going to happen.

On My Way
The Arts of Sarah Albritton

Edited by Susan Roach

Contributions by Sarah Albritton, Peter Jones, Susan Roach, and John Michael Vlach

Louisiana Tech University, Ruston

Distributed by University Press of Mississippi, Jackson

This work has been published in conjunction with *On My Way: The Arts of Sarah Albritton*, a touring exhibition, organized and curated by Susan Roach and Peter Jones, Louisiana Tech University, Ruston, Louisiana.

The publication and exhibition are funded under a grant from the Louisiana Endowment for the Humanities, the state affiliate of the National Endowment for the Humanities. The opinions expressed herein do not necessarily represent the views of either the Louisiana Endowment for the Humanities or the National Endowment for the Humanities.

Exhibition Itinerary

Masur Museum of Art
Monroe, Louisiana
August 16-September 13, 1998

Louisiana State University Museum of Art
Baton Rouge, Louisiana
September 20-November 8, 1998

Louisiana State Museum, Presbytere
New Orleans, Louisiana
December 20-April 5, 1999

African American Museum
Dallas, Texas
June 11-August 29, 1999

Meadows Museum, Centenary College
Shreveport, Louisiana
September 11-October 31, 1999

Published by Louisiana Tech University
Distributed by University Press of Mississippi
3825 Ridgewood Road
Jackson, MS 39211-6492
1-800-737-7788 http://www.upress.state.ms.us

ISBN: 1-57806-114-8

Library of Congress Catalog Card Number:
98-067413

Cover: *Hell* by Sarah Albritton
 Hell photos by Owen Murphy
Back cover: Sarah Albritton portrait
 by Camille S. Jungman
Frontispiece: *On My Way* by Sarah Albritton
Color plates photography by Peter Jones
Art editor: Peter Jones
Copy editing: Sim Shattuck
 Julia Hardie
Designed by Patrick Miller

Printed in Singapore by Toppan Printing, America

Table of Contents

Foreword

Typically the paintings created by women who are self-trained artists living in rural areas — women like Sarah Albritton — consist of images that celebrate the glories of days gone by. They offer visual recollections of the pleasant reassuring dimensions of everyday lives that contemporary viewers may never have known or that they are not likely to see again. Landscape scenes by Anna Mary Robertson Moses of up-state New York, better known as Grandma Moses, come to mind as examples of such paintings along with the works of such artists as Mattie Lou O'Kelley (Georgia), Queena Stovall (Virginia), Clara McDonald Williamson (Texas), and Minnie Smith Reinhart (North Carolina). Overall, one could say that the public appeal of their art, often termed "memory painting," resides in the comforting messages embedded within their renderings of home life, daily chores, and various seasonal events and celebrations.

The contrast between this body of images and the paintings of Sarah Albritton is immediately apparent. In her images we encounter a torrent of pain and sorrow. She begins "I was born in hell; I grew up in hell." From this starting point of rock-bottom misery, she proceeds to recount in dark and foreboding images a litany of abuse, abandonment, and rejection by her mother and other adults. Subsequently she provides grim descriptions of the grinding poverty promoted by the official policies and informal attitudes in which the practice of racial segregation was grounded. She reveals, for example, that even in a seemingly joyous scene like *The Swimming Hole* the children are actually swimming in the runoff from the sewage treatment plant. If we accept these paintings as memory paintings, they are unquestionably records of bitter memories.

But Albritton, it turns out, is not a bitter person. She manages to balance and soften the record of her sufferings with redemptive stories and images that reveal her devotion to God and the comfort that flows from her belief in His saving grace. The painting entitled *On My Way*, which also provides the title for this volume, presents her vision of a glorious finale that she anticipates when her life's journey is completed. One senses that this up-beat prediction of a heavenly reward provides her with an explanation for all the cruelty that she endured as a child. In her view the greater the struggle, the greater the victory. In other images Albritton reveals her belief in angels who stand ready to shield her from the evils that she lists as "all hurt, harm, and danger." Wrapped in their protective wings, she has been spared from the destructive effects of despair and self-pity. Instead, she responds to her soul-scarring experiences with a confidence that is patently heroic. She claims even to be proud of her suffering.

It is this feeling that motivates her to tell her story in vivid pictures. She does not flinch when she confronts the memory of events that must, at some level, be hurtful to recall. Instead she endures the pain and rises above it.

In some ways her narratives replicate the accounts of bondage recorded directly from former slaves. Delia Garlic, a woman who had been held captive in Virginia, Georgia, and Alabama, began her story: "Slavery days was hell." After recounting all the abuses and insults that she endured, she reported that conditions did improve somewhat. In 1938 she ironically remarked, "I'm eating whitebread now." But she most looked forward to hearing the Lord's call to move on up to heaven and she declared, "I'll be glad to go."

The resemblance of Garlic's life-story to Albritton's is more than fortuitous for Albritton explicitly draws direct parallels between her life and slavery times. In her painting entitled *Tarbor Quarters*, she renders a set of early twentieth-century dwellings that were constructed as rental properties for blacks. But she paints the buildings as if they were part of an antebellum plantation complete with a large white mansion, even though the site was never an agricultural estate and the white house was hardly a mansion. In her assessment of this image, she notes that the legacy of plantation slavery continues to mark the experience of African Americans up to the present: "From slave quarters to Tarbor quarters to the projects, you went nowhere." The essential point to be taken here is that Albritton's confidence and her will to survive may owe much to examples of courage and endurance widely available in the African American community from elders who had known the dark days of slavery.

What cannot be denied is that Sarah Albritton's story is a compelling human drama. We are indeed fortunate that Susan Roach and Peter Jones have devoted themselves to helping her share her story with a wider audience. With their guidance, we are able to listen more carefully and to see more clearly. The important nuances and details that might otherwise escape our darting glances or our casual reading are here usefully framed for our profound reflection because they have offered Albritton the benefit of their diligent scholarship. The partnership that we see here between artist and scholar is exemplary, and we are all richer intellectually and deeper emotionally because of it.

John Michael Vlach
Professor of American Studies and Anthropology
The George Washington University

Preface and Acknowledgements

Growing up African American in poverty in rural north Louisiana in the 1930s—in Hell—as she terms it, Sarah Albritton has struggled to take care of herself in her own way. On her journey away from Hell to a better place, she has expressed herself verbally and visually in a variety of performance roles: traditional cook, poet, lay preacher, storyteller, and most recently, self-taught painter and designer.

In the series of paintings from 1993-1998 that form this exhibition, Sarah Albritton represents important memories from her youth in the Ruston area and symbolic statements of her religious philosophy and spiritual vision. Albritton demonstrates her skill and resources in orchestrating her experiences into a rich variety of powerful visual statements that go far beyond the merely decorative. Instead of idealizing the past in a nostalgic manner as do many memory painters, Albritton's paintings often depict painful personal memories or complex philosophical issues. While visually compelling on their own, her memory paintings contain visual narratives, which the viewer cannot decipher fully without a key; therefore, we present here also the underlying stories and commentary for the paintings in the artist's own words, as recorded by folklorist Susan Roach and edited by Roach and Albritton. Our intent with this work is not to speak for Albritton but to provide a forum for her to speak for herself. To tell significant experiences from the artist's life in this work and the exhibition, we have grouped the paintings with their transcribed texts thematically and roughly chronologically as she experienced the events she represents. We also offer contextualization, clarification, and connections for Albritton's paintings and stories with her other expressive creations in her life, her regional community, and the art world. Applying folkloristic principles of reciprocal ethnography, which gives voice to the subjects of study, we have provided Albritton with our interpretive essays for her commentary and approval.

Albritton began this series of paintings following her participation as an invited celebrity for a North Central Louisiana Arts Council fundraiser in May 1993. Albritton was serving with us on the arts council board at that time. Invited to participate because of her popular local restaurant—Sarah's Kitchen, she joined a group of regional celebrities including a banker, lawyer, athlete, coach, businessman, and mayor to

2. *Christmas Lights Display by Sarah Albritton, 1996.* Using over 200,000 lights across the front of her home and restaurant, Albritton depicts Christ's life story in her annual Christmas lights. Note the crosses of the crucifixion on the left. Photo: Peter Jones

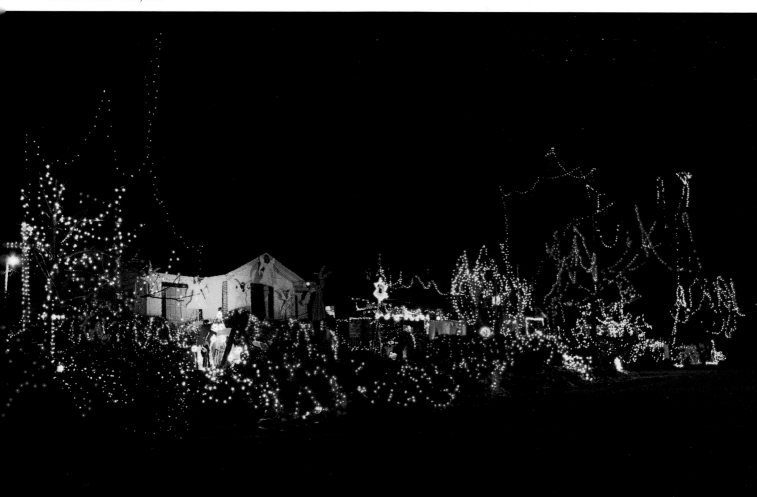

produce paintings at the fundraising party while guests watched them paint. The paintings were then auctioned to raise money for the arts council. In the months after this event, she began to paint some of her early childhood memories, taking a few minutes out of the day or evening to sit and paint in the corner of the kitchen. With no specialized training in painting, she drew on the visual creativity which she considers a "God-given gift" for this newest expressive mode.

Having both known Albritton for over ten years, we knew of the aesthetic awareness and creativity manifested in her cooking, restaurant décor and yard art; however, we were wonderfully surprised to see that she had continued to produce remarkable paintings following the arts council fundraiser. Her consistent work over the next two years led us to think that others needed to see this uplifting story of an African American woman who had overcome many obstacles to create an interesting productive life for herself. Jones felt from the beginning that her paintings needed to be seen together, almost like a Renaissance fresco cycle, so we began looking for a suitable venue. With the help of Mary K. Morse, the university gallery director, in March 1996 Albritton had her first exhibition of thirty-eight paintings at the Louisiana Tech University Art Gallery. Following that exhibition, fourteen of her paintings and accompanying narratives were featured in the fall issue of *Louisiana Cultural Vistas*, the Louisiana Endowment for the Humanities' quarterly magazine. The overwhelming response from the public, art collectors, and museums to this publication was directly responsible for the idea for this touring exhibit and catalog.

Since 1996, the many people who have helped make this project a reality are too numerous to thank, but we must mention the special assistance we received. We are especially indebted to the Louisiana Endowment for the Humanities for the generous funding of this publication and to Executive Director, Dr. Michael Sartisky, who published Albritton's work in *Cultural Vistas* and was instrumental in interesting the Louisiana State Museum in showing Albritton's work. Also we appreciate the assistance provided by Walker Lasiter, LEH Assistant Director.

We also thank James Selcik and Tamra Carboni, at the Louisiana State Museum, and Pat Bacot, at the Louisiana State University Museum of Art, for the initial booking of the touring exhibit and helping with our grant proposal. Thanks also go to Sheila Fischer, at the Meadows Museum; the Masur Museum of Art/Twin City Art Foundation; and Philip Collins and Alan Govenar, at the African American Museum in Dallas for the exhibition opportunities and support of the grant and installation.

We are grateful for the support of the Louisiana Tech University administration who allowed us to apply for the LEH grant and to produce this project and under the auspices of the university. We thank Dr. Daniel Reneau, Dr. Terry McConathy, Dr. Edward Jacobs, and Dr. Dennis Minor. Dr. Philip Castille and Dean Dablow, English and Art Department heads, have been most supportive of this project. We appreciate the assistance of the Louisiana Tech University Art Gallery and its director, Dr. Saul Zalesch, for assisting with loan and insurance matters. Thanks especially to the university staff Gaye DeWitt,

Jo Anne Walker, Sadie Hunter, and Mark Guida for their help with the maze of clerical and administrative details.

The catalog production has been a complex process with an incredibly tight schedule, which was facilitated by many people. We appreciate the encouragement and resources of Dr. John Michael Vlach and his contribution to the catalog. Dr. Sim Shattuck and Julia Hardie provided timely and cheerful copy editing and detailed proofreading. Jonathan Donehoo, Graphic Design Area Head, provided guidance in developing the initial catalog specifications, access to the excellent university design facilities, and advice on the complete production process. Gary Hauser lent his expertise to checking the color proofs. We thank the University of Mississippi, especially Craig Gill, for working out the distribution details. It has been a pleasure to work with Bibi Ali and John Hanley, at Toppan Printers, through phone and e-mail for this global production. And to Patrick Miller—a top-notch designer and computer expert, whose patience, good humor, and efficiency kept us on schedule—we give our greatest thank you!

We thank our family and friends for supporting and sustaining us: Nell Roach for her chicken pies, cowboy cookies, and telephone calls; Kathy and Ray Linder for helping out; and Nicholas Jones for computer advice. Thanks especially to our friends—Camille Jungman for the cover portrait of Sarah and taking her to meet Clyde Connell; Dr. Marianne Fisher Giorlando for reading the catalog text and her ongoing interest in this project; and Walter J. Jamieson, Jr. for providing a New York perspective. Thanks also to Mike Luster and Maida Owens.

We truly appreciate the efforts of the following for making the exhibition a reality: Eddie Haymaker for framing the new paintings; Sue Prudhomme, Masur Museum; and Tamra Carboni, Louisiana State Museum, for assistance with the interpretive text panels and all the museums' staffs for help with installation and publicity.

We are grateful to the following owners for generously lending their newly acquired works for such a long period: Edward and Karen Jacobs, Mr. and Mrs. Alex Hunt, Jr., Michael Sartisky, Ph.D., Dr. and Mrs. A. B. Cronan Jr., Robert and Melba Barham, Sallie and Doug Wood, Louisiana State University Museum of Art, Baton Rouge, Amos and Vaughan B. Simpson, Richard and Thetis Cusimano, Joe and Jody Brotherston, Judy F. Weller, Mr. and Mrs. James R. Owens, Randy Laukhuff, Kit Gilbert, and Senator and Mrs. Randy L. Ewing.

And most importantly, we thank Sarah Albritton, our colleague in this work and a dear friend, for sharing her life, arts, time, food, and wisdom with us.

Along with Sarah, we dedicate this work to our mothers and those special people who have helped Sarah on her way: Cassie Hicks, Robert Lee Albritton, Catherine McNeal, Mary Helen Duncan, Helen, Dale, and Chris Barbour, the Joe Smith family, Ann Bleich, and to the memory of C. P. Payne, Mary Lou Gunn, and Clem Wright.

Susan Roach and Peter Jones, Curators
Louisiana Tech University

The Arts of Sarah Albritton: On Her Way

Susan Roach

INTRODUCTION

For the past fourteen years in Ruston, my professional work as a folklorist and my volunteer efforts in the arts community periodically have included Sarah Albritton, a North Louisiana African American woman, one of the most creative and energetic people I will ever meet. Now it seems odd that we did not meet before this time. After all, we both grew up here with a little over a decade's difference in our ages, but our black and white communities were segregated then, although out in the country her great uncle and my grandfather did know and visit with each other occasionally. In the years we have worked together, we have compared and contrasted our fundamentalist Protestant backgrounds, upbringing, beliefs, and political views and found many similarities. Also we have collaborated and commiserated on a wide range of projects from presenting our mutual Southern cooking traditions and her stories to national and state folklife festival audiences, to planning cultural tourism and fundraising for community arts development, and to coordinating the current exhibition of her work.

Her creative energy has been manifested in different periods of her life in a variety of expressive representations—food preparation, preservation, and demonstration; restaurant décor, yard art, and annual outdoor Christmas decorations; autobiographical prose and poetry; and most recently, self-taught paintings and personal experience narratives. Her performances of these expressions allow her to represent her experiences and beliefs through her life journey and her aesthetic of emergent structure and improvisation—her way of expression, which draws on folk, popular, and fine arts.

In observing and documenting these expressive arts in Albritton's life, I have employed an approach recommended by John Michael Vlach in his essay "The Need for Plain Talk about Folk Art," which calls for an examination of "how individuals in distinct communities employ discrete formulas as they use particular techniques to fashion specific genres of art." He recommends the "life history or biographical case study" as the best means of this and investigating "artists' intentions first and the qualities of their works second" (Vlach and Bronner 18-22). This approach, used in Weatherford's work on Queena Stovall, a Virginia woman who began painting at age sixty, forms the foundation of this investigation of the arts of Sarah Albritton, who has practiced various folk traditions throughout her life and also began producing her self-taught paintings in her late fifties.

Thus, this study will explore Albritton's arts and their contexts: (1) the place where Albritton has spent her life, (2) the major events of her biography as revealed through my interviews with her and her narratives, (3) the various expressive arts she has produced, and (4) her four genres for telling and retelling her significant experiences and beliefs. Sampling from these four narrative vehicles—her written prose autobiography, autobiographical verse, paintings, and oral personal narratives—reveals common subjects and themes and her aesthetic of improvisation. Further focus on the paintings and the stories behind them also gives insight into Albritton's life, motivations, belief system, and community. These narratives also have strong connections with her other art forms: cooking, autobiographical poems and prose, and yard art. They also paint a vivid picture of the realities of life for a Southern black woman in this era.

Because Albritton is telling the personal narratives of a black woman through both words and pictures, feminist approaches to her work can also shed light on her experiences. Rayna Green has reminded us that feminist scholarship must study the work and lives of women, who establish their own versions of their past and present: "Realities of their lives are often forged in white-hot troubles—poverty, physical pain, loss—or abandoned as well to an existence of little consequence to anyone. Scholarly interpretation of their lives and work . . . would offer a new means of getting down their versions, their own meanings for their own lives" (Hollis, Pershing, and Young 6-7). According to a group of women scholars studying such life stories, "personal narratives illuminate the course of a life over time and allow for its interpretation in its historical and cultural portion of it. The very act of giving form to a whole life—or a considerable portion of it—requires at least implicitly, considering the meaning of the individual and social dynamics which seem to have been most significant in shaping the life" (Personal Narratives Group 4).

Just as I have with other folk artists, I have been concerned about documenting Albritton's life through her arts and presenting her work authentically and about the effects of my role as ethnographer and presenter of her work on both her work and the public (see Roach). In theory, then to provide context for Albritton's arts, I will strive toward the ideal that Linda Martin Alcoff advises: "We should strive to create wherever possible the conditions for dialogue and the practice of speaking with and to rather than speaking for others" (Roof and Wiegman 111).

Although I have tried not to speak for her, she has asked me to do so at times. For instance, when she is busy in the restaurant and does not have time to do an interview, she often refers people to me for information on her and her work. Since she has contributed to and read the material I have written on her, I believe that she feels secure in doing this; also it saves her precious time for her various creative projects. To a certain extent, my academic position provides me with privilege to speak as an authenticator for Albritton's work, and some channels are available to me that might not be open for Albritton. However, I do not consider this to be a position of power over her because she also has access to channels unavailable to me. Some of those are from the business and art worlds and beyond.

As for dialogue, Albritton seems to feel comfortable asking questions, exchanging information, and providing her own interpretations. One subject for dialogue, Albritton's painting *He Lifted Me*, expresses her interpretation of how Peter Jones as painter and I as folklorist documenting her arts have affected her life (pl. 2). In the painting, which can be said to represent reciprocal ethnography, Albritton, as the blue-skirted young Sarah, is being lifted out of a flame-ridden pit by angels while a white female figure holds out a microphone and another white male figure with an easel observes the experience. Her explanation of the painting gives insight into Albritton's perception of how our roles can be interpreted in her own world view:

> With Susan's guidance, and building me up and pretending I was so good, we started going to the folklife festivals, and I would cook north Louisiana cooking, and we called it soul food without the soul. After then, I opened the kitchen, and with Susan making me so well known, the kitchen was a great success from the beginning. So that's part of the painting, *He Lifted Me*. Susan is one of my guardian angels, and Peter too. You could not say that they was not one. So the scripture tells us be careful because we may be entertaining angels unaware. So they can take any form, shape, or fashion that they want to. . . . After meeting you and Peter—Peter at the farmer's market, and how God brought this all together. Now Peter was going one way at that time; you was going one way, and I was going one way, but God saw fit to bring the three of us together. So with you all's encouragement and being the mouthpiece for me, and helping me and encouraging me to paint. . . . If you had not gotten me to paint in the Celebrity Paint-Off, would I be painting? Probably not, right? . . . That one thing is what created all the other things. See, it all came together. God works in mysterious ways His wonders to perform. So when you look like—okay, let's say this is destiny; this is what God wanted us to do. If he had not, it would not be successful. Now look, out of that, out of inviting me to paint-off in the Celebrity contest, out of the interview—my home canning, I think that was what I was doing—out of that came the folklife festivals. Out of the folklife festivals came the kitchen. Out of the Celebrity Paint Off came the art, out of the art comes the book, and who knows, we're just going to keep on going if we keep on living. So God has lifted me through y'all. And you can't say it ain't true either. (13 May 1998)

And she's right: I cannot argue with her reciprocal ethnography in which she documents us documenting her, but I might view our meeting and working together as wonderful serendipity.

Nor have I had to pretend that she was "so good." That's just her modesty talking. Also, I have tremendous difficulty being seen as an angel and a mouthpiece. If I were an angel, why would I suffer such dilemmas as questioning my role, effects, and authority? Also I know that Albritton has the power and the gift to serve as her own mouthpiece, as these words, delivered with the authority of a folk preacher, and her other words in this document prove. And so with two voices, hopefully in harmony, we collaborate to tell and interpret significant, formative stories from her life through her creative artistic expressions (see Personal Narratives Group 201-202 and Lawless 36-37).

HISTORICAL, GEOGRAPHICAL CONTEXTS

Albritton has lived her life in north central Louisiana, an area often called the "piney hills" with the state's highest altitude near Arcadia at Driskill Mountain at 535 feet above sea level (see map, fig. 1). Often people unfamiliar with Louisiana stereotypically consider the whole state to be made up of French-speaking Cajuns, Catholics, and swamps; however, this misconception overlooks the fact that Louisiana is divided geographically, ethnically, and philosophically into two regions. Predominantly Protestant, north Louisiana is culturally part of the upland U.S. South. The majority of settlers in the central hill area were American-born, Protestant, Scots-Irish, descendants from Georgia, Alabama, South Carolina, Mississippi, and Tennessee (Wright 18).

The rural folk landscape was shaped by contacts among Native Americans, African Americans, and Anglo-Celtic Americans in pioneer, plantation, sharecropping, and small farm settings. The central hill parishes with their gently rolling, forested hills with mature gray, yellow, or red soils drain into creeks and bayous, which have strips of alluvial soils. The quality of the hill land does not compare with the rich black soil in the flat land of the nearby Mississippi River Delta or the Red River Valley, areas where cotton plantations could flourish.

Because of the poorer quality soils, slavery did not thrive in the north Louisiana hill parishes as it did in the rest of the South. Based on the 1850 census, African Americans made up about 40% of this region's population. Of the 41% of north central Louisiana households that owned slaves, only about 10% of these owned over twenty slaves (Roach-Lankford 5). Slave owners in this area, mostly yeoman farmers, usually did the same manual labor as the slaves. Generally, Protestants in this area have been evangelical fundamentalists of mainly Baptist and Methodist persuasion, with a few Presbyterians. Many slave holders held religious services for their slaves who adopted these religions with some modifications. Consequently, the majority of African Americans in the region are also Baptists and Methodists; however, their churches remain for the most part separate from whites.

3. Detail of *He Lifted Me*, 32 x 40, acrylic on mat board (not in exhibition). On the left bank, Albritton places a folklorist with a microphone and an artist with an easel, documenting her experience.

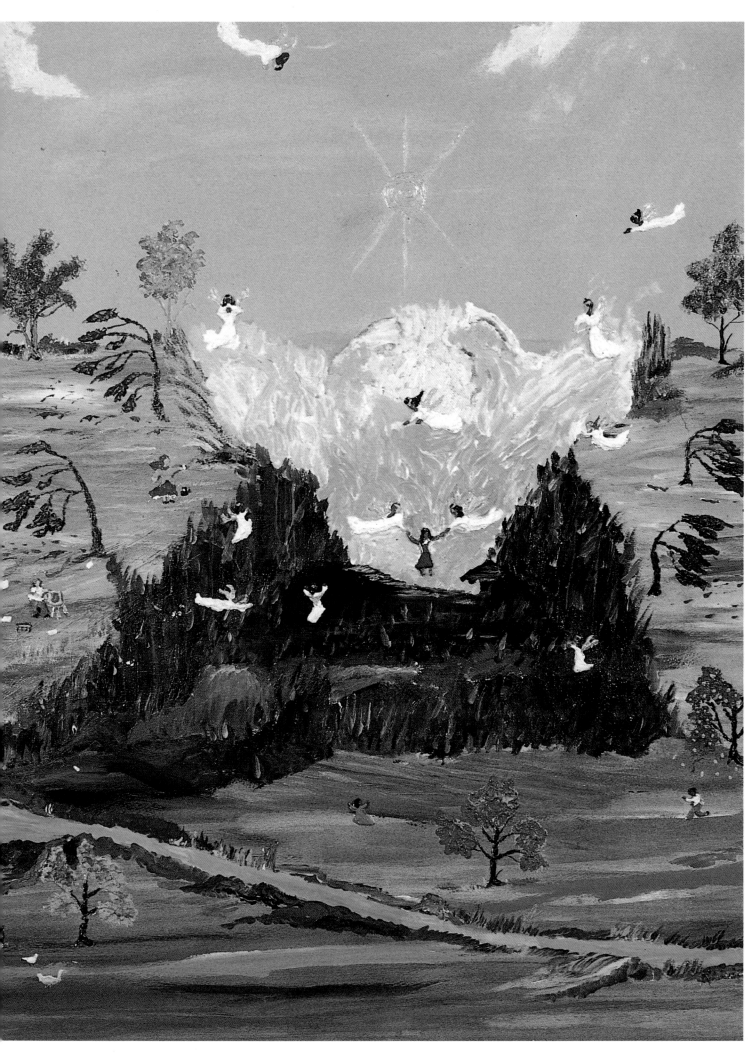

After the Civil War, blacks were without work and mostly without land in the area, and white farmers were broke and could not afford to hire labor. As a result, an agricultural system of tenancy evolved, taking one of several forms: sharecropping, share-renting, or the crop lien. Tenancy offered security but also was debt ridden. The owner furnished the land, seed, and sometimes equipment, and the sharecropper and family were responsible for an average of twenty acres, where they also might raise a couple of hogs and grow their own vegetables (Highsmith 218). The sharecropper had to raise a crop profitable enough to pay both the owner his share and his family's expenses. Given the decreasing quality of the hill country soil and the resulting lower cotton production, it was a difficult system that at times left the white as well as black sharecropper in debt to the owner and created ill feelings. The percentage of tenancy in Lincoln and Bienville parishes went from 25% or fewer in 1880 to 50-75% in 1940 (Goins and Caldwell 86). Some sharecroppers did manage to save enough to buy their own land to get out of the system. For example, Albritton tells how her great-uncle Clem Wright bought twenty-four acres with 150 dollars he had saved in a syrup bucket.

Subsistence farms which grew cotton as a cash crop were common in the hill parishes until the 1930s when highways and technology made commercial agriculture more feasible (Kniffen 140). Traditionally, the 40-200 acre-farm layout had several buildings arranged in a loose cluster (see pls. 23, 29). These included a barn, smokehouse, syrup mill, wagon/equipment shed, privy, corn cribs, and other storage buildings (Wright 113). World War II caused changes on the landscape and took many away from their family farms. While the north central farmers in the past were practically self-sufficient and dependent mainly on farming for their livelihood, few people today draw their complete support from farming. Today the region's farmers work in a variety of occupations from oil jobs to truck driving. New roads, railroads, and towns provided opportunities for rural residents to find new jobs in industry and commerce. Some, such as Albritton's great-uncle, Clem Wright, who worked for the highway department, still maintained their farming on a smaller scale. Those without lands were quick to move into the new lumber and railroad towns such as Ruston and Arcadia, which sprang up in the 1880s.

In the early 1900s, blacks moving into towns such as Ruston found white-owned, small rent houses and low-paying manual or domestic jobs. However, black neighborhoods also had small black-owned and operated businesses such as grocery stores and cafes, which appear in Albritton's paintings. In the 1960s with integration and the arrival of chain stores, these businesses gradually faded. Small industries spawned by the timber industry provided more employment, and later Interstate 20 brought in more small industry.

Today the area's African Americans are mainly descendants of former area slaves. According to the 1990 census, the African American population of Lincoln and Bienville parishes is 16,466 and 6,946 respectively, and the white is 24,732 and 9,006. The area is still predominantly rural, with no major metropolitan area. Ruston, in Lincoln Parish where Albritton lives, is the only town with a population over 20,000. Two universities, Louisiana Tech University, begun in 1894 as Louisiana Industrial Institute and College, and Grambling State University, an historically black university founded in 1901 as

Fig. 1. North central Louisiana hill parishes and southwest Ruston.

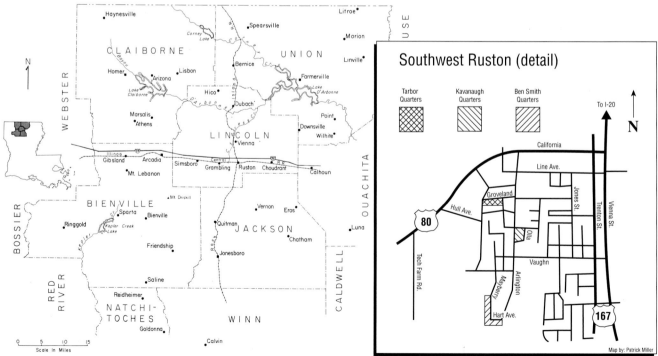

the Colored Industrial and Agricultural School, are located in the parish, near Albritton's restaurant, and have had tremendous economic impact in the area with white and blue-collar jobs.

BIOGRAPHICAL CONTEXT

A biographical context is helpful in reading the paintings and narratives included in this work and in understanding the types and roles of expressive arts in Albritton's life. Giving her birthday as February 6, 1936, Sarah Mae Drayton was born in Arcadia in Bienville Parish. Albritton's mother always told her that her maternal grandmother delivered her in the year of the big storm; that rather than a birth certificate validates her date of birth. Her single mother moved to the small town of Ruston in adjacent Lincoln Parish when Sarah was between two and four months old. They lived in various black rental neighborhoods, listed by Albritton as Ben Smith quarters, Kavanaugh quarters, and Tarbor (Talbot) quarters (see fig. 1). While the term *quarters* is currently viewed as pejorative, Albritton uses the term because it was commonplace usage among blacks and whites when she was growing up. Actually, the word denotes simple housing typically for military personnel, but in the time of slavery, slave housing on plantations was referred to as "the quarters," a term which survived past the Civil War into the twentieth century to designate sections of lower socio-economic housing. Usually white-owned, the quarters of Albritton's childhood consisted of 50-60 houses, built in shotgun or bungalow style (see pl. 14). The setting for such housing was often marginal, frequently located near undesirable structures such as sewage treatment facilities, just as Tarbor quarters was near the "cesspool branch" that appears in many of her paintings. This major Ruston drainage ditch, located near the sewage treatment station, caught any overflow. According to Albritton, "They're [city officials] fussing over it right now. They call it the lagoon. Sometimes when the motors are not running, they let it [the sewage] go in the branch." Nevertheless, the branch functioned as a major play area for young Sarah and her friends.

Some landlords, such as Dr. B. H. Talbot, provided better housing than other landlords. His houses had running water within walking distance of each house and five public toilet houses with flush toilets across the site, an uncommon convenience for most quarters houses at the time. He may have taken greater pride in his property since he lived nearby in an adjacent big house, which was not unusual at this time. It is interesting to note that the big house and quarters plan that *Tarbor Quarters* (pl. 14) represents recapitulates the plantation layout. However, the shotgun house is not based on the common slave house type but on an urban house type spread from Haiti to New Orleans (Vlach *By the Work*, 210).

In Albritton's childhood, houses were primitive: a two-room house heated with a cook stove, which caused frequent fires. Albritton remembers when she was about seven, their house burned and they moved:

In the quarters, the house caught on fire. We had a coal oil stove, and they would explode for some reason. I think the fire would go down in this little glass bottle with the coal oil in it, and the house caught on fire. And I was glad the house caught on fire. I was because I thought if the house caught on fire, the situation would be different, but it was no different. It was just the same thing over and over. . . . And mother come and she was down on the ground crying because her house was burning. She was at work; she was working for Mr. Graham over on southside . . . And the house burned, and we moved to another house at that time. . . . Actually, we moved off the street right behind. The houses was four rows deep, no roads through them, just four rows deep, and one road; you have to cut through the trail to get to each other's house. (1 August 1997)

Also of interest here is her comment on the "trail" used to move from house to house, which is analogous to the improvisational trails that were "central elements of the slave landscape" (Vlach, *Back of the Big House* 13).

Families moved frequently, and children also were moved around. Typical of many rural African American families, her mother's extended family helped raise Albritton. In her early years she was shuttled unwillingly back and forth from her mother in Ruston to her relatives on small farms in the country, where she learned about farm life. Around the age of five, she was sent to live with her great uncle Mann Drayton in the country, but this only lasted for a few days. As a child she did spend most summers on the farm with Cassie and Thomas Lewis but most often with her great aunt and uncle, Annie Mitchell ("Auntie") and Clem Wright, about ten miles outside of Ruston. She considers Clem Wright one of her great teachers, who told her, "If a man won't work, he'll steal, so I want you to stay in your books, get a job, and buy you a little piece of land and save a quarter," which she basically took to heart (see pl. 26). Also in this country community of Mount Harmony, she would occasionally visit her sister Elouise (living with their Cousin Sue) and her sister Ella Mae (living with their Cousin Quemine). She also learned the basics of traditional farming and cooking farm-grown vegetables and cornbread from her relatives. As she puts it, "I used to watch Auntie [cook], but she wouldn't let me make nothing but dog bread."

Spent mainly in the various black rental areas of Ruston, her formative years, to which many of her paintings are devoted, were painfully difficult, but she did manage to receive her elementary and high school education in Ruston, where she attended what was then segregated Lincoln High School. Finding the nurturing she desperately needed at school and in the neighborhood, she values especially her fourth and eighth grade teachers—Mrs. Mary Helen Duncan and Mrs. Catherine McNeal—who encouraged the development of Albritton's potential. Mrs. Duncan says that the young Sarah always got into fights, but that she always let Sarah tell her side of the story; in other words, the teacher gave her an unusual opportunity to

speak. Typically, she had been punished without being allowed an explanation for her behavior. It is interesting that Albritton says she remembers all her teachers, a sign that they were most important to her.

Work

A constant theme running through Albritton's life and art is that of work, from working on the farm, depicted in works such as *Learning Her Lesson* and *Working on the Farm* (pls. 26 and 23) to working in town doing odd jobs and finally cooking (see *Hanging at the Church* and *Tarbor Quarters*, pls. 40 and 14). To her repertoire of basic Southern cooking, she gained experience working from three to eight hours per day, often the evening shift after school in jobs at a number of local restaurants. Having run errands in her immediate community for small change around age nine, she began her first real job washing dishes at the Tech Hitching Post Restaurant, where she learned to short order cook from a white cook, Mrs. George Heard. She had to stand on two coke cases to reach the stove; nevertheless, she became so good at the job that by age twelve, she was head cook. Mrs. Heard's death when Albritton was fourteen prompted a new job at the College Café, where she worked until her white boss made a pass at her. She then moved on to the Deluxe Café, near the college, where she worked with success for several years. A better offer moved her on to the Olympia Café downtown. She even made local civil rights history by being the first black to be served there. As her narrative indicates, she and her work were valued enough to keep her on in spite of her challenging local rules of behavior:

> I was the head cook there . . . and I made up my mind I was going to eat out front or I was going to quit. I was fixing lunch and after we served lunch, I decided since today was payday, so I said, "Frances"—she was one of the waitresses; she was white—"Bring me my check." She asked me what was I going to do, and I knew I wasn't supposed to be eating in here. I said, "I bet you I do." So I ordered and [the owner] walked up and asked me what I was doing. I told him, "What does it look like I'm doing? I'm eating." He told me I knew I wasn't supposed to be eating up in front because it was against the law. I asked him whose law was it. He told me I just couldn't be doing that because I was colored. I told him I knew what color I was. Then he asked me what if his customers came in. I told him either I eat here or you find a cook; you got a choice. He told me to go on and eat there. (14 December 1995)

For the next years she worked at a number of other restaurants, with many jobs running simultaneously. She lists the following restaurants in her cooking experience: Tech Rendezvous, the Olympia, the Anderson Donut Shop, Naff's Cafeteria, and the Post Office Café, where she worked for five months until she was fired over her refusal to cook spoiled peas.

When she was fifteen, she began working part time as a cook at the Catholic School, where she met another white family, for whom she began babysitting part time (fig. 2). When she was sixteen, she added another job painting and striping broom handles with the new handle factory, Diamond Industry, for seventy-five cents per hour, which was top wage at the time. Even in this job she found that she could improvise on the striped designs on the handles by the way she twisted the handles in the paint bucket.

Interestingly, Albritton is beginning to explore her adult work experience in two of her most recent paintings, *The Road of a Cook*, painted in May-June 1998 (fig.12). Intended to be seen as companion pieces, these mural size paintings depict all the places where Albritton worked as a cook, although they are deliberately not presented with geographical accuracy.

During and after these years as a cook, she also had her own private businesses: "I was doing private catering and parties, and I also had a home canning business. I did a lot of catering for some of the people here in Ruston, and sometime out of Ruston; I was a travelling cook; I would go wherever they wanted me to do catering. . .And I was a farmer too." She also worked as a housemother, operator of a janitorial service, and store manager.

Marriage, Family, and Community

In 1954 Sarah Drayton married Robert Albritton, from Ruston. They have three children—Jacqueline, Daphne, and Lewendoski (see fig. 3). They are proud that their hard work put all three children through college and saw them launched into professional careers. They also raised six of her uncle's children. During these years she continued to work as a cook for various restaurants and institutions.

Along with these jobs, in 1969 she took a job with the Louisiana State University Cooperative Extension Service as a nutritional aide working closely with Dorothy Barton, the associate home economist. She describes her work: "I worked with 150 low-income families, and I had 300 children I worked with in those families. . . . I taught nutrition, money management, and budgeting to the low-income families. And I also taught the visual aid workshop for the nutrition aides in the four parishes. . . . Now working for L.S.U. was fine; I made good money working for L.S.U." (19 May 1998). This job added an academic dimension to her folk cooking techniques and repertoire. Later she developed her own catering service and cottage canning business. A prolific gardener, she also helped organize the North Central Farmer's Market Association.

Never idle and always interested in learning throughout her life, she took short courses in carpentry and welding at the local vocational school, the Ruston Technical Institute. In 1978, she also took a Louisiana Tech continuing education short course entitled, "Learning to Draw," taught by university professor, Edwin Pinkston, the only formal art training she has had. Her talents and interests are reflected in her work, hobbies, and service. Along with her recent painting, she states her hobbies as reading, collecting antiques and primitive cookware, gardening, cooking,

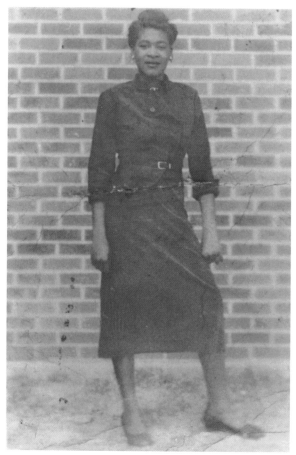

Fig. 2. Sarah Albritton, age 15.
Photo courtesy of Sarah Albritton

collecting food for the needy, and writing. She has written two unpublished autobiographical manuscripts, *Poor Black Girl* and *Living from Day to Day*.

About the time of her marriage at age nineteen, Albritton had a strong religious conversion experience, described in her narrative for *Crucifixion* (pl. 48). As years went on, she became more immersed in her religion. She began serious study and graduated from the American Baptist Theological Seminary (then a Ruston correspondence extension of a Nashville Baptist Bible school). And most important, she received a call to the ministry, which she, like so many who are called, resisted (see Rosenberg). She describes her experience:

I didn't see anything, now, like they say you're supposed to see. I knew I was called, but I just didn't want to do nothing; I didn't believe it, so I asked the Lord, I said, If You really want me to go," I say, "within seven days I want You to show me." I said, "Don't leave me confused; I want to see it just as clear." I was working for the extension then, and I was supposed to go to Jonesboro that day, but I didn't. I went on southside [of Ruston]. I don't know why I went on southside, but I went to southside.

And it was a young man met me; he was gay. And he stopped me, and said, Miss, will you help me?"

I said, "Yes, you want to talk about it?" I really don't know why I said yes, because I didn't know what he wanted with me. I got out of the car and sat on the porch. (15 May 1984)

When the young man told her that he was suicidal over his situation, she talked with him and tried to get his family to help him, but they refused. She then took him to the mental health center for counseling and continued to work with him for some time. She considers this to be a sign that God had provided to indicate that she should become a lay minister to work in the community: "That was a clear calling because it was on the seventh day [since she had asked for a sign]. After then, I started visiting the gambling houses and pool halls" (15 May 1984). In her volunteer work as a lay minister, she sought out those needing help and held prayer and Bible study group meetings in the community.

Also people began to turn to her for healing. When her mother-in-law was pronounced terminal in the hospital, the family called her. After she reached the hospital, the woman had practically stopped breathing, but Albritton asked everyone to leave the room and she "laid Bible on her and prayed, and in ten minutes she was sitting up talking" (15 May 1984). Albritton says that such healing ability is one of the special thirteen gifts the Lord promises in the Bible, and that one person can be given more than one gift if the Lord chooses. In 1984 she also referred to her canning as "a gift." She also believes in the power of prayer, another gift, to help

Fig. 3. The Albritton children: Daphne, Lewendoski, and Jacqueline.
Photo courtesy of Sarah Albritton

Over the years in her role of community nurturer, she has been an ardent, politically involved volunteer and lay minister, who has helped organize a food program for needy children and assisted the predominantly white Trinity Methodist Church members with cooking those meals. Playing a visible role in both black and white communities, she has served on a number of community organization boards including the Domestic Abuse Resistance Team, Lincoln Guest Care Center, Ruston United Group, Lincoln Total Community Action, Inc., Lincoln Parish Black Caucus, and the North Central Louisiana Arts Council. She has also worked with the Lincoln Parish Mental Health Association, the Mayor's Commission for Women, the Head Start Policy Council, the Lincoln Parish Homemakers' Clubs, and the Lincoln Parish Beautification Board. Among her many honors and awards are the Ruston NOW Outstanding Woman Award, NAACP Appreciation Award, the Louisiana Extension Service Para-Professional Award for Outstanding Nutritional Aide, the Grambling State University School of Social Work Outstanding Service Award, and the Lincoln Total Community Action Award for Head Start Program service. In 1998 she received an award from the Ruston Mayor for outstanding service to the community.

Folklife Festival Presentations

I first met Albritton when she was working for the extension service, which recommended her as a good community contact in 1984, when I was conducting a folklife survey of north central Louisiana. I went to her home where she did her canning for her business, and documented her making dewberry jelly. I was impressed by her ability to explain and demonstrate the procedure while I taped and photographed her. She also expressed her underlying values and aesthetics of cooking, emphasizing the importance of the "deep purple color" of the jelly, the one-half inch head space for the jar, and cleanliness. For example, she explained her reasons for boiling the filled jars:

> So it [boiling] will be enough to kill the bacteria, and also it cleans your jars; you know, usually you might spill something on your jars. It cleans your jars and your jars will be nice and pretty . . . I don't want you to eat anything I wouldn't eat. If I cook well for myself, I want to do equally as well for you. And we should all feel that way about our canning, freezing, our cooking, whatever. I've always felt this way about my cooking. They have an old saying, I'll "wash something to death." The neighbors say it takes me all day long and half of the night to cook, and they're probably telling the truth, because like if I have greens, I'll make sure my greens are clean . . . I'll wash them until they are clean, and I don't see anything in the water. I might wash them twenty times. (15 May 1984)

Also from the interview, I learned that in addition to her cooking skills, she is outgoing, loves to talk, and a consumate

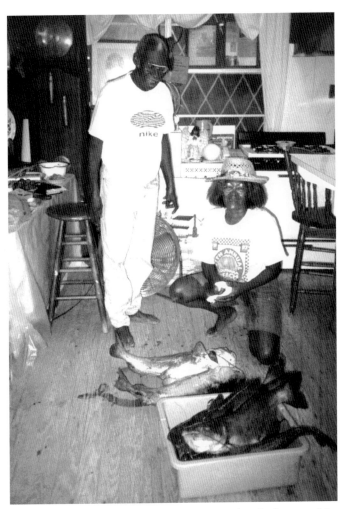

Fig. 4. Sarah and Robert Albritton admire an unusual catch of seven catfish, a total of 106 pounds, from a nearby farm pond. Photo: Susan Roach

accomplish one's goals. Even her outdoor activities such as gardening and fishing inspire her religiously: "You know, out in the field growing something, you're close to God, and it makes you think about life and death. I stand there and pray the Lord will give a good crop" (15 May 1984). Indeed, Albritton has been blessed with diverse gifts.

Given her belief that these gifts are from God, she is required to use them, or God may take them away. Even though her multiple interests and talents require her to constantly work on several projects at once, she does take time to relax. Probably her most frequent form of relaxation is fishing in area farm ponds and lakes, where she often retreats in late afternoons with her longtime friend and fishing buddy, Retha Smith. They take snacks, a variety of fishing poles, from casting rods to cane poles using predominantly live bait to fish for bream, bass, and catfish (fig. 4). Even when she fishes, Albritton has two or three lines in the water simultaneously, while she takes a quick nap. Her fishing luck is generally good if she doesn't lose a pole to a big one, but she rarely eats fish; usually, she gives them to friends or the pond owners.

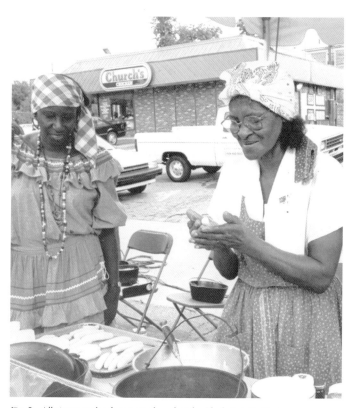

Fig. 5. Albritton makes hot water bread at the Black Arts Festival in Atlanta, Ga. Photo: Courtesy of Sarah Albritton

1991 the *Smithsonian Folklife Cookbook* included her recipes for hot chowchow relish and plum jelly, along with her personal narrative of why she began making jelly (Kirlin and Kirlin 152, 155). Her narrative, recorded on one of our 1985 cooking stage presentations recounts a childhood berry and plum picking experience which resulted in her mother's making jelly. The next day her mother served breakfast of "rice, salt pork, biscuits and one spoonful of jelly." Sarah ate hers and begged for more, but her mother said no, to which Sarah responded by running under the house and crying. She said, "When I grow up and get me a job, I'm going to make all the damn jelly I please and my children can eat all they want."

In addition to demonstrating cooking at festivals, Albritton began to tell her stories on both festival cooking and narrative stages, which brought her storytelling abilities to the forefront. As a result, I recommended her for the Louisiana Storytelling Project, which led to the publication of two of her stories, as well as two from her husband Robert Albritton, in *Swapping Stories* (Lindahl, Owens, and Harvison 202, 305). These were not personal narratives, but fictive stories: "The Reverend Gets the Possum," which uses religious humor to make fun of a hypocritical minister, and "She Has the Key," a story about how God gives woman some power in the male-female relationship by giving her a key to lock the door. Interestingly, both of these themes—hypocritical Christians and women obtaining power over men—appear in her other narratives as well.

Sarah's Kitchen

When I first had interviewed Albritton in 1984, she had talked about opening a "shop" to sell her canned items and soul food. However, she believes that her folklife festival performances finally led her to the realization of that dream: the September 1987 opening of Sarah's Kitchen, a restaurant specializing in fresh, nutritious Southern style food, along with catering and canning. Because of Albritton's reputation in the community, her restaurant is a crossroads for community blacks and whites, although it sits in a black neighborhood just off Interstate 20. It also draws considerable tourist traffic and has been publicized in various television cooking shows such as Chef Folse's *A Taste of Louisiana*, and touring guides such as *The Lonely Planet Guide to the Deep South: Louisiana, Mississippi, Alabama*, which lists Sarah's Kitchen, a "café-cum-folk-gallery" as a "must for anyone traveling anywhere near Ruston." This guide advises the traveler:

> Instead of wolfing down a burger at some highway hash house, seek out this inestimable eatery at 607 Lee Ave. in a neighborhood of tidy clapboard homes. Sarah is a stickler for fresh foods. On any given day she offers four to five meats and 13 to 15 fresh vegetables. Turnip greens, black-eyed peas, okra and tomatoes and yams are menu mainstays. If you're lucky, Sarah will be serving her special sweet-and-sour squash, a hybrid she developed in her own

performer with exceptional skills in recounting personal narratives. Given her networking ability in the community, she also led me to other tradition bearers in the parish for the survey project. Because of these skills, I recommended her for foodways presentations in 1984 Louisiana World Exposition. In 1985 when the Smithsonian Festival of American Folklife featured Louisiana, we both traveled to Washington, D. C. to work together as folk artist and folklorist, demonstrating traditional Southern soul food, which included preparing biscuits and jelly, black-eyed peas, hot water cornbread, chicken and dumplings, and tea cakes. For the next two weeks, we spent many hours together on stage and off, forming the bonds of a longtime friendship. By the time we worked again at the Louisiana Folklife Festival, we knew our repertoire, and had standard elements of our performance, to which audiences responded enthusiastically. For example, in Washington, when she was demonstrating biscuit or hot water bread making and putting ingredients together without measuring, I would ask her what measurement of flour or meal she used, and she would tell the audience how she just dumped some in the bowl; the amount dumped would determine the amounts of the additional ingredients. Typical of traditional folk cooking, this method inspired her to coin a phrase for her cooking: the "dump method."

Albritton went on to demonstrate her way of cooking almost every year at the Louisiana Folklife Festival and other numerous regional festivals as well, with one of her favorites being the Black Arts Festival in Atlanta, Georgia (fig. 5). In

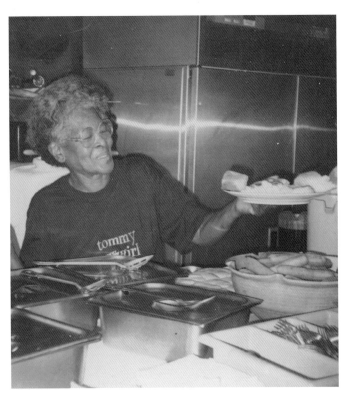

Fig. 6. Albritton serves a work of culinary art at Sarah's Kitchen.
Photo: Susan Roach

backyard. As good as the food is, the surrounding gardens and restaurant decor may be the prime attractions. The makeshift fence is constructed of old radiators, and cast iron stoves overflow with plants. Inside, every surface of the ramshackle, wooden building is covered with mementos of Sarah's culinary career. African tribal art is stacked in a dark corner. Yet, all is overshadowed by Sarah's visionary paintings. (Stann, Marshal, Edge 297, 571).

Albritton herself designed her kitchen interior in the eighty-year-old, one-room house that she moved next door to her home. About a year after her opening, she added a dining room and attached a restroom, designed as an old-fashioned outhouse, but with running water, sink, and flush toilet. Interestingly, her kitchen cooking space is set up in much the same way that the national and state folklife festival kitchen stages are arranged (compare fig. 5 with fig. 6 and pl. 6) . Her stove, sink, and refrigerators sit behind a long counter. On the right end of the counter are the fourteen rectangular covered stainless steel pans of vegetables, cornbread, and rolls. During her open serving hours, usually from 11:00 a.m. to 6:00 p.m., her entrees are on the left of the counter; otherwise, this part of the counter is used for preparation.

Often dressed in what she calls her uniform—white pants or skirt and shirt with her hair covered by a white or red "head rag," Albritton stands behind the counter (see fig. 6 and pl. 6). While she had to cover her hair with a scarf because of

health codes when she began working in Ruston restaurants, today she still consciously chooses a scarf tied in the manner of slave cooks. Saying that in slavery, the cook was the boss of everyone both black and white in the house, she identifies with this manager, nurturer role. Interestingly, Vlach's *Back of the Big House* notes that the cook claimed the kitchen as her own territory (17). Thus the head covering, instead of being a stereotypical symbol of subjugation, signals her power and strength in the kitchen. The customer coming in the door must face the counter and the cook and ask her for food. The customer selects the preferred dishes from one of the 5" x 8" photocopied menus, which Albritton has designed, complete with a list of all the foods, drinks, prices, and a poem (fig. 11). The standard plate lunch consists of a meat entrée (often chicken and dumplings, beef tips, lemon peppered chicken), a choice of two vegetables from the fourteen or so offered, hot water bread or rolls and a beverage (ice tea, lemonade, or sassafras tea). The customer places an order, which is written on a small short order ticket book. Albritton or one of her assistants, often Robert Albritton, dishes up the food as it is ordered unless there is a large group. In that case, the orders are taken, the group sits down, and Robert Albritton delivers the served plates to the customer. If the food does not seem warm enough, it is warmed in the microwave oven behind the counter for a minute.

Albritton's serving is a performance in itself, wherein she carefully scoops up large servings with a long-handled stainless steel serving spoon on to a large, heavy plate or styrofoam box for take out orders. The product of the serving performance—the served plate—becomes a work of art with mounded servings of steaming vegetables arranged in a colorful array: red and green tomatoes and okra, creamy mashed potatoes with a pool of dark tan gravy, yellow squash or corn, golden pones of hot water bread or rolls (see fig. 6).

In the restaurant, she does the cooking, coming in between two and four a.m. when it is quiet. She does have help from Robert Albritton and others with preparing the food for cooking: peeling potatoes, shelling peas, etc. She prides herself in using only fresh, unprocessed food—"No cans or boxes" and in adapting the traditional fat-laden Southern recipes into healthier, leaner ones, by eliminating animal fats and unnecessary sugar to produce what she terms, "Soul food without the soul." She explains her use of fats:

It's not healthy for you, that's why. Traditionally, we think we have to have the butter, the oil, the sugar, and the eggs. We have just been taught that, and we just do it. We don't even know why we do it, just because we were taught that. There is a reason, let me go back to this fatback. When I was little, my mother used to cook fatback; let me say saltback. You all know what fatback is, all right? Salt meat—we would have rice every morning and biscuits. These were the good days. She would put that little bit of salt meat on my plate and I would pick out that lean from out around

that fat. And I would get a whipping every time we had salt meat because I was not going to eat it. I never liked fat meats and oils. (14 Dec. 1995)

These innovations to traditional cooking, no doubt, were inspired by her work with the extension service. Today, in spite of the fact that she has improvised upon traditional methods of cooking, she is concerned that she cannot find help to cook exactly her way, which she considers to be a superior way of cooking. And yet, she does not openly give out most of her recipes. For example, when one of my students asked her how she seasoned the turnips, she replied, "That's a million dollar secret. I use my herbs and spices. And that's a million dollar secret. You should just play around with them" (15 Dec. 1995).

Restaurant Décor and Yard Art

After getting the order, the customer can either sit at one of the three small tables adjacent to her painting table (now holding a myriad of painting supplies, table easel, and papers) in the kitchen itself or go into the dining room on the right. The crowded, creaky tables with their mismatched wooden or metal chairs are set simply with white plastic table covers and utensils wrapped in a paper napkin. By each place setting, where they can be read like fortune cookies, are Bible verses on business-size cards. The dining room, like the kitchen, has unpainted wood walls, covered by Albritton's assemblage of works of art, photographs, letters, poems, photos of family and friends, portraits of Albritton by area artists, newspaper features of Albritton, numerous awards and certificates and antique utensils. Because the grease and smoke from the kitchen have aged the displayed papers, first-time patrons often assume the restaurant has been in operation for decades. For curtains, one window sports on each side tee shirts from the Grambling Tigers and the Louisiana Tech Lady Techsters basketball teams, who frequent her restaurant. The walls change constantly with her additions and from patrons' subtractions. Occasionally, she would refer me to a poem or other memento on a certain spot on the wall, only to learn that it had "disappeared," no doubt, at the hand of a diner seeking a souvenir from the unusual restaurant (fig. 10).

A similar assemblage, the garden in front, or as she would term it "front yard," contains additional tables and chairs for outdoor dining, old sinks, radiators, a Garland stove, statues, angels from her Christmas display, an antique ice house, a gravestone intended for her Uncle Clem Wright's grave, and a restored 1950 Chevrolet—all somehow incorporated into a lush flower and herb garden (fig. 7). Each spring, she buys dozens of flats of flowers such as begonias and petunias as well as more exotic varieties to plant in converted planters and beds. Albritton's

Fig. 7. The front yard art of Sarah's Kitchen ranges from Christmas angels, an antique community ice house from Albritton's childhood, and a gravestone intended for her Uncle Clem Wright. Photo: Susan Roach

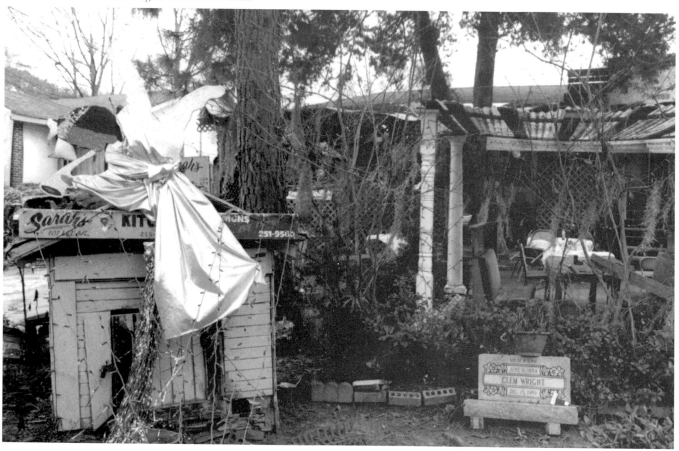

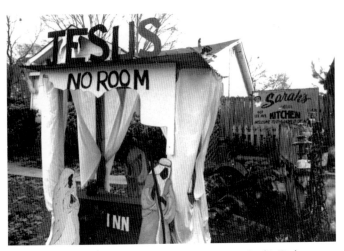

Fig. 8. The "No Room Inn," part of the nativity story in Sarah's Kitchen Christmas display, 1996, is built of scavenged materials.
Photo: Susan Roach

creativity at recycling elements is remarkable, and her combinations show her to be a true bricoleur as described by Levi-Strauss, as she "make[s] do with whatever is at hand" with finite materials that are the "result of all the occasions there have been to renew or enrich the stock or to maintain it with the remains of previous constructions and destructions" (17). To enrich her materials, she loves to attend the Bonnie and Clyde Trade Days flea market in nearby Arcadia, and is continually adding to her collection of objects (see fig. 7, pl. 5, and Thompson 124-25). Like the kitchen wall, the yard is constantly changing as she improvises to take care of destructions from natural causes or time. When a structure, her "gazebo," of carved plastic columns holding a fiberglass roof over an outdoor table collapsed in a storm, she hauled it out and moved some flower containers to accommodate the new space.

While some scholars such as Thompson attribute such collections to African memory and religion, Albritton does not want to have anything to do with "voodoo" because it goes against Biblical teachings. As a matter of fact, when she was asked by a friend to help find a voodoo practitioner to help her with a problem, Albritton made up an alternative ritual consisting of reading certain Bible verses and sprinkling some flour around. This is not to say that an African improvisational aesthetic does not exist here, for it undoubtedly does.

Such improvisation is also the case with another form of yard art she has added to her restaurant and adjacent home yards in the last few years—her display of Christmas lights and scenarios. This popular art form has burgeoned during the last few years with the city of Ruston outlining its downtown buildings with white lights and the town of Jonesboro starting a Christmas lights festival, featuring millions of multi-colored lights. Following suit in a somewhat competitive, yet community spirit, many other public as well as private entities have added their own Christmas displays focusing on the sacred as well as secular seasonal symbols. In the local newspaper, the month of December runs regular listings of light displays,

including Sarah's Kitchen. She also advertises them on the local cable television channel as a thank you to her customers.

While her annual Christmas yard art lighting display is a three-dimensional progressive work, basically she has designed it to "tell the story of Christ's life." She has built, painted, and lighted with 200,000 lights not only structures depicting events from Christ's birth including the nativity manger scene, the "No Room Inn," and the temple, but also "the crucifixion, the resurrection, and the ascension" (see pls. 2, 5 and fig. 8). In 1996 she added a "host of angels," modeled after the angels in her paintings and cut out with her jigsaw. In true bricoleur style she builds her light-covered tableaux from recycled building materials including plywood, styrofoam, and scrap lumber; found objects such as concrete and plastic statues, which she drapes as robe-clad figures; and various containers such as plastic cups, clustered into stars. Preferring to do most of the installation herself, she has even climbed tall trees to put up her lights, although I made her promise she would not do that again. Even before the current display is disassembled, she is preparing for the next year, going to after-Christmas sales to get more lights.

Actually, because she is too busy with the restaurant, painting, fishing, and other projects, some of her additions such as the angels and a life-sized, plastic, fake fur-covered gorilla (bought to start an unrealized Christmas kiddy land) have stayed in her yard all year long. In fact, many of the lights themselves have remained up all year. For example, the strung lights are still stapled to the railings of the restaurant, and the light-covered crosses in her side yard are still standing as a constant testimonial for Christ's crucifixion.

In eleven years of operation, Sarah's Kitchen has received extensive press attention with feature articles in north Louisiana newspapers including the *Ruston Leader, Tech Talk, The News Star* (Monroe); urban newspapers such as, *Atlanta Tribune, Times Picayune*, and *Gannett News Service*; and state and regional magazines including *Louisiana Life* and *Southern Living*. Her television and film appearances range from KNOE *Good Morning Ark-La-Miss* and Louis Redden's *Backroads* to Louisiana Public Broadcasting Chef John Folse to a Paris, France, documentary, *Good Things of America*. In short, Albritton has become a celebrity.

PAINTING CONTEXTS

Albritton's strong community presence indirectly led her to begin a series of paintings. Having no idea of her painting interest or skill, I suggested that she be invited as one of the celebrities producing paintings for auction for a North Central Louisiana Arts Council fundraiser in April 1993. She joined a banker, lawyer, coach, businessman, athlete, and mayor to paint at the party while guests watched. Her painting, *Sarah's Kitchen* (fig. 13) raised more money than some of the other celebrities' works, and brought her back to painting, which she had tried years ago. Following the fundraiser, she began to paint some of her childhood memories at her table easel in the kitchen of her restaurant, after preparing the day's food. Although she doesn't

Fig. 9. Albritton and Louisiana artist Clyde Connell exchange autographed copies of their *Louisiana Cultural Vistas* covers in spring 1998.
Photo: Susan Roach

paint during the busy noon rush, her current painting is usually on the easel with a couple of completed ones standing around in the corner. Looming high in the corner, the faces of her color television and the adjacent grandfather clock dominate her kitchen studio, juxtaposing past and present as her paintings do. Not the studio of a trained artist, but instead a kitchen—a woman's space—it is a place where she can paint in the interstices of woman's time, but it is also a public space that makes the act of painting another one of her performances (see Kapchan 479). Afternoon customers will watch her paint and talk to her, asking what the paintings are about, and she will tell one of her stories.

Albritton had very limited artistic training by non-arts specialists in her elementary and high school years in Lincoln Parish, where she mostly played with crayons and watercolor paints. She recalls that at seventeen, she did her first painting in oil of "a woman and some flowers." Her continuing education class in drawing, in which she did pencil drawings in a "realistic style and abstracts" seems to have had minimal effect on her painting. While she has had some contact and interaction with local professional artists who have frequented her restaurant and given her encouragement and support, she does not seem to use their styles, approaches, techniques, or subject matter. She has, however, used the medium of pottery to paint her stories, thanks to local potters Kent Follette and Bruce Odell, who provided her with a half dozen of their unfinished pots. Watercolorist Douglas Walton has encouraged her to take

his class, and she has posed as a model for his famous "Watercolor Encounters." Peter Jones was instrumental in helping her get her first exhibition and offering advice on matters such as framing and pricing. Photographer Camille S. Jungman, who had made photographic portraits of Albritton and had studied Clyde Connell, a noted north Louisiana sculptor, wanted the two women civil rights activists to meet because both of them found inspiration for their work in memories of African American experiences. So a few months before Connell's death, we went to visit, which was a touching experience for all involved (fig. 9). During the visit, because Connell had found inspiration for her art in the spirituals of her black nurse Susan, Sarah sang "Amazing Grace" while Connell, ninety-six and frail, sang along. Albritton said later of their visit, "Something about her and her work touched me deeply, but I can't explain it. She's probably someone God wanted me to meet."

Although Connell too is somewhat self-taught, she worked in an active community of academic artists in the Shreveport area and made frequent trips to New York to museums to keep abreast of developments in the art world. Albritton, on the other hand, is ultimately self taught. When asked what she called her work, she responded with an art world term that folklorists find pejorative: "primitive, because it deals with the past" (3 March 1996); actually this is a term also applied to Connell's sculptural work, which is out of the mainstream of contemporary art.

Most important in categorizing Albritton's work is her own consideration that her creativity is a God-given gift: "Didn't nobody teach me this; God gave it to me; it's a talent, and you're supposed to use anything the Lord give you. If you don't, he'll take it away" (3 March 1996). Her answer to the question how do you decide what to paint is significant and points toward her status as a visionary or outsider artist:

> I think about what section I want to paint—if I want to deal with Tarbor Quarters, Ben Smith Quarters, or the country—I think about that, and when I sit down, something drives me to do whatever I do. It's kind of like— of course, nobody would believe this if you don't believe in God—have you ever started on something and you could not stop? . . . When I sit down to paint, everything unfolds to me just like certain colors. I might want to change that little shotgun house to another color, something real crazy. I can't do it to save my life. It's as if I'm being driven to do what I am doing, and I believe that. I think I'm doing what the Lord wanted me to do. Doing it as to what purpose now, I can't tell you that. I hadn't asked Him. (20 Jan. 1998)

As evidence of her awareness of her own position and that of other self-taught artists as outsiders in the art world, Albritton has not used a dealer or commercial marketing to sell her work thus far (see Yelen 17). Because of her independence and entrepreneurial spirit, Albritton performs as her own dealer to sell her paintings directly. The collectors have to come to her kitchen where they must talk her into selling one of her cherished memories. The success of the negotiation depends on the situation and the day. An avid reader of black history, Albritton has a heightened awareness of blacks' lack of credit or royalties for many of their creative inventions. Her understanding of the way black artists such as Clementine Hunter have been treated makes her suspicious of even the typical relationship between artist and dealer. She frequently states that she does not want to be exploited as Clementine Hunter and Grandma Moses were in the marketing of their paintings, so she does not care if she sells or not. It is interesting that she views Grandma Moses as having been exploited. Albritton is most concerned that she receive adequate compensation for her works, so much so that she has been unwilling to contract with an art dealer. Even in doing her own selling, she has often been reluctant to price and sell many of her works.

In addition, Albritton has psychological motives for producing her work, which could be a reason to place her as an outsider artist. Her comments in response to the question of where her ideas for her religious paintings come from is interesting in that it characterizes her as being driven—a common feature attributed to outsider artists (see Yelen 17-20):

> On the religious paintings, we be born into this world, and we really don't know where we going be, how we'll survive. You might have your parents, but they could die on you. I had parents, but they were dead—dead to me; they was alive, but yet they were dead, so I had to fight for myself all the time. Only time I had someone on my side was when I was in the country. My mother never stood up for me, and my stepdaddy misused me all time. Nothing was ever nice at home. Why God didn't let me starve to death, why did He always let someone to pick me up? I didn't have sense enough to know that, what I'm saying, then. But now I realize that it was the mercy of God, and I used to go and pray to Him. When I was hungry, I'd go on the creek, that little branch, and I'd ask him why this and why that or send me this and send me that. Still do the same thing today. So God held the hand of protection over me. And a lot of people used to say—and even my mother and my stepfather, "You'll never amount to nothing; you'll be dead before you get teenage." I mean they said all kind of mean things to me. And that made me determined to make them all a lie. So that's what pushes me. It pushes me today. (20 Jan. 1998)

In spite of the problems she experienced and the horrors she witnessed in her childhood, Albritton claims that these did not bother her. As she puts it, "Ain't but one thing touched me about these pictures, and that's *Mama, Don't Send Me Away* (pl. 11). Now that can make me cry. I was not a crybaby. You learn to be hard and accept things."

With this artistic background, it is difficult to easily classify Albritton and her painting. Her active community status, her biographical background, and her minimal art training make Albritton neither a trained academic painter nor an isolated outsider. Since she is not working in a traditional art or craft, such as quiltmaking, typically learned from others in the community, her work would not be termed folk art by many academically trained folklorists. As a folklorist, I believe the term self-taught art is more accurate, although her observations of her traditional folk background form the foundation of her painting. A more appropriate term for her work might be simply art that draws on a folk cultural background and the folk genre of personal narrative and memories of her childhood (see Braid on personal narrative).

VERBAL ARTS CONTEXTS: RETELLING HER STORY

Albritton had sought to record her childhood experiences in writing both prose and verse even before she began painting and telling her story. In fact, when asked why she started painting, she gives as her reason her need to retell her prose autobiographical account of her childhood, an unpublished manuscript, *Poor Black Girl*, in a different format. She cites her childhood suffering as the inspiration

for her series of memory paintings:

> My childhood means a great deal to me simply because of all the suffering I went through to grow up, so I want to paint it; I want to preserve it; it will be here when I'm dead, hopefully. I've written the story, but now I want to tell it in pictures . . . The book I've written is—the title is *Poor Black Girl*, and I wanted to tell my story. You know, people look at you and think, "Well, you have it made; nothing ever happened to you." Well, that's not true, especially if you're poor. . . . I wrote the story because I wanted to document everything that I could remember that happened to me, and it's in that story; it's not a pretty story at all. It's the exact words that were spoken to me and the exact words I spoke under the house. You couldn't speak out, so I would run under the house and talk (and cuss too). And this book tells the story. (14 December 1995)

In her family life, she was often punished and banished from the house; she was not allowed to tell her side of events; hence she could not speak; she had no authority. For her then the experience of being a child, black, and poor is hidden and unvoiced; consequently, taking authority upon herself, she decided in her adult life that her experiences needed to be seen as well as heard, thereby multiplying the power of the message. As she puts it, "Some things people just need to see. Seeing is believing" (14 December 1995). So painting for Albritton becomes another mode of voicing her story, a materialization of her narratives.

Thus, during her adult life, Albritton has selected four means of telling her story: autobiographical prose, poetry, painting, and oral personal narratives. In their transcribed textual form, the oral narratives have actually generated another frame for presenting her story as well. A sampling from these various works reveals their common themes, stylistic variations, and her constant improvisational aesthetic.

Written prose autobiography: *Poor Black Girl*

Written when she was in her thirties, Albritton's autobiography of her formative years, *Poor Black Girl* is a double-spaced typed manuscript of over 200 pages dominated by dialogue and loosely structured into sections bearing the following titles: "The Country" (describing her life after her mother sent her to live in the country), "Busy Bee Café" (detailing her mother's socializing at the nearby café/dance hall), "Them Bad Boys" (outlining her playing and fighting with neighbor children), "My Stepfather" (exposing the cruelty of her stepfather), "School and the Mitchell Boys" (presenting the happy times with playmates), "The Sawmill" (noting the grueling cold weather and gathering slab wood), and "My Friends" (celebrating her school and neighborhood friends who made her life tolerable).

The following excerpt from "The Country" section of *Poor Black Girl*, concerning Cassie Lewis's mother, Mrs. Mayfield, taking the young Sarah money hunting, offers an interesting comparison to the oral narrative she gives for *Money Hunting* (pl. 19). This earlier written narrative is written in a very different prose style. Her written style is different from her oral narrative style in that her writing is more direct, detailed, dominated by dialogue with some crude language, and sometimes more fully explains the situation. Overall, in her autobiography, the written narratives exhibit a stiffer, more formal style. The relaxed style of her oral narratives has more rhythm, formal repetition, and poetic devices—qualities of the folk preacher (see Rosenberg and Davis).

In this excerpt (134-136), the character of Willie Dean Mayfield, Cassie's mother, is more fully developed. Ironically, the same character who uses a switch to teach young Sarah her prayers (see *Learning My Prayers*, pl. 20) forces Sarah to go with her into the woods searching for money that will be revealed through what Albritton calls "voodoo" magic. Regarding the woman and her spells as evil and mean, Albritton paints her in the usual cast of characters descending into Hell (see *Hell* and *Pay Day*, pls. 8, 49). The passage opens in the context of Cassie having warned Sarah not to go into the woods alone because of poisonous rattlesnakes, to which Sarah replies:

> "I ain't going in no woods. But your mother make me go with her. I am afraid of snakes. You tell your mother not to make me go."
>
> "What? When?"
>
> "When you and Thomas go to the fields."
>
> "She won't be taking you any more, I will see to that." After we had eaten breakfast, Thomas and Cassie left for the fields.
>
> "Get ready, we are going to look for that money again," Mrs. Mayfield said.
>
> "No! Cassie said for me not to go in the woods again. I ain't going no where with you."
>
> "Yes, you is, hussy, or I will beat you ass good. Do you see this red string and spoon? It will lead me to that pot of money."
>
> "That's just a string and spoon, crazy woman. It ain't going to help you find a penny. Wouldn't nothing but a fool believe that."
>
> "I will teach you to sass me. I am going and get a good switch. When I get through with you, you will be glad to go."
>
> When Mrs. Mayfield went outside to get the switch, I slipped out the back door and ran down to the field where Cassie and Thomas were. "Cassie! Cassie! Mrs. Mayfield is going to whip me."
>
> "Why do Mother want to whip you?"
>
> "'Cause I wouldn't go down in the woods, and help her look for money."
>
> "Come on, let's go back to the house." When we got to the house, Mrs. Mayfield was sitting on the porch with the switch

in her hand. "Mother, why do you want to whip Sarah?"

"She sassed me. All y'all doing is spoiling her. She ain't going to be a bit of good, to herself or anyone else."

"Mother, you keep your hands off Sarah. Don't you ever make her go into the woods with you to look for money ever again. If you want to be that big of a fool, thinking you will find a pot of gold it's all right with me. But you had better not take Sarah. Do I make myself clear? And another thing, if we spoil her, it ain't none of your business. If you want to go back where you came from, Thomas will be glad to take you. You are just a trouble maker."

"What is this world coming to? My own child turning against me. I would like to see Thomas make me leave. I am going to stay as long as I want to."

"No, Mother, you pack your clothes. You will be leaving tomorrow."

"If you don't want me here, I don't have to stay."

"It's not that we don't want you. You cause trouble everywhere you go. It is best that you go home. You can do what you want to there. Mother, I don't want to talk about it anymore. Come on, Sarah, I am taking you with me.". . .

Mrs. Mayfield walked back into the house and slammed the door. I played under the trees and in the sand, while Thomas and Cassie worked. "Come on, everybody, let's go home. A mule get off at five."

When we got to the house, Mrs. Mayfield was sprinkling some powder around the house. "Mother, what are you doing?"

"I am casting a spell on y'all. You and Thomas will never have any money. You and Thomas will break up, and this hussy will go back to her mama." Mrs. Mayfield threw some black powder down by Cassie's foot.

"Go on and cast your spell, Mama; it will be just like you looking for that pot of gold, all of these years."

"You hush, girl, or I will hit you. I am your mama, and I is all you got in this world."

"Mama, I am tired of your foolishness. Get your things together; I am sure Thomas will take you home."

"I will be glad to leave these woods, good riddance.

We went into the house. "Thomas, Mother is ready for you to take her home."

"I will be ready in a few minutes."

"Cassie, I will go back to Mother if you want your mother to stay her with you."

"No, dear, it is best that she go."

After Thomas and Mrs. Mayfield left, Cassie went into the kitchen to cook supper.

This written version of *Money Hunting* (pl. 19) does provide the reader with a greater understanding of Albritton's regard for Cassie, who is *Tall Woman* (pl. 21). Acting the mother to the young Sarah, Cassie is willing to sacrifice her relationship with her own mother to protect the young girl from the old woman and her magic. It is interesting too that the old woman, who casts voodoo spells, is trying to take the child into the woods, a place for secret rituals, and that the woods are full of snakes, an African vodun religious symbol of life, and a Christian symbol of the evil tempting devil. Thus Cassie saves the child from evil and banishes this evil from her life.

Written Poems

Even before her prose autobiography, Albritton was writing blues songs, spirituals, and poems. She collected the poems into a six-part work, titled *Living from Day to Day*. While the whole collection is not published, she has published individual poems in church programs, bulletins, and newspapers, and has a few posted on her restaurant wall. Even her Sarah's Kitchen menu features one of her poems and a rhymed blessing. "God is good God is great, let us thank him for this plate" (fig. 11). She is often asked to compose and read poems for special religious programs and occasions such as anniversaries and funerals. In general, the form of her poems uses the rhymed couplet with no prescribed length, a popular form used by blacks and whites in local newspapers and church services. However, Albritton does not stick to the form completely; again, an aesthetic of improvisation is at work here. Instead of a couplet rhyme, the rhyme may fall in two half lines, as it does in the following poem in the second stanza, line seven: "I know you think bad, about a dad you never had." Her themes in the poems echo those of her painting narratives; in fact, the way we grouped the paintings and narratives in the catalog offers an interesting parallel to the way she grouped her poems. Part I is devoted to poems centered around mothers, fathers, and children: "Welfare Mothers," "Welfare Fathers," "Welfare Children," "Father, Father," and "My Stepfather." The latter poem reports the cruel behavior of her stepfather narrated in many of her stories; for example, stanza four describes her food deprivation and beating:

He made a big grocery box;
The first thing he did was buy a padlock.
When my stepfather was home, I didn't get anything to eat.
I was a little beggar out in the street.
He beat me, kicked me, and left me for dead;
The next day, I could hardly lift my head.
I told my mother, what he had done to me.
She said, "I don't care, you are mean as can be."

The next two stanzas end the poem with the basic story of the children's revenge in *Dirty Old Man* (pl. 39).

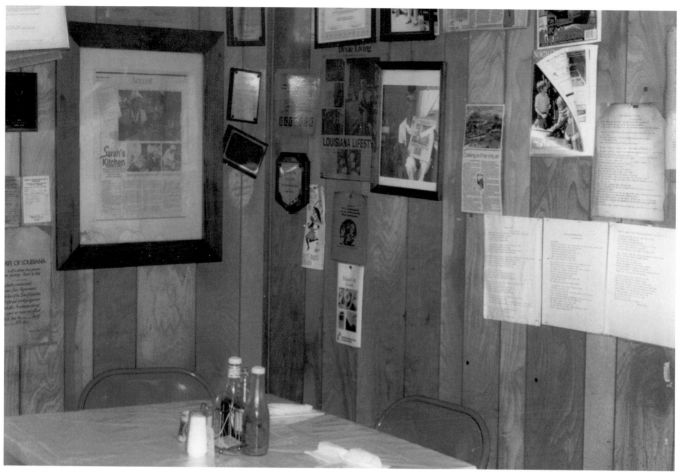

Fig. 10. The walls in Sarah's Kitchen display a montage of documents from Albritton's life.
Photo: Susan Roach

Of the other poems in this section, one is so special to her that she has posted it on the wall in the restaurant dining room (fig. 10). When I asked her what poems she would like in the catalog, she requested it: "Letter from an Unknown Father," which she wrote as a response to her poem, "Father, Father," that opens with "Father, Father, where are you?/ Why did you leave when I was a baby? / You and Mother could have made it maybe." No doubt, the letter reflects her own wish to hear from her father that he loved her and needed her forgiveness for abandoning her:

Letter from an Unknown Father

Dear Daughter,
After all of these years, I have wondered about you and how you were getting along.
Have you thought about me, since I have been gone?
I know you must hate me, for running away.
I couldn't put up with your mother another day.
I have never looked upon your lovely face.
I know I caused your mother some disgrace.
But, I just had to leave that awful place.

What I am trying to say is, don't hate me for running out on you.
Dearest, darling, there was nothing else to do.
Just before you were born, I decided the best thing to do was go.
Your mother said, she didn't want me any more.
After all of these years, we have been apart .
You were always with me in my heart.
I know you think bad, about a dad you never had.
I don't want pity or hate.
Your mother and I couldn't get a thing straight.

I know sometimes you were hungry and without clothes.
I heard that you even got cold.
But you see dear at that time, there was nothing I could do for you,
Because I was hungry and cold.
I just fell down on my knees, and asked God to keep your little soul.
You see, your mother didn't want you to have a dad.
Oh, darling daughter, I am really sad.
Forever since that day I have been roaming from place to place;
Trying to forget an unborn baby face.

I am sure before this letter is read; I will be dead.

You see dear, I am getting old.

But, I want my side of the story told.

You must be about forty-two or forty-three, if I recall.

I am sorry I caused such a hard fall;

But your mother and I just couldn't get along at all.

Once I started to come back, and ask your mother for another chance.

Before I left she already had another romance.

My eyes are filled with tears;

When I think of all the wasted years.

My heart is breaking dear, just trying to explain.

Please forgive me for causing so much pain.

So darling daughter, I hope that you will forgive an old man.

Because, dear, you won't hear from me again.

I would die happy if only I could see your face.

But, you are there and I am in another place.

When you read this letter, I am sure I will be dead.

I have missed the chance to put my hand on your sweet head.

Well, darling, I tried to explain my reasons for leaving.

Always remember that daddy has done a lot of grieving.

So, good-bye daughter, this is all I have to say.

Oh, yes, one thing I ask of you is to pray.

Pray not for me to live;

Pray that you may be able to forgive.

Unknown Father

Part II of her collection features poems based on her childhood experiences. Most of the themes running through this section focus on her difficulties, reflected by her titles: "Life for Me was Hard," "Ugly Child," and "I Was Born Poor"; however, "Those Mitchell Boys and I" echoes her tomboy escapade of swimming and fighting with the Mitchell boys that are presented in *The Swimming Hole* and *Crawfishing* (pls.18, 17). One of the most poignant ones that she displays on her restaurant wall, "Little Black Girl," might be well illustrated by her paintings *Mama, We're Cold* or *The Beating* (pls. 37, 38):

Little Black Girl

I know a little black girl that lived by the railroad track.

She always carried a begging sack on her back.

She went to the sawmill every day;

To see if they had any wood to give away.

Because she was so small, only about four feet tall;

I don't see how she carried that old sack of wood at all.

She would dump the wood out in the yard;

Life for this little black was very hard.

She would pick up that old axe, and try to chop the wood.

She didn't have the strength cut it very good.

If she rested for a minute to steal a blow,

Her mother would holler, "Hurry with the wood before I beat you some more."

I really feel sorry for this little black girl. I bow my head to God,

And ask him, "Why did he let her be born into this mean world?"

When she carried the wood into the house and placed it into a box,

Her stepfather would tell her, "Get into a trot."

She got up early every morning to make a fire.

She asked God almighty to please let her die; she didn't want her mother to see her cry.

After the house was warm, her stepfather would get out of bed,

And slap her across her head.

She backed into a corner and covered her little black head with her hands;

Wondering how she would fit into God's plans.

Her mother would cook and have food to throw away.

Yet, this little black girl went without food everyday.

The little girl had to clean the house, scrub the floor, and wash the dishes,

Before she could go. She scrubbed the floor on her hands and knees.

Her only words were, if you were there, God, help me please.

Lord, I don't know why I am here; I try to be good as I can be.

Why do my mother and stepfather always beat me?

My face is all puffed up so I can hardly see.

Please, God, take care of me.

Her mother would whip her with a large strap

Just so she would be a good chap.

She took the spite out on this little black girl for what her father did.

Her mother didn't have sense enough to know that she was her kid.

The little black girl was beat and cursed on every hand.

The poor little girl just couldn't understand.

She tried to tell her mother things her stepfather had done and said;

The poor, pitiful mother would hit her on her head and knock her across the bed.

The little black girl decided to run away;

Maybe, God loved her, and would help her find a place to stay.

Her mother and stepfather didn't miss her; they were glad she was gone.

Now, they had the house all alone.

God did find a place for the little black girl to stay.

She was cared for and loved each and every day.

The little black girl trusted God, and he did make a way.

Her third person view of her "poor, pitiful mother" and herself as the "poor little girl" shows that she not only has taken care of her own inner child, but also now understands her mother's predicament.

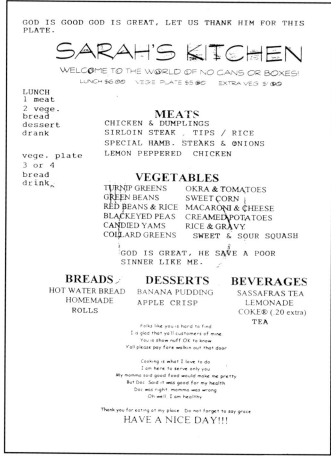

GOD IS GOOD GOD IS GREAT, LET US THANK HIM FOR THIS PLATE.

SARAH'S KITCHEN

WELCOME TO THE WORLD OF NO CANS OR BOXES!

LUNCH $6.00 VEGE. PLATE $5.00 EXTRA VEG $1.00

LUNCH
1 meat
2 vege.
bread
dessert
drank

vege. plate
3 or 4
bread
drink

MEATS
CHICKEN & DUMPLINGS
SIRLOIN STEAK , TIPS / RICE
SPECIAL HAMB. STEAKS & ONIONS
LEMON PEPPERED CHICKEN

VEGETABLES
TURNIP GREENS OKRA & TOMATOES
GREEN BEANS SWEET CORN
RED BEANS & RICE MACARONI & CHEESE
BLACKEYED PEAS CREAMED POTATOES
CANDIED YAMS RICE & GRAVY
COLLARD GREENS SWEET & SOUR SQUASH

GOD IS GREAT, HE SAVE A POOR
SINNER LIKE ME.

BREADS	DESSERTS	BEVERAGES
HOT WATER BREAD	BANANA PUDDING	SASSAFRAS TEA
HOMEMADE	APPLE CRISP	LEMONADE
ROLLS		COKE® (.20 extra)
		TEA

Folks like you is hard to find
I is glad that ya'll customers of mine
You is show nuff OK to know
Y'all please pay fore walkin out that door

Cooking is what I love to do
I am here to serve only you
My momma said good food would make me pretty
But Doc said it was good for my health
Doc was right, momma was wrong
Oh well, I am healthy

Thank you for eating at my place. Do not forget to say grace
HAVE A NICE DAY!!!

Fig. 11. For Sarah's Kitchen, Albritton creates her own photocopied menus which combine her cooking arts with her verbal arts.

In Part III of her collection, her primarily religious themes deal with sinners, the materialism of modern life, repentance, hypocrisy in the church, anniversary celebrations, and a church member's death—themes that are echoed in her painting stories, *On My Way, Where Are You Going?* and *The Crucifixion* (pls. 1, 47, 48). Her titles, as usual, give an idea of the range of topics: "Have You Ever Heard a Sinner Trying to Pray?" "What Is Wrong with the World Today?" The Devil Is Going to Church Today," "Lord, I'm Trying to Do My Best," "Devil, Devil, Get off My Back," "Do Not Weep for Me," "Lost Deacon," and "Today Is Your Day, Ministers." Albritton deals even more with these themes in paintings not shown, including *Christian Community*, which illuminates hypocrisy among church members, and *Trying to Git There*, which shows people in their struggles to reach the door of Heaven.

The next two sections focus on family and helping the elderly, seemingly inspired by actual events in her family and neighborhood. Titles in Part IV include "My Husband Is a Good Man," focusing on how her husband loved and worked for their family; "Lord, Something Is Worrying Me, It's My Son," addressing her worries over one of her adopted children; and "Family Fights." Part V describes the needs of the aging with titles such as "Old Mothers and Fathers Have Been Cast Aside," "This Old Body," "Hello, That's My Telephone," "Lend a Helping Hand, Please."

Part VI has an assortment of themes from considerations of race to gardening. Her "Black Woman, Leave That White Man Alone" addresses the old theme of the sexual exploitation of black women by white men in an interesting dramatic monologue addressed to a black woman. The poet admonishes the black woman to keep away from white men and instructs her on how the white man will treat her: "He won't date you in the light; He will sneak around with you at night." Her "I Would Rather Be Black than White," which catalogs maltreatment and exploitation of blacks, has a powerful concluding stanza with a classic statement of black pride. Note the closure achieved with the rhyming of the last three lines:

I'd rather be black simply because, Blacks can sleep at night.

Blacks don't have to give an account for all the things white men have done.

Whites have always tried to keep black men on the run

It's a new day, white man, you have done all you can.

Black men are standing as tall as any man;

They are going to help rule this great land.

Other poems in this section include "Good Years," "The Garden Contest," and "Grow a Garden." Her gardening poems were written when she was working for the L.S.U. Cooperative Extension Service. For example, "The Garden Contest," which outlines her steps in making a garden to enter in the parish contest, is an interesting composite of traditional and institutionalized gardening advice and help from county agent F. O. Levasseur:

First, I had to learn about soil testing, and to work in Doctor God's land.

Do you know, God stepped out and lent a helping hand. He also gave knowledge to man.

Mr. F. O. came out in the cold to pick up a few tubes of sand.

Then, he mailed it to another man after he had carefully stirred it with his hands.

When the tests came back, he told me point-blank what I had to do.

Soil tests are really true, if you are willing to try what they recommend to you.

The next lesson is cultivation. This can be very hard.

Get ready "old back" and pray to our good Lord.

In "Grow a Garden," she encourages others to garden, giving advice about its empowering nature:

So many of us sit around and complain,
About the prices at the store.
If you raise your own vegetables,
They will be cheaper, you know.
Do something about it; grow your own.
Don't stop by a friend to make a loan.
You make the first step, and God will make two.
Grow a garden and see what you can do.

Again, in this verse, she returns to a religious refrain, which promises that God helps those who help themselves. The cheerful note of this work recalls the joyous tone of her paintings, such as *Fighting the Chickens* (pl. 27), that include colorful gardens.

Paintings and Spoken Personal Narratives

Interestingly, the same themes appearing in Albritton's poems recur in varied forms in her autobiography, oral narratives, and paintings. Through the religious beliefs, indomitable fighting spirit, traditional ingenuity, and perseverance shown in all these works, she triumphs over hunger, loss, death, and racism. While visually powerful in themselves, the paintings become more potent with Albritton's narratives of her experiences or visions, which function as a key for deciphering the paintings. I discovered this in her restaurant one day when I asked Sarah to tell me about a particular painting, *Mama, Don't Send Me Away* (pl. 11), which illustrates the poverty and the resulting precariousness of Southern black family life in the post-Depression era. She responded with a complex narrative that was, at most, only hinted at in the painting. The painting—depicting what looks like a normal day, full of activity and people in an early 1940s setting—takes on a sinister nature with the addition of a narrative featuring a cruel stepfather, a desperate mother, and a house located near the "cesspool branch," her term for the local sewage system drainage ditch.

Because of these hidden narratives in the paintings, when Albritton was given her first exhibition opportunity, I asked if she would like to display narrative texts with the paintings. She liked the idea, so we decided to tape record her stories about the paintings. The stories that she told basically centered around the young Sarah, usually in the blue pleated skirt. Since some of the recorded narratives were quite long for such an exhibition and some had material too sensitive for a local audience, we agreed to edit the recorded stories. The editing took place in one or more of three ways: (1) as she told the individual stories; (2) after the story when she might decide to delete a certain name; and (3) after she received a copy of the transcription where she could correct my errors and modify her own telling if she wished (if the stories were told to a larger group). Sometimes we discussed the pros and cons of edits in great detail. Admittedly, I was the more conservative about

wanting to delete names of people in her family and community who might suffer embarrassment from the stories; she was more willing to tell all. In general, my transcriptions followed the precepts noted by Preston (see editor's note, page 36 of this catalog). Because the edited transcriptions accompanying her paintings not only explicate the paintings but also offer the reader insight into Albritton's life, to tell the artist's story, we grouped paintings thematically and chronologically as much as possible. We were happy to learn that the viewers of the first exhibition, as well as a New York gallery director, were interested in the stories along with the paintings. In fact, people who purchased paintings wanted the narrative texts also, an idea that had not occurred to us upon mounting the exhibit, but to which we agreed.

My formal collection and recording of the oral personal experience narratives began in December 1995 in preparation for her first painting exhibition in March 1996. To furnish her with an audience and to demonstrate interviewing, I took my university Folklore Studies class on a field trip to the restaurant after the lunch hour when she had some time to meet with us. Albritton had brought out some of her paintings and was prepared to talk about them. After the interview was under way, we began discussing her painting with her work *Mama, Don't Send Me Away*. When Albritton retold her story for the class, she provided an even more detailed narrative than the one she had first told me in private. In this more audience-centered, animated performance, she gives a graphic description of the poverty of her early living conditions and opens with a challenge to the audience to compare their situations to hers (see Braid). Seeming quite comfortable in this audience-centered performance, Albritton is very much in control of the situation and uses a pointer to designate particular figures and parts of the painting, much in the manner of a teacher:

Any of you rich? Any of you poor? [She looks around for raised hands or nods and sees surprised faces.] No, y'all are too young to be poor [laughter]. This [the painting] is a scene from the south side [of Ruston] across from Louisiana Tech; it is now called the west side. We lived in Moate Kavanaugh quarters, and he lived on Cooktown Road. Me, my mom, and two sisters all lived in a two-room house. We had a bed, a chair, a table, and a stove; hung clothes in the corner on a stick, and this would be the clothes closet because you didn't have many clothes. Mother worked for T. C. Beasley, the mayor, and paid twenty-five cents a week for rent because that's all she could afford. She made $3.00 a week. I have two sisters—all three of us lived there along with our mother; we had no father. Somewhere down the line she was talking to some of our relatives saying that she couldn't afford to take care of us, so she was going to send us to live with some relatives down in the country.

In that house we almost froze to death in the house, and we had very little food, so she decided that she could do better if we could live with some relatives. So his truck you see here—it's Spudlow's truck; he lived in Tarbor Quarters, but he would haul people around, and he hauled wood. It was slab, but I know you don't know what slab is, but slab is lumber. She got him to take us to the country.

Elouise was sent to our Cousin Sue, Ella May, my second sister, to Cousin Quemine. I was to go live with Uncle Mann. I didn't want to go, so I jumped off the truck because I didn't want to go. I wanted to stay at home; I didn't want to go to the country. I ran back. And this [pointing] is my stepfather here; he was standing there glad I'm gone. It was true because he was glad we were gone because he didn't like children. I ran to mother, but she is going to later put me back on the truck, and we did go in the country.

While we were getting on the truck, word spread that she was sending us away. You see all of these little boys running out trying to stop the truck. If you notice here [pointing], this is Charles Jenkins—we called him "Pig Baby." He was trying to hold back the truck. These were my play buddies because I was a tomboy. Mrs. Annie May—this is her here—she came out to see us off. She did try to talk mother into the notion of keeping us, but mother didn't listen to her. So she came on out to wave me good bye, and later on will be another story, she will be in my life for quite a while. This is Mrs. Charlotte Lewis. She lived next door. She didn't want us to go because I stayed at her house. She didn't have any children, so I stayed at her house most of the time in the afternoon.

If you hear of a big fight here in Ruston, it is about the famous cesspool on south side of town—the lagoon. This [pointing to left corner] is the cesspool, but they call it the lagoon now. We played in this trench here. We got sores. And this [pointing to the figure of a white man] is Mr.—well, maybe I will think of his name in a minute, but he is still here. He worked for the city, and his whole family has worked since I was a child for the city. I don't know why I can't think of his name. So he walked by; he was always meddling [with] us. I have another picture where I'll show you he was picking on us. We had to go right by his place to go to school, and he lived at the cesspool at the time.

When we got in the country, we dropped Elouise off first and then Ella Mae. I didn't want to leave my sister Ella Mae. I didn't care about leaving my older sister because I was closer to my second sister. But any way, I had

to go because Cousin Quemine told me if I didn't get back on that truck, she was going to give me a whipping, and she meant that. So I got back on the truck, and he took me on Highway 33 down by the old parish park to Uncle Mann's. And out there they were real nice to me and let me do anything I wanted to do. After I eat all I want and got full, I wanted to come back and live with mother. That was my intention the whole time; I never planned on staying there. So I cried for three days and three nights. And they brought me back home. I didn't go back in the country to live; I only went back in the summer. (14 December 1995)

Albritton often changes her narratives, usually by giving more or less detail, depending on the audience, her energy level, and her assessment of the situation. The above narrative is a much longer version told to a larger audience than the shorter version presented with plate 11, which was retold to Peter Jones and me almost three months later. In a later collection session, there was some confusion over whether she had told us this story, so she wanted to tell it again, with the result being a more poetic version of an appropriate length for reading in an exhibition. The above longer version of the narrative is told in a more journalistic style but also has poetic features of repetition; for example, in the third paragraph she reiterates that she "didn't want to go." However, the shorter version collected later is even more poetic and lyrical, especially in its closing cumulative sentence: "So I stayed out there for three days, ate all I wanted to eat, and got full, and I hollered and hollered and hollered, and they brought me back home." The poetic effect of the repeated "hollered" echoes the persistent child crying for her mother.

Albritton's narrative style also varies from the everyday conversational style apparent in most of the narrative above to a highly poetic style, echoing the poetic metaphorical speech of the African American folk preacher (see Davis and Rosenberg). For example, her story accompanying *Hell* (pl. 8), which uses not only rhythm and incremental repetition, but also internal off-rhyming of *home* and *alone*: "There was hell in my job and hell in my home; I wonder when hell's going to leave me alone." Incremental repetition, one of her most frequently used stylistic devices, often appears in the middle of her most conversational style. The third paragraph of her narrative for *Bridge over Troubled Water* (pl. 43) provides an illustration: "and I made up my mind—I didn't care what Mother said, what the whites said, or what anyone said—I was going to do the best I could for myself, and if it meant crossing over, then I would cross over that bridge. If crossing over that bridge would keep me from being hungry, naked, and cold, I was going to cross that sucker."

Her use of the word *sucker* illustrates another characteristic of her written and spoken narratives: constant shifts from standard to non-standard English grammar and vocabulary. Part of this is, no doubt, due to rural Southern dialect, which frequently makes such shifts; however, Albritton shows that she is aware of language difference, as her story for

Working on the Farm (pl. 23) reveals when she tells how she was whipped for failing to use the rural Southern pronunciation *yestiddy*, instead of *yesterday*. Again showing the rural dialect in her autobiography excerpt about money hunting, Albritton has the old woman, Willie Dean, primarily speak non-standard English grammar and slang, while she and Cassie use more standard English with little slang. In this case, it seems that the "nice" language comes from the mouths of the nice people and the bad language from the mean people. Actually, when her autobiography is examined further, her stepfather and mother use obscenity and profanity as well as non-standard grammar, and when the child is confronted, she uses similar language in self-defense. After all, she is a fighter by her own admission.

Some of the dialectal non-standard vocabulary is due to black English traditions. For example, in her narrative *Where Are You Going?* (pl. 47) she says, "We was playing the Seabird, and I was listening to the music," using the black English pronunciation to refer to the jukebox with the Seeburg brand, a Southern black English "Metaphor as Mistake" discussed by Walker Percy (63-82). Also, her community pronounced Dr. B. H. Talbot's rent house neighborhood "Tarbor," which probably originated with hearing an *r* for the soft internal *l* and dropped *t* ending of the white pronunciation of the word. However, "Tarbor" has a soft inviting sound, perhaps drawing from the word *arbor*, and according to Albritton, Tarbor Quarters was the most advanced living space available at that time for blacks at that socio-economic level.

Albritton is aware of what she would term "proper" English and black dialect, and in public performances, she is often quite careful in her pronunciation, especially when giving instructions. Yet she seems proud of her black dialect. On one occasion, she joked that she had used Ebonics on a sign she had made to advertise her jelly; the first line stated: "JELLIES FUR SALE/ MAYHAW With Painting – GOOD GIFT." Some titles for her paintings show a preference for dialect. When I was writing the title for *Trying to Git There* (not in the exhibition), she made me change *Get* to *Git*. Also when she was discussing her painting *Chunking Rocks* (pl. 35) with my class, she explained that "chunkin'" was "our word" for throw.

Her variations in grammar, style, and content may be attributed to the rhetorical situation since she is a seasoned performer and moves easily between black and white worlds. Also it may be due to her constant improvisation. John Vlach discusses the "extensive sense of improvisation commonplace in the Afro-American experience," emphasizing that the African-American aesthetic of improvisation is pan-African, not only in verbal arts, but in material culture as well: "For black material culture, then, improvisation is the touchstone of creativity. Whether manifested boldly or subtly, it is ever present, transforming the American into the Afro-American. Should we fail to understand this, we risk the danger of mistaking imagination for error, variation for imprecision" (*By the Work of Their Hands* 5-6).

Narrative Types, Themes, and Motifs

Improvising on various themes in her painting series 1993-1998, Sarah Albritton represents important memories from her youth in the Ruston area and significant stories and lessons about her religion and philosophy. Embedded in these paintings and their narratives are themes of childhood poverty, hunger, pain, loss, and abandonment; working, playing, and learning on the farm and in town; racism and black-white relations; and her spiritual quest.

The elucidation of the paintings through narrative illustrates that the paintings function as "memory objects for life review," Kirschenblatt-Gimblett's term for objects which "materialize internal images and through them recapture earlier experiences" of the artist (331). The framed experiences captured in the paintings are reframed in the exhibited narratives. These memory objects represent memories from her rural traditional lifestyle in North Louisiana, significant stories of spiritual development, and symbolic statements about her religious vision.

Albritton's narratives suggest three categories for her paintings: (1) memory paintings in which Albritton figures as a central participant in key events in her own life, (2) memory paintings in which she functions as an observer or presenter of events in the history of her family and community, and (3) religious visionary paintings in which she represents her philosophical and religious beliefs and teaches moral lessons. Each category has its own thematic concerns.

Paintings in the first category typically are full of activity with many groups of figures carrying on different activities. If the viewer questions Albritton about these, she may supply several stories about individuals in the paintings; however, when she is asked what is the story behind the painting, she generally responds with a core narrative, where she figures as the central character, usually in her blue-pleated skirt. Ironically, in reality the skirt had a brief life, having been dirtied in fighting and disintegrated in lye in the wash pot. However, in her paintings this skirt, earned with money from her first job, becomes her eternal symbol of her independence. This category can be broken down further to include paintings and narratives that focus on one-time specific events in Albritton's life and those that focus on generic accounts of typical habitual experiences in a specific landscape or scenario. Examples of one-time experiences include *Mama, Don't Send Me Away*, *Tornado*, and *Lying* (pls. 11, 15, 22). Examples of habitual experiences are in *Money Hunting*, *Hoboes*, *Aunt Mary's Place*, and *Tarbor Quarters* (pls. 19, 16, 24, 14).

Albritton's life as depicted in these paintings and narratives presents a fascinating, little heard study of race relations. For example, *Tarbor Quarters* (pl. 14), depicting life in small town black rental housing transfers the agrarian model of the plantation big house to a small town setting in the mid-twentieth century. Not only in the painting does the house look like the stereotypical, columned big house, but also Albritton's narrative reveals that inside that house was the young black child playing the traditional plantation maid, assisting with the mistress's

grooming ritual. *Tarbor Quarters* also presents the marginalization of low socio-economic housing—the quarters, located near the cesspool branch, a recurrent motif. In her painting and narrative Crawfishing (pl. 17), in the same branch, hungry children forage for food and roast tasty crawfish—a food that was considered trash in north Louisiana culture during this time. The complex ambiguities of this situation can be explored by contrasting *Tarbor Quarters* and her visionary work *Trouble Quarters* (pl. 44) which metaphorically expresses her views on this type of racist housing. She comments further on the concept of the quarters:

> From the slaves' quarters, all of you know where the quarters are, quarters is where blacks are supposed to live, but whites live in quarters too and nobody says anything about them. They say blacks live across the tracks, but you know what I figured out, how come the white folks don't live across the tracks? You see what I'm saying? Now that's funny, blacks are across the track and you sitting on the other side of the tracks. That doesn't make much sense. I just wanted to do this, simply because it showed you went nowhere. From slave quarters to Tarbor quarters to the projects, you went nowhere. (14 Dec. 1995)

Also within this group, Albritton deals with darker themes of childhood poverty, hunger, pain, loss, and abandonment, as well as lighter, optimistic themes of childhood friends and play. Her settings are in town and on the farm. Her most poignant stories are of her separation from her mother: *Mama, Don't Send Me Away*, *Chunking Rocks*, and *Lonely Road* (pls. 11, 35, 36), where we see the young child put out of the house with her "little clothes." Even more horrifying are her stories of childhood abuse: *The Beating* and *Dirty Old Man* (pls. 38, 39). *The Beating* details her beating at the hand of her stepfather with a leather cotton gin strap with holes bored in it to suck up the flesh. In *Dirty Old Man*, however, the young girl resists his sexual advances and retaliates. The painting's vaginal-like pit waiting to engulf the potential rapist no doubt symbolizes her ultimate female victory in the situation. It is no wonder that she says of her stepfather: "I hated my stepfather because mother loved him more than me. When mother would leave, he would eat all of the food and not give me any. He was the only person I ever hated. My stepfather came to live with us when I was eight years old. . . . I hated him for thirty eight years." The miracle of redemption is that she forgave him, and helped him through his final illness and paid for his funeral.

Whippings are another focus in many of the narratives; however, these should not be confused with the abusive beatings, also termed "whippings." Instead, they were the common rural Southern Protestant means of child correction, based on the Biblical admonition: spare the rod and spoil the child. The rod in this case was usually a switch, a small supple limb from a shrub, applied below the waist. Consequently, Albritton's paintings and narratives involving working, playing, and learning on the farm and in town may also have correction involved. Even her beloved Cassie was firm with her as the *Lying* narrative (pl. 22) states that Sarah got a whipping for lying about the vanilla. The hated Miss Willie Dean uses a switch to teach young Sarah the Lord's Prayer in *Learning my Prayers* (pl. 20). The school also uses "whipping" to punish fighting in *Fight after School* (pl. 28). In this time and culture, however, such response to children's improper behavior was expected and a part of a child's learning.

Many of her works in this category feature people whom she found to be surrogate parents and positive role models, such as her Uncle Clem and Miss Cassie who befriended and protected her during her stays in the country. In *Tall Woman* (pl. 21) Cassie Lewis washes for the family, works in the field and the house, and yet is not too busy to give young Sarah the attention she needed—her first hair ribbon, pretty dresses, and "plenty of food." Uncle Clem teaches her about saving money and taking care of herself in *Learning Her Lesson* and *Fighting the Chickens* (pl. 26, 27).

Many of the paintings concerning Albritton's childhood focus on the young Sarah learning about religion when she went to live with her relatives. While her mother discouraged her religious impulses, telling her that God was a white God, who didn't care about blacks, her relatives such as Uncle Mann taught her about Christianity and prayer. For example, she prays for deliverance in *Lord Help Me* (pl. 12) and looks for an escape from her abusive family and poverty in *I'll Fly Away* (pl. 13). She recounts her innocent youthful attempt, pressured by her sisters and the congregation, to join the church in *Baptism* (pl. 30) which echoes Langston Hughes' autobiographical account of his "Salvation."

Another frequent topic in the first group of work is Albritton's childhood friends' playing and fighting. Young Sarah plays and fights with friends in *Hoboes*, *The Swimming Hole*, *Fight After School*, and *Neighbors Picking Cotton* (pls. 16, 18, 28, 29). Yet in the midst of these happy times with her friends, the work *Tornado* (pl. 15) shows their vulnerability to nature as two of her young friends are killed in the storm.

Another motif in *Tornado* is the food she would find on forays with her friends. In Albritton's paintings, narratives, and folk art performances as a traditional cook, food is always there. Her culinary art is backgrounded even in her publicity for her visual art; along with one of her most recent traditional foodways performances at the 1996 New Orleans Jazz and Heritage Festival, she was invited to exhibit her paintings with a group of outsider artists. Food is a major theme running through all of Albritton's life, even in her childhood, as her narratives reveal. For example, in *Mama, Don't Send Me Away* (pl. 11), her mother cannot afford "to take care" of her; i.e. feed her on $3.00 per week. When she gets to the country, she stays three days, eating "all I wanted to eat" before she cries to come home. In *Crawfishing* (pl.17), Sarah and her friends cook their own food, and in *Tall Woman* (pl. 21), she has "plenty of food," "biscuits and cornbread," and when asked what she would like

from town, she requests "a loaf of bread." The high point of her *Hoboes* story (pl. 16) is the Baby Ruth candy bar the conductor throws her every day, along with the fact that the hoboes would feed her. *Homecoming at Mount Harmony* (pl. 34) also focuses on food—the peanut butter and crackers, the dinner on the grounds—rather than the religious service or other ritual matters. In another painting also set at Mt. Harmony, *Funeral Procession* (pl.32), the centrality of an unfamiliar food—hickory nuts—is coupled with the loss of her favorite aunt, Willie Bell, because of ptomaine poisoned food. Even her playing involves food: making mud cakes and dog bread as illustrated in the narratives for *Lying* and *Learning Her Lesson* (pls. 22, 26). Turner and Serif in their work on St. Joseph's Day altars have found in women's expressive culture themes of community, nurturing, and kinship manifested through food—a symbol of life and the labor of women (Hollis, Pershing, and Young 18). Having been deprived of food and nurturing in her early years, Albritton has compensated with her bountiful restaurant and stories of food. For her, food is love, wealth, life; however, on the darker side, spoiled food is death, hence her concern with quality food.

To a certain extent Albritton is documenting her folk traditions, some of which are bound to food, others to her religion, such as in *Homecoming at Mount Harmony* (pl. 34). Traditionally, in rural Protestant churches in north Louisiana, church, community members, and families who had moved away would gather at the church on a designated Saturday for a "graveyard working" or Memorial Day, where gravestones were cleaned, grass scraped away or mowed, and flowers placed on graves. A memorial service and dinner on the grounds were either held the same day or the following Sunday. This activity might also initiate or follow a revival service as it does in Albritton's case. Traditional outdoor baptisms are also described in *Baptism* (pls. 30, 31). Another narrative accompanying *Neighbors Picking Cotton* (pl. 29) describes an impromptu prayer meeting, which takes place after the community chips in to help with the cotton harvest. Albritton calls attention to "Praying Amos," who could "really pray," suggesting that as a child she was already in tune to the aesthetics of African American verbal arts of prayer.

The second category of her work—representing historical events of the community or family—includes the smallest number of works; however, these are quite powerful. For example, *The Sun Is Gonna Shine* (pl. 42) tells the generic shared plight of the poor sharecropper and the slave, and then illustrates this with her family's story of the consequences of her grandfather's avoiding a beating and his subsequent running away from the farm where he worked. Although it also has features of her first category, the work *German Prisoner of War Camp* (pl. 24) also documents a parish historical event during World War II; although the war does not loom large in her narrative, she is curious about these people who talk differently from her.

In Albritton's works, race is frequently a subtext and a major message in others. For example, the paintings, *Hanging at the Church* and *The Hanging* (pls. 40, 41), focus on what was supposedly the last lynching in Lincoln Parish on October 12,

1938. Incredibly traumatic for the black community, this event was discussed for decades, although many of the details of it were not known. Consequently, many theories and conflicting stories arose. It is not surprising that at Albritton's first exhibit, *Hanging at the Church* stirred quite a controversy and raised the issue of validity in oral historical accounts. Some viewers thought her narrative was in error. Actually, her story does not coincide with the facts gathered by *Morning Paper* publisher John Hays. His investigative report based on interviews with involved members of both the black and white community in 1978, forty years after the lynching, tells names of white participants who had been omitted from the 1938 newspaper reports. One discrepancy with Albritton's narrative is her stated age at the time—about five or seven. However, the *Ruston Leader* reporting the lynching is dated October 13, 1938, which would make Albritton two and a half years old, probably too young even for a precocious child to be running errands. Nevertheless, Albritton says that she clearly remembers the aftermath of the lynching, having been taken there by the midwife she had run to get for a neighbor. Also she says that she didn't see the hanging itself or robed Klan figures, yet she portrays the mob in Klan attire, drawing on the stereotypical lynching images. If she did this, she must have been at least five as she states, but this would make her birth date earlier than 1936. This is a possibility since she has no birth certificate or other family written records. She also says that she had gone to get the midwife, whose son was a messenger for the black man courting the white woman—elements that do not appear in any of the reports of the event. All the newspapers report one black man, on two different occasions, attacked white courting couples parked in their cars. Allegedly, he beat the first man and attempted to rape his date; the second time, he killed the man and raped the date. According to both the 1938 and 1978 reports, only one man was caught and lynched. In contrast, Albritton's narratives tell a story of a taboo sexual relationship to explain what she considers motives for the mob action, as well as the details of torture of the messenger and the lynching of his black friend. It is not surprising that both her narrative and the newspaper reports vilify the other race or that so much discrepancy revolves around the tragedy, for it is in these types of "intertextual fields" that each race is seeking to negotiate its own "politics of identity" (see Kapchan 482).

With this controversy, after her exhibit, many white people wanted to buy her painting, *Hanging at the Church*. Some of the would-be-purchasers, who said they were descendants of whites that tried to stop the hanging, told Albritton their own stories of the event. One white woman even corroborated Albritton's story, saying she had been friends with the white woman who was seeing the black man. After hearing all these stories, Albritton decided to tell both sides of the story and painted another version *The Hanging*, set at night, although in actuality the hanging occurred in the afternoon, but crowds gathered into the night.

Competition to buy both paintings was so intense that Albritton decided not to sell them at all. Albritton resists being

stereotyped as a single-issue artist. In fact, when offered the opportunity to sell the paintings *Bridge over Troubled Water*, The *Sun Is Gonna Shine*, and *The Hanging* (pls. 44, 43, and 42) for a traveling exhibit organized by an African American dealer around a segregation theme, she refused because she felt she might be perceived as racist. She said she would have been more interested in selling if the dealer had wanted other works as well.

Certainly, her work *Wondering* (pl. 45), in which the older generation teaches the younger generation a moral lesson about race and importance of interracial sensitivity and understanding, shows her interest in generating racial harmony. Even her *Bridge over Troubled Water* story (pl. 44) reveals her positive view of whites: "there's a lot of whites that's not like people say they are. . . I met a lot of good white people once I crossed it [the bridge]. If it wasn't for them, I don't know what I would have done." Section VI of her poetry manuscript also reiterates this belief. Yet she is constantly aware of the boundaries between the races as her *Bastard Baby* (pl. 10) vividly illustrates with its wide ditch dividing the white side, "living the good life" from the black side "where we were hungry, naked, and cold." Perhaps her new knowledge that she is of both races increases her ambivalence and marginalization.

Always conscious of race, Albritton says she is not a racist herself. She is a self-styled activist. While she belongs to organizations such as the NAACP, she also speaks her own mind if she doesn't agree with current trends. For example, as illustrated by her cover portrait in fall 1996 *Cultural Vistas*, the state humanities magazine, she frequently wears a scarf, or "head rag" as she terms it, in the kitchen (see fig. 9). This actually offended some of the black audience for the magazine; however, this is an image that appeals to her so much that her original "signature" on her paintings is a small, scarved figure dressed in white. It is interesting to note that this is the same attire worn at traditional African American baptisms she depicts (see pls. 30, 31). Only on preparing for her exhibition and upon the request of buyers of her work and advice of the curators did she actually sign her paintings.

The third category for Albritton's work, the religious visionary paintings and narratives, presents her visions of the afterlife in heaven and hell, her metaphorical stories about her journey through life. *Where Are You Going? Crucifixion*, and *On My Way* (pls. 47, 48, 1) give an account of her adult struggles and need for conversion, her actual adult conversion through the crucifixion of Christ, and her redemptive peace she found when she was converted and "on the way to heaven." Some of her most powerful images and narratives deal with her envisioned retribution for those who have not found the way: *Hell* and *Payday* (pls. 8, 49). Equally potent are her visions of heaven: *In the Twinkling of an Eye* and *Wrapped in the Wings of Angels* (50, 51).

Her latest paintings include more and more visionary motifs such as angels. This motif originates in the childhood loss of her aunt. This, undoubtedly, made a lasting impression on the young Sarah, and led to a visionary experience involving an angel apparition and a lifelong belief in angels as the narrative for her painting *Angels Watching Over Me* relates (pl. 33). David Hufford may offer insight into such experiences. He does not subscribe to the common academic theory that folk belief about spirits is false; instead he presents an "experience-centered theory" that "much folk belief about spirits is reasonable, that it is rationally developed from experience" (11). While past analyses of such visits from deceased family might have been "considered a pathological symptom of disordered grieving, . . . within the past twenty years these experiences have come to be considered a common and normal aspect of bereavement" and "have been documented in many different cultural settings" (Hufford 35). Given Albritton's experience, her fundamentalist belief in the Bible, and the current popular interest in angels, it is not surprising that angels appear more and more in her latest works. She states openly that she believes in these spirits. Not only does she believe in guardian angels, but in God's directing of people in their daily lives:

> Now I believe in angels; I don't know what you all believe. But I believe that God will protect you. Wait, let me go back. I know God will protect you. I know each one of us, if you're a Christian, have a guardian angel. So if an angel's guarding you, it's not but one other angel can mess with you. And that's Satan. So in other words, God will protect you. I believe that, I know that, and as they say, I'll go down with that. I'll always believe that. And once you really become—not a church member, not a church member: you can walk up and tell your minister you've been saved all you want to; it does not constitute a Christian; you became a church member, and we have a lot of hypocrites—y'all don't know what hypocriting is; you're too young. But you have to sincerely be born again, and when you're born again, your whole life change, and that's the key to that. And God has Susan—she don't know that—to work with me. I didn't look for Susan; Susan found me. Why? See, there's a reason for everything. It's true, so God wants Susan to work with me, and Susan could not—she don't know this—she could not quit if she wanted to until God said so, until He finish it. (20 Jan. 1998)

Thus Albritton shows her ultimate belief about her art-filled life: that it is driven by her religious belief. God has taken care of her, not only with His angels, but also by leading people to her who would help her in her endeavors to realize her self. He has provided all her gifts of talent, which she uses to express that self and its stories.

CONCLUSION

Albritton manages to speak, to voice her stories in various expressive modes. She is a unique individual: traditional, yet self-taught; conservative, yet innovative and spontaneous.

In her traditional role of cook in an innovative restaurant, Albritton has appropriated a popular and fine art genre of painting to inscribe her story in Technicolor; with her narratives, she adds sound to the scene. Thus she speaks through her arts, and her arts speak to each other. If we modify the gendered words, Levi-Strauss's description of the bricoleur is fitting: Albritton "does not confine [her]self to accomplishment and execution: [s]he 'speaks' not only with things, . . . but also through the medium of things: giving an account of [her] personality and life by the choices [s]he makes between limited possibilities. The bricoleur may not ever complete [her] purpose, but [s]he may always put something of [her]self into it" (21). Albritton, like Texas storyteller Ed Bell, uses various types of narratives as "expressive creations and recreations of the performed self" that are "systematically interrelated, formally, functionally, and thematically" (Bauman 219).

Albritton's expressive performances—the written and spoken narratives, the paintings, her public foodways demonstrations, and her restaurant and yard art—while formally different, display similar themes, all brought together at her restaurant. As an African American cook, she has claimed a traditional historic role of power, but in Sarah's Kitchen, her owned space, she has the key and, therefore, the greater power. As customers drop in, the kitchen functions as a stage for re-presenting the complexities of her life and her beliefs through her painting and storytelling performances. In these paintings and narratives, created in her kitchen, she has found her most powerful voice yet to tell her story. In all of her performances, Albritton charms her audience, improvising and recreating a lively picture of herself as nurturer, creator, and seer—so distant and transformed from the poor, abused, yet spirited child. In retelling her stories, she exorcises the pain of poverty, hunger, abandonment, and racism. Achieving an empowering cathartic break through the bonds of personal and political oppression, she tells her life story, which screams to be told and retold to herself, her community, and outsiders alike, in her own inimitable way.

Fig. 12. *The Road of a Cook*, diptych, 24 x 48 each, acrylic on paper, a 1998 Albritton work, depicts the restaurants where she worked (not in exhibition). Photo: Peter Jones

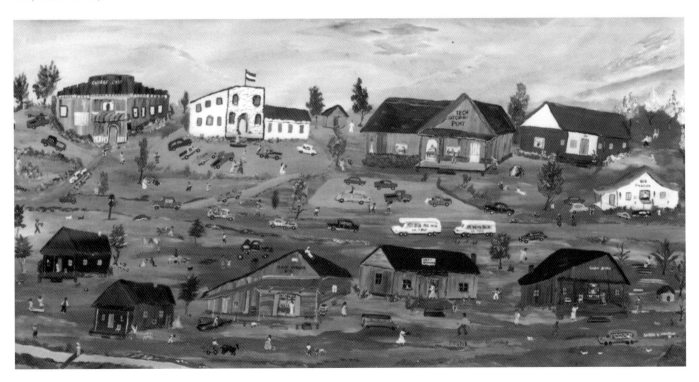

The Paintings of Sarah Albritton:
The Improvised Landscape

Peter Jones

My first exposure to Sarah Albritton's painting was at the North Central Louisiana Arts Council's Celebrity Paint-off fundraiser in 1993. In purchasing at auction the unfinished canvas of the kitchen (fig. 13) that she painted that night, I was motivated by my respect and admiration for Albritton's accomplishments as a traditional cook, as the designer of her remarkable restaurant, and as a performer on foodways and narrative stages at the Louisiana Folklife Festival. I was not prepared for the impact of her subsequent painting when she showed me an 18" x 24" drawing pad filled with acrylic renderings of scenes from her life story. I was struck by the consistency of the work and by the way in which, from the beginning, she had created and solved for herself formal and narrative problems with sophisticated graphic skill. They were not merely interesting pictures; they worked as fully realized, compelling paintings, with complex color relationships and expressive brushwork. She had orchestrated the figures and other narrative elements in her compositions to tell her stories forcefully and efficiently, with the resulting merging of form and content creating memorable, iconic images. Those early works led to her successful first exhibition at Louisiana Tech University. It is clear from this exhibition that she has continued to broaden the scope of her aesthetic inquiry while revisiting the major themes of her work with freshness and originality.

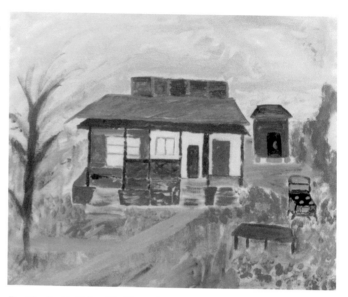

Fig. 13. *Sarah's Kitchen*, 16 x 20, acrylic on canvas, painted by Albritton in 1993 for the North Central Louisiana Arts Council Celebrity Paint-Off Fundraiser (not in exhibition). Photo: Peter Jones

The Landscape

The principal genre in Albritton's memory paintings as well as her more metaphysical visionary work is the landscape with figures. (There is only one interior in this exhibit.) The meticulously remembered and re-created landscape of her Lincoln Parish childhood is the stage for her autobiographical work, which takes the form of a journey through the landscape where she finds food, shelter, friendship, and love. Most importantly, she finds God. "I lived in Hell until I could take care of myself" (*Hell*, pl. 8). These early memories are exceptionally visual. As she told Lori Tucker of the area newspaper *The News-Star*, "I don't know why I remember my childhood so well; all I have to do is think about it and it's like a TV screen" (Tucker 5D). She also uses the forms of the landscape in paintings that portray her spiritual journey and teach moral lessons. Albritton's memory paintings of her childhood, in both town and countryside, are notable for the way in which they recall a child's palpable, gritty experiencing of the landscape, through which a small patch of ground becomes a vast world, with paths, trees, hiding places, bodies of water, bridges, and adults engaged in mysterious adult activities.

While not conventionally realist, Albritton's treatment of the landscape is highly developed, with a very strong sense of place and of the elements of earth, sky, water, and air. The landscape is not simply a backdrop. Both her experience and her pictorial account of her journey through the landscape may contain elements of an African American landscape aesthetic described by John Michael Vlach in *Back of the Big House; the Architecture of Plantation Slavery* (12-17). Vlach discusses the landscape of the slave-holding plantation as personalized by the slaves with systems of secret paths and private spaces: "Beyond their master's immediate scrutiny, at the margins of the plantation and in the thickets beyond its boundary lines, slaves created their own landscape." Vlach suggests a possible ethnic basis for this process, which consists of "a series of improvisational responses to the given landscape rules of white masters" (13). He finds similarities in "the creation of distinctive African American forms of speech, music, and dance," and describes the results: "Recognizing that they could define a space for themselves, they took back the quarters, fields, gardens, barns, and outbuildings, claiming them as parts of a black landscape. Empowered by this territorial gesture, they were able to forge an even stronger sense of community, which few planters would ever recognize or acknowledge" (16).

Albritton is acutely aware of black history, and in her paintings and narratives she finds parallels between twentieth century black experience and experiences from slavery times. She refers to sharecropping as "a form of slavery" in her narrative for *The Sun's Gonna Shine* (pl. 42), while in her narrative for *Trouble Quarters* (pl. 44), she describes black existence in slave quarters, "white man's quarters," and housing projects, as " just an endless cycle." She represents Dr. Talbot's house in the 1940s as a "Big House" set among unpainted shotgun dwellings in *Tarbor Quarters* (pl.14), giving it the form of a much earlier Greek Revival style plantation house, rather than the early twentieth century style house we see in fig. 16. The landscape she delineates is charged with awareness of "the given landscape rules," containing black and white neighborhoods, boundaries, and barriers, as well as areas where black and white people interact. It is not too farfetched to see her journey of self-discovery through the landscape as a series of resourceful improvisations which find a parallel in the improvisations of her compositions. With great freedom and spontaneity, she rearranges the elements of the landscape to suit her emotional, dramatic, and aesthetic requirements. For example, buildings with significance in Albritton's life are lined up to tell her story in *Road of a Cook* (fig. 12), while in *Bridge over Troubled Water* (pl. 43) the blue house where her mother once worked is combined with elements from several settings. The bridge Albritton crosses resembles the wooden railroad bridge several blocks away from the blue house, but she adds the stream running beneath it, and the black neighborhood on the other side. In the one work not based on the landscape, the interior, *Working in the Kitchen* (pl. 6), the contents of the room have been rearranged to make them all visible at once and to represent the way the room feels upon entering: the stove with its copper hood is on the right hand side, where it can be represented frontally, instead of at an angle on the left wall, and the serving containers have been spread out in a single line. The artist's easel and paints are in their proper place to the left. The unifying color scheme and the flatness of this picture, as well as its freedom recall Matisse's *Red Studio*.

Part of the popular appeal of Albritton's work seems to be that she brings a fresh and inventive approach to a major genre of traditional painting, the landscape with figures, which was for centuries a fixture of European painting as well as classic Chinese painting. The aim of such works was never simply to mirror nature, but rather to recreate images from nature in the service of higher ideals. It is important to note that both of these traditions consisted of landscapes executed in the studio, whether or not the paintings were based on sketches or drawings. In the seventeenth century, the heroic landscapes of Poussin and the pastoral landscapes of Claude Lorrain comprise two archetypal variations on this genre. In a classic Chinese treatise on landscape painting, written in the eleventh century, the painter Kuo Hsi ranked the categories of landscape in ascending worth as "those fit to walk through, those fit to contemplate, and those fit to ramble in and live in" (Siren 44).

Albritton's landscapes invite the viewer to enter and ramble through a re-created world, slowly contemplating a wealth of detailed information. That world may appear pastoral, but the struggles represented are, more often than not, heroic. The drama of Albritton's relationship with her mother and stepfather takes place in the landscape; even the scene of *Dirty Old Man* (pl. 39) is played out in a sky filled with protective angels, with a pit below the bed to catch the abuser. In *Mama Don't Send Me Away* (pl. 11), Albritton runs back towards her mother while her stepfather jumps for joy, neighbors come running and a little friend heroically tries to stop the truck. The landscape is the source of food for a hungry

Fig. 14. The house lived in by Dr. B. H. Talbot during Albritton's childhood in Tarbor (Talbot) Quarters as it stands in 1998.
Photo: Susan Roach

child scavenging in *Crawfishing* (pl. 17) and *Hoboes* (pl. 16), and is filled with the edible bounty of the farm in *Fighting the Chickens* (pl. 27) and *Working on the Farm* (pl. 23). The sugaricing look of *Mama We're Cold* (pl. 37) is in ironic contrast to the painful chill felt by the children struggling with heavy slabs of firewood, while the landscape provides the setting for violent death in *Tornado* (pl.15), and death ritual in *Funeral Procession* (pl. 32). A magically glistening landscape is the imagined source of wealth in *Money Hunting* (pl. 19) in which an old woman fruitlessly obsessed with finding money leads the reluctant figure of Albritton as a child into the woods, away from the busy residents of the small farm. The landscape provides the shapes and images for her metaphorical paintings, too. The path symbolizes an earthly journey in *Lonely Road* (pl. 36), while the paths in *On My Way* (pl. 1) and *Where are You Going?* (pl. 47) represent spiritual journeys.

Self-Taught Artists and Memory Painting

Another factor in the positive reception given Albritton's work is the current popularity of the work of self-taught artists, frequently lumped together under the marketing term, "Outsider Art." The January-February, 1998, issue of *Art Papers* is subtitled "Inside the Outside, Rethinking Folk Art" (Cullum 10-15). This is scarcely a new phenomenon, stretching back as it does to the interest of Picasso and Matisse in the work of the self-taught Henri Rousseau at the beginning of this century, but the contemporary works represented in surveys of self-taught art, such as *Pictured in My Mind* and *Passionate Visions*, can also be seen as both a precursor and offshoot of contemporary neo-expressionism. In her essay in *Passionate Visions*, Jane Livingston describes "a new passion for narrative imagery," and cites the influence of Philip Guston's late work on a "ubiquitous strain of this new cartoonlike, but 'serious' figuration"(23). Guston, a figurative painter early in his career, had returned to figuration in the late 1960's after twenty years

of abstract painting. His famous remark, "I got sick and tired of that purity! I wanted to tell stories" (Lynton 11) dramatizes his break with abstraction and his reaction to formalist modernist criticism. In a sense, contemporary self-taught painting is looked to for relief from the perceived sterility of modernism, just as earlier self-taught painting was looked to as an antidote to the perceived sterility of academic representational painting.

In conversation Albritton often mentions Clementine Hunter, the self-taught painter from the Natchitoches area. It is indeed interesting to compare Hunter's experience at Melrose Plantation, with its visiting artists and writers (Trechsel 98-101), with Albritton's experience in her Ruston restaurant, which has been frequented by artists, writers, and academics since its opening in 1987. Both artists had been recognized for their creativity before they began painting in earnest at their mid-fifties. Both artists painted scenes of farm work, such as picking cotton, and religious rituals, such as baptisms (See Hunter's *Panorama of Baptism on the Cane River* in Yelen pl. 79). Hunter's work, however, emphasizes flat abstract design, with less detail and more pattern, showing perhaps the influence of her quiltmaking experiences (*Quilt, Melrose Plantation*, Trechsel, pl. 66, 98-101). Her figures are often painted in profile, sometimes occupying a single plane, and she sometimes combines different scenes with different horizons in the same composition to construct a "sequential narrative." (*Sugar Plantation*, pl. 22, Yelen 95). Deep space is not a primary concern in Hunter's work. In contrast, Albritton's memory paintings stand out in their more cohesive spatial treatment as well as their complexity of detail.

Albritton also refers to Grandma Moses, a self-taught painter whose stylistic conventions have perhaps more in common with her own. On her restaurant wall, Albritton displays a regional magazine cover with a photograph of DeCinter Farley. Farley, another self-taught memory painter from this area who paints scenes from her childhood, shows one of her paintings to a group of children. All three artists share stylistic similarities, in particular the use of a tilted ground plane, or high point of view. Albritton's characteristic viewpoint makes the gently rolling landscape of Ruston seem more hilly, and after studying a painting such as *Tarbor Quarters* (pl. 14), the viewer is surprised at the flatness of the landscape surrounding the actual house, which is on a slight rise (Fig. 14). It is almost as if she has swooped down over the landscape and represented it from an angel's-eye view.

I am intrigued that these three memory painters from disparate backgrounds and periods use such similar conventions. This may be partly a matter of style and influence, particularly that of nineteenth century vernacular and popular art, but there may be a more basic reason for these similarities. The nineteenth century French artist Courbet once said that the realist painter must be able to render something without knowing what it is (Hughes 209). The memory painter, on the other hand, is interested in clearly representing something already known. The high point of view may be a feature of remembered landscapes because the way a landscape is conceptualized may

differ from the way it is seen from a fixed point of view, and because the landscape itself is initially experienced up close and on foot. The landscape painted from memory is often a cross between a plan and a view of a site, with a minimized sky and a sweeping expanse of land permitting the display of a large number of buildings and figures, each occupying a clearly defined space. If the memory is a childhood one, distances in the landscape may be relative to the size of a child and may reflect the time taken in getting from one place to another. The vast space between the rails in *Chunking Rocks* (pl. 35) and *Hoboes* (pl. 16) owes nothing to the rules of perspective or fore-shortening and everything to a child's experience of walking down the tracks, balancing on the gleaming rails and feeling the ties and crushed rock under foot.

Works by trained artists like Poussin and Lorrain were designed to look as if they had been painted from life, even though they were actually painted in the studio from memory. Academically trained artists achieved this effect through exhaustive study of anatomy, perspective, and light and shadow, and often worked from sketches done on the spot and studies of models. Self-taught adult artists working in memory and visionary modes do not usually work from models, and lacking academic training, may use signs and symbols the way children do, though their art is in no way the same as children's art. Also, like many contemporary artists, self-taught painters may not be interested in the look of traditional academic art, and either find academic techniques irrelevant to their work or use them selectively in constructing images which allow their memories and visions to take form.

Albritton makes it clear that she knows how the realist painter operates. In *He Lifted Me, detail* (pl. 3), she paints me standing at my portable easel, to the left of the pit of fire. She prefers, however, to work from memory in her kitchen, as in this way she is able to choose whatever degree of realism she deems necessary. A building may be represented with two sides in the same plane, equally visible, as Albritton does in *Tarbor Quarters* (pl. 14), using just enough linear perspective to create the illusion of volume. A tree may be structured like a hat rack, to which the various component parts of a tree, branches and leaves are then added, because the artist may find it more important to convey the idea of a tree than the effect of light and shadow on its foliage. Albritton represents trees in a number of different ways, but they generally have individualized shapes, nicely varied, with trunks carefully delineated and rooted to the ground. They are often relatively small in relation to the figures and buildings, and she treats them as important design accents, rhythmically placed. This approach allows her to weave 52 figures, by Albritton's count, and 32 trees, by my count, into the splendid fugue that is *Homecoming at Mt. Harmony*, (pl. 34). The effect is more like that of a rich documentary film than of a conventional realist painting.

One of the pleasures of viewing Albritton's landscapes is the discovery of the wealth of secondary figures, engaged in recognizable individual or group activities, who react to or appear oblivious to the drama unfolding in the center of the composition. *Bridge over Troubled Water*, detail (pl. 4), with its central image of Albritton skipping in her blue skirt across the bridge marked "white only," illustrates the complexity of her imagery, from the watching angels at the top to the scratching chickens at the bottom of the painting. Innumerable tiny figures are busily engaged in ordinary activities in both the black and white sections of town, while hooded Klansmen wait on the white side of the bridge. A black child and a white child have shinnied up poles on their respective sides of the bridge to get a better view of her crossing. Albritton's ability to reproduce gesture from memory is exceptional, and she has a sharp eye for social interactions. (In this way Albritton's work echoes that of the Flemish painter Peter Breughel the Elder). I recently sat at a table in front of her restaurant looking down on a constantly shifting group of brightly dressed basketball players at the court across the street, which is set below street level. The scene reminded me of the fluid design of *Fight after School* (pl. 28). I asked Albritton if she thought that watching these activities might have influenced her figure compositions, and she answered no, that everything she painted was from her memory.

Medium and Size

Albritton's earliest works in this show were painted on drawing paper in acrylic. She has stayed with acrylic paint throughout, experimenting with different surfaces, including masonite and mat board panels, canvas board, and stretched canvases. The bulk of her work in the exhibition is painted on water-color paper, possibly reflecting her friendship with the watercolorist Douglas Walton. She has tried other media for her narrative paintings: one friend, local ceramist Kent Follette, gave her several undecorated bowls and platters on which to paint, while another friend, Bruce Odell gave her one of his raku vases which she incised and glazed with a landscape. The size of her work has varied from 8" x 10" to 24" x 48", with the majority of her pieces falling in the 18"x 24" and 22" x 30" category. During the 1997 Christmas season she decorated the lids of about twenty half-pint jars of her mayhaw jelly with 2 1/2" round paintings. (fig. 15) (The jelly was sold almost immediately).

She has located her materials at the local university bookstore as well as the various chain stores catering to artists and hobbyists. She is resourceful and inventive with the materials she finds. In a nicely ironic story, she told Susan Roach how she discovered a line of premixed acrylic colors called Folk Art: "I just decided that's what I wanted." Designed for the hobbyist to produce work similar to the nineteenth century-like paintings often marketed these days as "contemporary folk art," these materials have proved liberating to Albritton, who has coaxed an exemplary richness and variety from them. Her painting table also contains tubes of standard acrylics from Liquitex, as well as Plaid and Delta. Another artist suggested that she try Liquitex modeling paste in her heavily built up figures; she sometimes employs its ethereal pearly color without adding other pigments. Metallic paints appear in her work as well, as gold in angel's wings and rays of light, and as copper in rusty metal roofs.

Earlier Works

Albritton is such a restlessly creative artist that it makes sense to talk about the differences between earlier and later work, even though the work in this exhibition covers only five years. Albritton says that she did some drawings and other paintings over the years before her 1993 series, but she does not show them. Works from the first group I saw, such as *The Kitchen* (pl. 7), *The Hanging* (pl. 41), *Tall Woman* (pl. 21), and *Learning her Lesson* (pl. 26), can be distinguished stylistically from the later work. In these earlier works, her compositions are generally simpler, with fewer, larger figures, and her palette is more subdued, with expressive brushstrokes and atmospheric gray and brown tones scattered throughout. *The Swimming Hole* (pl. 18) provides a good example of why I found her initial body of work so compelling. With an impeccable sense of design, she manages to compress a great deal of information into a tightly organized composition. The viewer spots the white child in the group immediately, and the black child climbing the tree (the shy Alvin). The treatment of Alvin's figure is uncannily similar to Giotto's handling of a figure strewing the ground with olive branches in his fourteenth century fresco of *Christ's Entry into Jerusalem*. In both cases the scale of the tree is reduced, and the figure is superimposed against the tree for maximum visibility. In Albritton's formally rigorous composition, she echoes the strong horizontal *V* shape of the centrally placed swimmer with the larger *V* of the path and bridge. The bridge serves as the fulcrum for a balance between the two figures at the left and the swimming children. An implied line connects a second swimmer's gesture with the precisely angled structure of the church in the background.

Like a Renaissance artist, Albritton has developed a system of iconography. Familiarity with Albritton's work quickly teaches the viewer her basic cast of characters, who are portrayed in characteristic dress with significant attributes. The child Albritton wears her iconic blue skirt, while the adult Albritton wears her signature cook's white outfit. In many paintings, this figure is her signature, making a storyteller's gesture in the lower right corner. In other paintings the figure is incorporated into the composition. Her mother often appears in a white dress with a red apron, while the stepfather wears a white shirt, tan vest and pants and brown boots, and sometimes carries a stick or strap in his upraised hand. Other constant and recognizable elements include the little stream that flows through all her narrative paintings, as Albritton points out in her narrative for *Lord Help Me* (pl. 12), and the structures and textures of the landscape of her childhood. The stream has different functions in different paintings. One of these is to serve as a barrier, sometimes bridged, sometimes not, between the black and white worlds.

In *Learning Her Lesson* (pl. 26), the three figures of Uncle Clem, Auntie, and Albritton are prominently featured, and the supporting cast is the landscape itself with its outbuildings, animals and implements. The figure of Uncle Clem, who plays a heroic role in Albritton's story, is both monumental and rooted in the soil he tills. The figures loom larger proportionally than the buildings, in one of several instances of Albritton's use of hieratic scaling. In *Tall Woman* (pl. 21), the figure of Cassie Lewis stands tall over the other figures, much as she does in the story of Albritton's life. Albritton returns to the theme of the Tall Woman in the later painting, *Working in the Kitchen* (pl. 6); here it is Albritton herself who towers over her helpers and customers.

Later Work, 3-D Effects, and Night Scenes

Beginning in 1995, her work gradually becomes more colorful, with heavier layers of textured paint creating a beautiful sense of light in richly colored works like *Fighting the Chickens* (pl. 27), *Crawfishing* (pl. 17), and *Money Hunting* (pl. 19). *Working on the Farm* (pl. 23), a classic image from this series, reminds me of Joan Miro's early paintings of farm scenes both in its sense of light and in the way the organic shapes of growing crops are marshaled into ordered rows and patterns.

Albritton's need to realize her memories and visions as vividly as possible leads her to a more concrete phase, in which she builds up figures in low relief. In *Mama Don't Send Me Away* (pl. 11), the heavily built up structure of the sewage treatment plant anchors the lower left of the composition, and lends a jarring counterpoint to the emotional separation scene. In its color and drawing, this passage is reminiscent of the late work of Philip Guston. Albritton's paintings have always possessed an expressionistic quality in their drawing and in their handling of paint, and she freely manipulates the forms of the landscape. Like Kokoschka and Soutine, she creates vistas in which buildings lean and tilt, trees undulate, and the skies mirror the internal reality of the scene. This is readily apparent not only in visionary works such as *Hell* (pl. 8), but also in more realistic narrative works like *Crawfishing* (pl. 17), with its wonderfully skewed houses and *Money Hunting* (pl. 19), where the curve of the cabin roof is continued by the curve of the path into the woods, leading the eye towards the two figures.

Fig. 15. Albritton's mayhaw jelly with jar lid paintings on drawing paper, 1997, combines two of her art forms.
Photo: Susan Roach

31

Trouble Quarters (pl. 44) contains an extraordinarily textured sky, resembling a lava flow. I asked Albritton about that sky one day as the painting sat, nearly completed, on her easel. "That's trouble," was her reply.

The visionary painting *In the Twinkling of an Eye* (pl. 50) is an important transitional work, as it is one of the earliest paintings in which Albritton contrasts heavily built up and texturally modeled figures with a thin background. Albritton's own satisfaction with the effect of that work (the painting remains one of her favorites) was reinforced by the positive reaction to the work in her first exhibition. Further explorations of textural effects followed. In some ways Albritton's three-dimensional effects are more akin to relief sculpture than to the traditional oil painter's impasto, which is usually applied in the representation of light and shade. I recently watched the progress of the diptych *Road of a Cook* (fig. 12) through successive visits to the restaurant. First she blocked out the landscape and buildings in flat shapes of color, then she peopled it, and then she built up and detailed the buildings and the figures, imitating stucco and masonry walls with thick textured paint. Works in this vein take on the quality of jeweled embroidery, with thick spots of strong color providing rhythmic accents across the surface of the composition.

When Roach asked Albritton about building up her characters, Albritton traced her interest in the technique back to her experience doing visual aids as a nutritional aide for the Extension Service, and to her experience at the movies: "I like to do things in 3-D. It might go back to when I was a child, when we first had 3-D movies." In another interview Albritton described how she left containers of acrylic paint open on purpose, and the resultant thickening lent itself beautifully to textural effects.

Another important formal development in Albritton's work is her adoption of the night scene. The early *Hanging at the Church* (pl. 40) is the key work in this development, as the genesis of the idea for the night scenes may have been the casual question asked by Roach, when following up on the details of the narrative, about the time of day represented. Albritton replied that it had taken place at night, and almost immediately thereafter began her dramatically different series of night paintings.

The first night scene painted by Albritton after Roach's remark is *The Beating* (pl. 38), an experimental work that looks as if it had been lighted by a forest fire, filled with lurid orange light and smoky darkness. In subsequent night scenes, Albritton employs even more inventive color schemes, with saturated colors standing out in contrast to rich blacks and blues. Skies become vehicles for highly expressive colors, shapes, and brushwork. In *Chunking Rocks* (pl. 35), the horror of the central event, a mother throwing rocks at her child to keep her from following her to a bar, is magnified by the angry colors of the sky, across which lightning flashes threateningly. Oranges and yellows flicker ominously against blacks and grays in *Bastard Baby* (pl. 10). As the sky becomes a more important expressive element, Albritton lowers the horizon. For example, in *Lonely Road* (pl. 36), the blue-skirted Sarah trudges along a road stretched out across a flat desolate plain dotted with shotgun houses. *The Crucifixion* (pl. 48), a panoramic work in which the sky turns black and the sun drips blood, is notable for the brilliant spots of red on the figures of the soldiers and the startling gold and purple on the facade of the temple. Albritton returns to the theme of *Hanging at the Church* (pl. 40) in the 1997 work, *The Hanging* (pl. 41), which is characteristic of this later style, with stark color and value contrasts, heavily modeled figures, and an apocalyptic sky.

Albritton also uses more vivid color contrasts to enliven scenes representing daytime. *Baptism #1* (pl. 30) and *Baptism #2* (pl. 31) offer a striking contrast. The first is painted in the more somber grays, browns and blacks and greens of Albritton's earlier style, while the second version is a much more elaborate and complex composition, with the shape of the body of water acting as a hub for radiating figures and buildings. The warm reds scattered among the onlookers vibrate against the yellow greens of the field. In place of the more intimate look of the first work, Albritton has created a broad vista filled with luminous daylight, encompassing not only the rural buildings and activities of farm life but an angel bearing witness to the scene below. This startling apparition is not unlike the appearance of the angel in Corot's great realist landscape in the Metropolitan Museum, *Hagar in the Wilderness*.

Increasingly, angels and flames are inserted into Albritton's narrative landscapes, with the spiritual coexisting on the same plane as the observed natural world. This duality recalls late Gothic Flemish painting. In *I'll Fly Away* (pl. 13), a poignant vision of the answer to her prayer for release from misery, Albritton in her blue skirt is borne away on a golden cloud while the shotgun house below her goes up in flames. In *He Lifted Me* (detail, pl. 3), a pit of fire is carved into a naturalistic landscape, while angels bear up the blue-skirted Albritton. The force of this break in the natural landscape blows the trees on either side away from the center. The adult Albritton, in her cook's outfit, appears in the lower left, tending a garden. In *Angels Watching Over Me* (pl. 9), it is difficult to separate the representational from the metaphorical in the landscape. The journey paintings *On My Way* (pl. 1) and *Where are You Going?* (pl. 47), and the unusual and moving early painting entitled *Wondering* (pl. 45), are entirely metaphorical. *The Breakthrough* (pl. 46) is an amazing image, in which the landscape is almost entirely consumed by flames, save for a tunnel to the sky beyond. The ditches, ponds, streams, culverts, and paths of Albritton's childhood landscape continue to shape even her most abstract and metaphysical works.

4. *Bridge over Troubled Water* (detail of plate 43). The adult Albritton is seated by the stream in her signature cook's outfit, watching the young Sarah crossing the bridge.

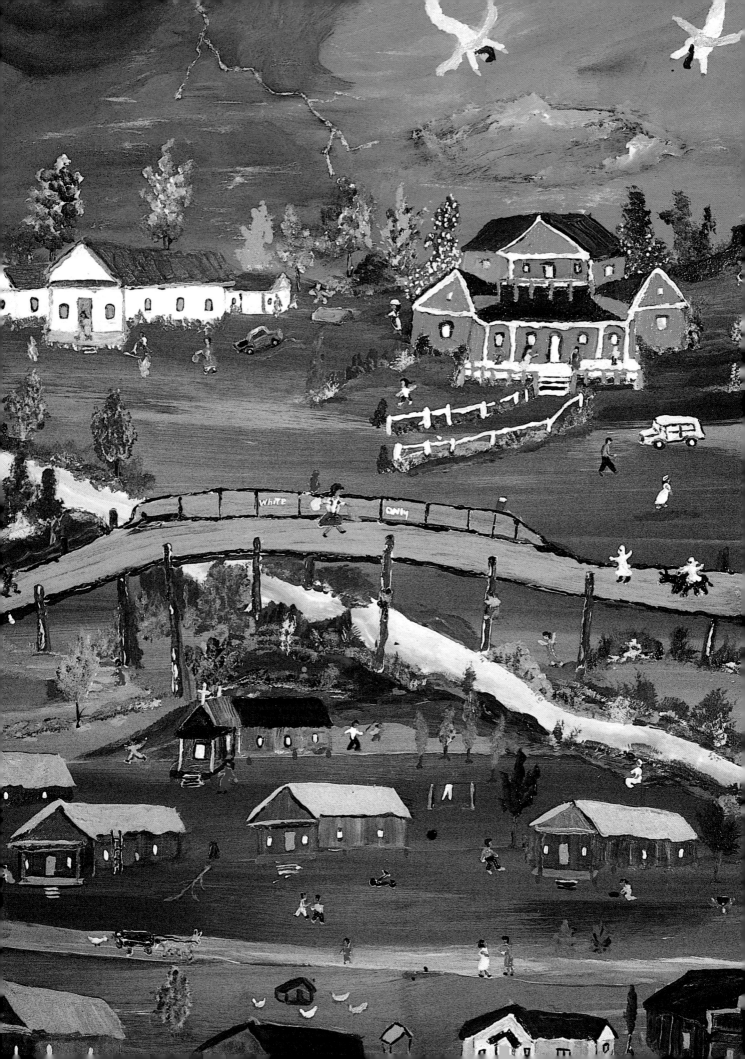

Visual Sources

Philip Guston once said, "I should like to paint like a man who has never seen a painting, but this man, myself, lives in the world museum. Obviously the painting is not going to be a primitive painting" (Hopkins 45). The self-taught artist may be freer from the burden of a lifetime of conscious immersion in the history of painting to which Guston refers, but in many ways all artists partake of the profusion of images which characterizes our culture. It is useful, for example, to describe the influence of film on both Guston, a lifelong movie buff, and Albritton. (I knew Guston well, growing up as I did in Woodstock, N.Y., and I can personally attest that he enjoyed talking about film almost as much as he enjoyed talking about painting.)

Albritton loves collecting artifacts, and has a keen eye for antiques, kitchen utensils, and old farm implements. This certainly lends authenticity to the details of farm life in her memory paintings. Another possible influence on her work is the popular culture of film and television. Next to the grandfather clock in the corner of the kitchen which serves as her studio, the small color TV is often switched on, sometimes to the local news or to CNN, sometimes to a film on tape. The antique stove hides a stack of videotapes. One day I recall talking to Albritton about her work while a tape of Ben Hur played soundlessly in the background, and it occurred to me that some of the cinematic qualities of Albritton's figure compositions might owe something to these sources. The tradition of narrative painting in European art that stretched from Giotto through the nineteenth century has been continued in our century largely through the art of film, and one can see the possible influence of film in Albritton's sweeping panoramas, in works like *Crucifixion* (pl. 48), in her special effects-filled skies, and in the vigorous movement of her figures.

Albritton has acknowledged the impact of 3-D movies on her work, and she has spoken in other interviews of the importance of her movie-going experience both before and after integration. The Dixie Theater, a downtown Ruston landmark currently under restoration, still contains the long-unused relics of segregation: the separate entrance, ticket window, and stairway to the top balcony. The Dixie is clearly depicted in Albritton's *Road of a Cook* diptych (fig. 12) with "white only" lettered on its facade and separate lines of black and white patrons entering the building. In place of the eagle, molded in relief, that still decorates the theater's facade, Albritton has painted an angel. Filmmakers from the beginning have borrowed from the language of painting, just as Giotto is said to have borrowed from a form of medieval theater; in this vignette Albritton shows us her view of film as a major component of our common experience.

The television set is our other common window to the world; with the sound turned off it becomes a series of de-contextualized images. I was watching CNN when it occurred to me that the abstract blue backgrounds for text and headlines were not unlike the background to *Payday* (pl. 49), a work that returns to the theme of the earlier *Hell* (pl. 8), and expands on the notion of the path to salvation. Whatever the source, this blue background is noteworthy in its gestural freedom and its graphic appropriateness. Another predominantly blue image, *Wrapped in the Wings of Angels* (pl. 51), fittingly serves as the final work in this catalog. Like *Payday*, it sums up many of the narrative themes in Albritton's earlier paintings. At the same time it represents Albritton's response to new formal challenges, with its unusual oval shape, its thickly textured surface, and its lavish color scheme of blues and golds.

Albritton has established herself in a brief five years as an accomplished artist, who paints her past and present, as well as her future. Driven by the powerful memories of her childhood experiences, her style reflects her awareness of popular culture, fine art, vernacular and self-taught art, and her own traditional culture. Embodying her restless creative spirit, her work is never formulaic; each return to a motif or theme previously treated is the opportunity for a new invention, a new improvisation.

Paintings, Stories, and Lessons from Sarah's Kitchen

By Sarah Albritton

5. *Sarah's Kitchen, Christmas, 1996.* Each year, Albritton lights and decorates her restaurant for Christmas along with presenting the story of the life of Christ. Photo: Peter Jones

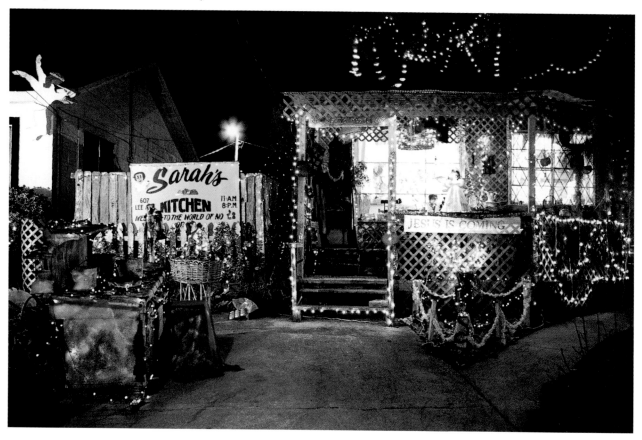

Paintings, Stories, and Lessons from Sarah's Kitchen

By Sarah Albritton

Editor's Note

Sarah Albritton's narratives and commentary with the following paintings were recorded and transcribed by Susan Roach and edited by Roach and Albritton. To tell Albritton's story, we have ordered the works chronologically and thematically. Text titles are the same as the paintings. Recordings were made at Sarah's Kitchen from 1995-1998, with varying audiences. Recording dates and Albritton's age at the time of the painted experience are provided in square brackets ([]) at the end of each narrative.

Other conventions used in transcribing the oral narratives into written text follow those of *Swapping Stories: Folktales of Louisiana* (Lindahl, Owens, and Harvison 27-28; Preston 305-26). Like many rural Southerners, Albritton frequently switches from standard to non-standard grammatical structures and vocabulary in her spoken language; therefore, we have transcribed the text as closely as possible without notations such as [*sic*], which might imply negative judgments and interrupt the flow of the language. The stories are as told by Albritton except for the following editorial conventions: (1) ellipses (. . .) replace deleted words or sentences from the recorded speech that were inaudible or confusing, or that were too sensitive, (2) square brackets ([]) provide editorial comments for clarity of pronoun referents, explanations of withheld information, etc., (3) false starts and incidental sounds such as "uh" are deleted, (4) standard English spelling rather than attempted dialectal mimicry is used (see Preston). Some names in the text are spelled according to Albritton's pronunciation and dictated spelling. Especially of note is the spelling of Tarbor Quarters, which is named for Dr. B. H. Talbot (1870-1952), who owned the houses in this neighborhood. "Tarbor" was a black folk pronunciation for "Talbot," and Albritton wanted it spelled the way she had heard it in her community.

6. *Working in The Kitchen*, 16 x 24, Acrylic on paper

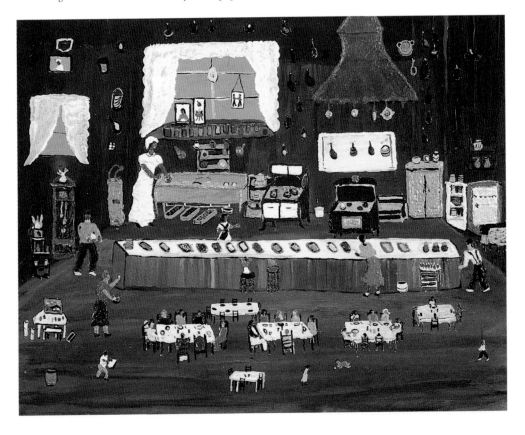

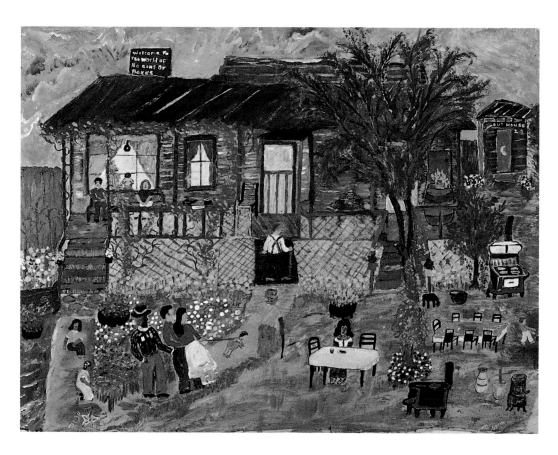

7. *The Kitchen*, 18 x 24, Acrylic on paper, On loan from Mr. and Mrs. Alex Hunt, Jr.

The Kitchen

For about twelve years, I decided I was going to open a canning kitchen, so I started buying equipment a little at a time, and finally I bought the land and the building [an eighty-year old house she had moved] and renovated it. When I started, I had three tables, . . . and then I had a door for a counter to cook on. And for some reason I had a lot of people coming, and I didn't have a place to seat them, so I decided to put tables outside, so I did for a number of years. And can you believe it, the Lord did not let it rain at twelve o'clock until I got the other part of the building, and that's the truth, so that was angels still watching over me. But really, when I opened the kitchen, someone talked me into the notion of cooking, because I had quit cooking; you know, I did banquets or parties or something for somebody around here, but they talked me into cooking, and I had to give up my canning because I couldn't cook and can at the same time; that's a no-no anyway . . .

The kitchen is different. I like primitives [iron cookware, etc.], so it's filled with primitives, and people like primitives too. . . . And a history of Uncle Clem (we have a Clem Wright wall in the kitchen) and different articles that go back to 1920s . . . I wanted to do something different from anybody else. I wanted to be totally different. There's no service here; you have to serve yourself. . . . And then on the outside, I love flowers . . . And I decided that rather than have a bathroom, we would have an outhouse, so we have an outhouse, and it's a lot of fun if you're old enough to know what an outhouse is. . . . Of course now, you know you got to have some sewage. [The kitchen opened in 1987; March 3,1996.]

Hell

I was born in hell; I grew up in hell. I started to say, there was hell in my job and hell in my home; I wonder when hell's going to leave me alone . . . Let me describe hell to you. If you go back and look at the situation, I was born, nobody loved me, I was hungry, I was naked, and I was cold. And I lived in Hell until I could take care of my own self. It's hell when you can't get any food. It's hell when people misuse you and abuse you. So this is hell, and I drew it because someone will pay in Hell for what happened to me . . . Someone will pay. The angels were watching over us [my sisters and me]. That is true because that was the only way we could have made it. [March 1, 1996]

8. *Hell*, 18 x 24, Acrylic on watercolor paper, Collection of Michael Sartisky, Ph.D.

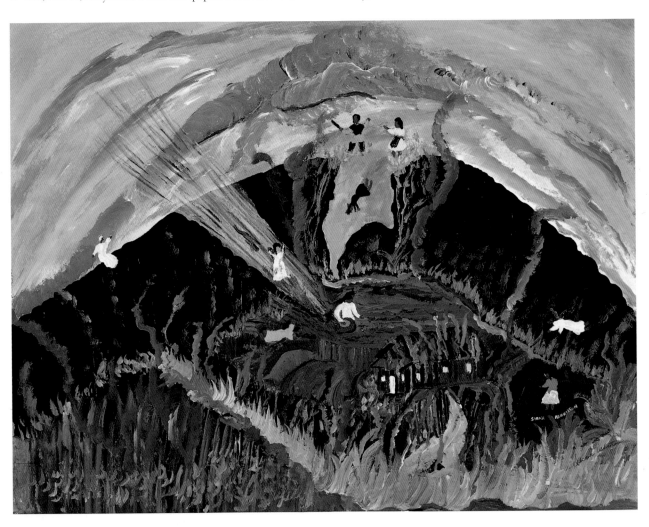

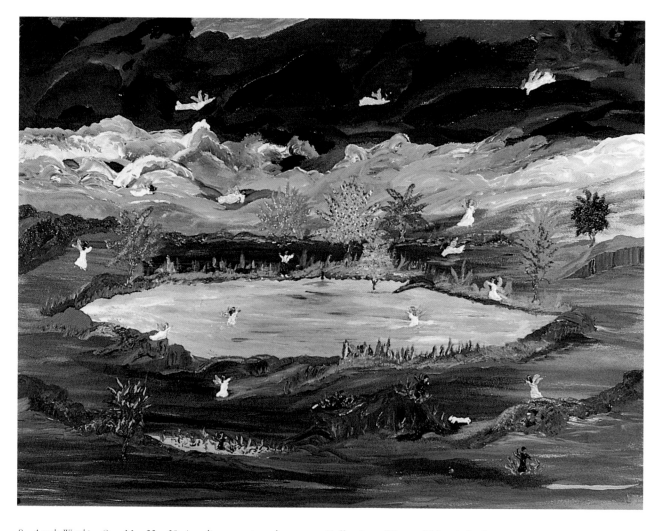

9. *Angels Watching Over Me*, 22 x 30, Acrylic on watercolor paper, Collection of Dr. and Mrs. A. B. Cronan, Jr.

Angels Watching Over Me

All the time from a child up, God held the hand of protection over me, and the angels held a protection over me, and that's the story there. They watched over me; they made sure of this: when I got hungry—Mother and them didn't feed me—I could go to Miss Annie May's and eat; I could go to Miss Willie May's, and she would give me food. Now there were some that wouldn't give you nothing . . . and there was Mama Nelson—those were three places I could always go and eat when I didn't have anything. And sometime they would give me hand-me-down clothes. So that's the story: Angels Watching Over Me. And once I left Ruston, God always had—the scripture say a ram in the bush. I could go to Thomas's and Cassie's; I could go to Aunt Mary; I could go to Uncle Clem's; I could go to Uncle Mann's; or I could go to Cousin Quemine's—to those places. And when I wanted to come back to Ruston, it would start over again. Those same people would feed me again, and when I got ready to go, the same ones would take me. It kept me within a circle from Vienna to Mount Harmony . . . So angels always held a hand of protection over me no matter where I went. [Age 5-10; May 13, 1998]

Bastard Baby

I was born in Arcadia and we moved to Ruston when I was two months old to Ben Smith quarters, then to Kavanaugh quarters, and then Tarbor quarters. . . . I didn't have a father, but sometime Mother's boyfriend would come to the house. And Hot Shot came one night, and I told him he better not go to sleep there, or I was going to set him on fire. So I must have been about seven; this was before [my step-father], and he did go to sleep, and I got some paper and lit it on the stove and set his head on fire [laughs]. I did that; I didn't like no men coming around the house.

So later my mother always went to the Busy Bee [café] after she got off work. She met my step-father there, and he moved in with Mother. . . . I used to ask Mother how come I wasn't black like my sister, and she'd tell me, the buzzard laid me, and the sun hatched me. And I would ask her who was my father. She still tell me the buzzard laid me and the sun hatched me; I didn't have one. But she told my other sisters who their father was. . . . I been asking all my life who is my father, and someone would tell me, "Well, [name deleted] was my father, so I'd check that out, and I'd go back and ask Mother; she'd say, "No." Nobody who they said was my father [really] was my father. So when I got sixty-two, Sarah [mother's friend] came down from Arcadia with another lady, and we were sitting around talking. And the lady just happened to ask me what was my last name, what was my father's name. And I told her I was a Drayton. Then I said York was my last name. Mother always told me my daddy was a York; she always said, "York." That's all, nothing else.

She says, "What?"

I say, "York."

She says, "Oh, my God!"

I said, "Well, what's wrong with York?"

And she said, "Ain't no black Yorks in Arcadia, ain't none now, and it wasn't none then." See, Sarah was Mother's classmate. They was buddies; they ran together, and she always come to see me—Sarah Dunn.

And Mother said that she met my father in jail, and they went on dates while he was in jail; he was a trusty. And she say he could build anything with his hands.

We did some research and found him there [in] the records there, and I came back and asked Mother. And she said, "Yeah, it's true; he sure was a nice man," she said. So that's *Bastard Baby*, and it reflects that my father on the white side was living the good life, and on the other side where we were hungry, naked, and cold. And there was a gulf between my mother and my father because he was white, and she was black, and that was a no-no to get married or anything. But now, you could always slip around, but you couldn't come out in the open with it. [April 19, 1998]

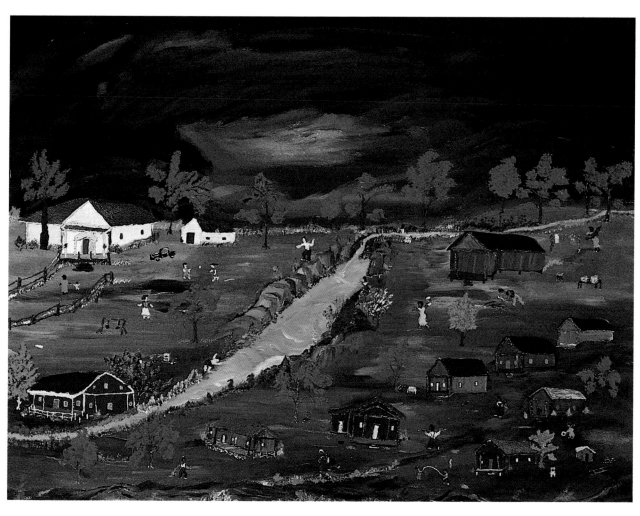

10. *Bastard Baby*, 22 x 30, Acrylic on watercolor paper

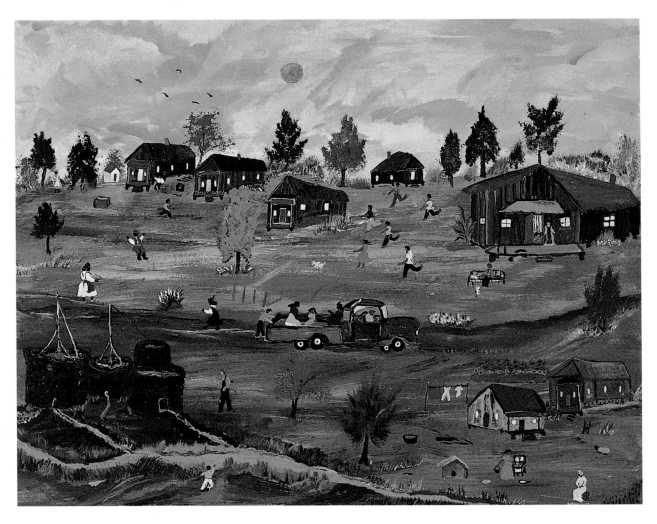

11. *Mama, Don't Send Me Away*, 18 x 24, Acrylic on watercolor paper

Mama, Don't Send Me Away

I was five years old, and Mother decided that she couldn't take care of us anymore. She only made three dollars a week, and we was living in Moate Kavanaugh's Quarters at that time. And she said she was going to send us out in the country to live with our cousins, and she did. She got Spudlow [the only person in the community with a truck] to take us out there, and she put me on the truck, and I got off the truck, and I ran back to her crying because I didn't want to go; I wanted to stay with her, and my stepfather was out waving us good-bye. Lord, how I hated that man . . . But Mother did put me back on the truck, and I went out to Uncle Mann's and stayed three days. (His name is Mann Drayton; he's twins with my grandfather.) So I stayed out there for three days, ate all I wanted to eat, and got full, and I hollered and hollered and hollered, and they brought me back home. [Age 5; March 1, 1996]

42

Lord, Help Me

Everywhere I have been a stream of water has followed me, the same stream of water, not a different stream of water, but the same stream of water. I would go down by the creek, and I would be hungry, and I would pray, "Lord help us," and I would tell him, "Mother don't love me no more; nobody loved me no more, and I need You to help me." I would do that constantly; you could always find me by the stream, down at the creek. The reason I would go out there and ask him to help me was when I went out to the country to Uncle Mann's, they told me that anything you wanted, just ask the Lord for it. They were real religious, and they taught me that. The entire time I was there they talked to me; I talked to them. So when I came back, I was going to do some tall praying. So I would go there and pray. [Age 6; December 14, 1995]

12. *Lord, Help Me*, 18 x 24, Acrylic on canvas, Collection of Robert and Melba Barham

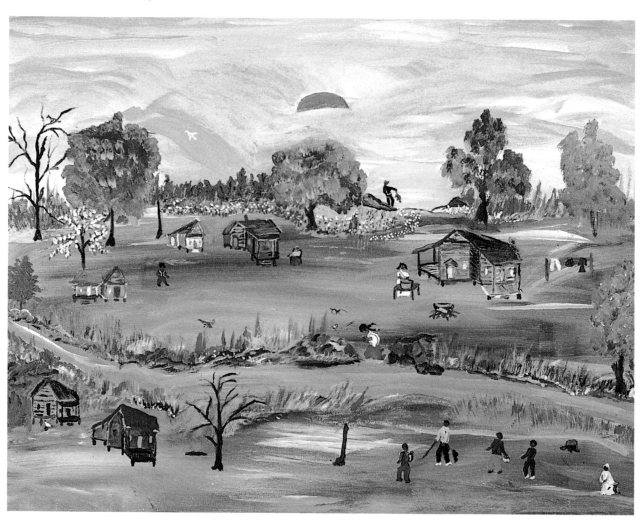

I'll Fly Away

This story starts with me going out to the country, living with my grandfather's twin brother—Mann Drayton. While I was out there—Mother gave me to him, so this is the second pass around; she gave me to him—Uncle Mann . . . I stayed three days, and ate all I could, got full of everything, and they would take me to the field with them. It was a long ways in the woods, and we would take a syrup bucket—take dinner in a syrup bucket—and we'd have some biscuits, syrup, and a piece of meat—that's what dinner was. If we didn't have the syrup bucket, we would have a sack, and we stayed over there all day. And during the lunch break—we didn't call it lunch break then; we just had lunch, Uncle Mann would sit down and talk. I would ask, I was real curious about why some people had things and some did not have. He told me this, said: "The Lord will always provide for you." And he taught me that anything you want from God, just ask Him, and He'll grant that. I didn't understand that, but when I came back home after hollering for two or three days, they brought me back home. And I'd go down to the cesspool branch, and I'd heard Uncle Mann talk so much about God's home in Heaven, I just knew that was a good place, so I'd go down there and ask the Lord, "Can I go home with You?" And I would fly away, just fly away, just get up and fly away like a bird and go home to live with God. So I did that regular—never went home to live with him, but I did it, I believed it, and I still believe I'm going to fly away one day.

In the quarters, the house caught on fire. We had a coal oil stove, and they would explode for some reason. I think the fire would go down in this little glass bottle with the coal oil in it, and the house caught on fire. And I was glad the house caught on fire. I was, because I thought if the house caught on fire, the situation would be different, but it was no different. It was just the same thing over and over. . . . [My friends] came over to see the fire, and they were happy for me that the house was burning down. We just didn't have sense enough to know we was going to be in worse shape with the house burned down. And mother come, and she was down on the ground crying because her house was burning. She was at work; she was working for Mr. Graham over on southside . . . And the house burned, and we moved to another house at that time. . . . Actually, we moved off the street right behind. The houses was four rows deep, no roads through them, just four rows deep, and one road; you have to cut through the trail to get to each other's house. [Age 8-9; August 1, 1997]

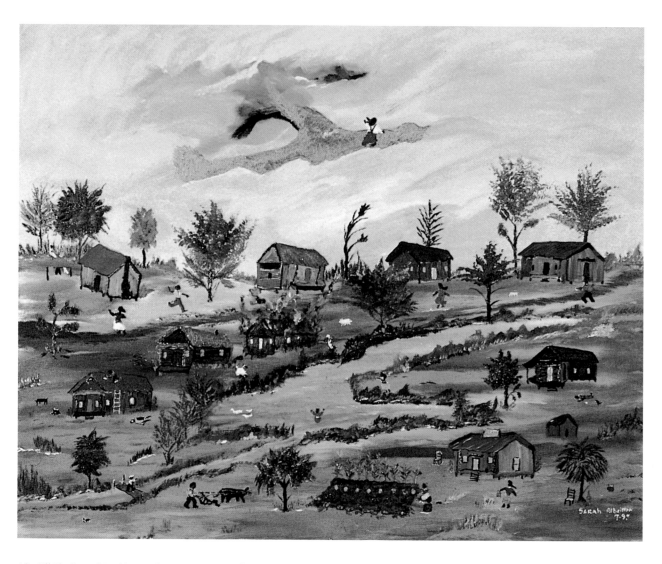

13. *I'll Fly Away*, 24 x 30, Acrylic on canvas, Collection of Sallie and Doug Wood

Tarbor Quarters

My mother moved to Dr. Tarbor's [Talbot] Quarters when I was real small, exactly when I was five. Tarbor Quarters was a little better than the other quarters; we had running water and sewage there because Dr. Tarbor believed that every person should have sewage and running water. The houses was kept neat and the yards; he didn't allow them to throw junk around; you couldn't do that. And the big house—I used to go up there. Mrs. Tarbor had long hair; it hung to the floor, and I would go up there, and she would let me comb and mess around with her hair, so I loved that. . . .

Tarbor Quarters brings good memories and bad memories; a lot of days I was hungry in the house, and I remember my stepfather making a grocery box, and he would lock the grocery box, and wouldn't give us anything to eat when Mother left to go to work (she was working for Mayor T. C. Beasley at that time). And every evening I'd break the grocery box open and take the food out; that caused me to get a whipping. And here in Tarbor Quarters my two sisters came back from the country to live with us, and he [my step-father] wanted them to go back; he didn't like us—he used to call us chaps; he didn't like children, so he wanted us to go back out in the country. In Tarbor Quarters everyone had to work: Get out of school, you would come home, and you had your night work. Mother used to call it night work; that mean you work from the time you got out of school to night. In Tarbor Quarters . . . this is where I got my first job. . . . [Age 5 up; March 1, 1996]

In most of my paintings, you see me in that blue skirt and that white blouse, and there is a reason for this. When I was nine, one of my friends got a blue pleated skirt, and I wanted one, and mother said she couldn't afford it. [She was making three dollars a week]. I cried and kicked and hollered but still didn't get the skirt; it didn't do no good. So I finally asked her if I could find me a job, but she told me no; I was too young to work. I said no; I know I can work, and we went on, I bet you, for a month talking about me getting a job, and she still say I was too young to get a job and didn't know how to do anything. Anyway, that's what she said. And finally, she said yes, and I walked over here to the north side up there by the cemetery to Dr. Rutledge's house. I don't know why I went to that house now, but I stopped at that house, and Mrs. Rutledge hired me to clean and watch her cats; she had eighteen cats. So I did that in the afternoons, and then my other sister—she was working for the Tech Hitching Post, which is the West California Doughnut Shop now. And Mrs. Heard wanted me to come work for her . . . so I was nine. I couldn't cook, but she put me on two coke cases, and she taught me how to cook—short order cook there. And then, I bought the skirt and got it dirty fighting. And I wanted to wash it, and Mother was washing in the wash pot. And you put lye in your pot then. And it [the skirt] was wool, and it [the lye] melted my skirt, so I lost my skirt; I didn't have my skirt long. And after then I didn't get another skirt because mother would take the money we made, and she would give each of us twenty-five cents, and the rest she gave to my stepfather. So we weren't any better off actually by working. [Age 9; December 14, 1995]

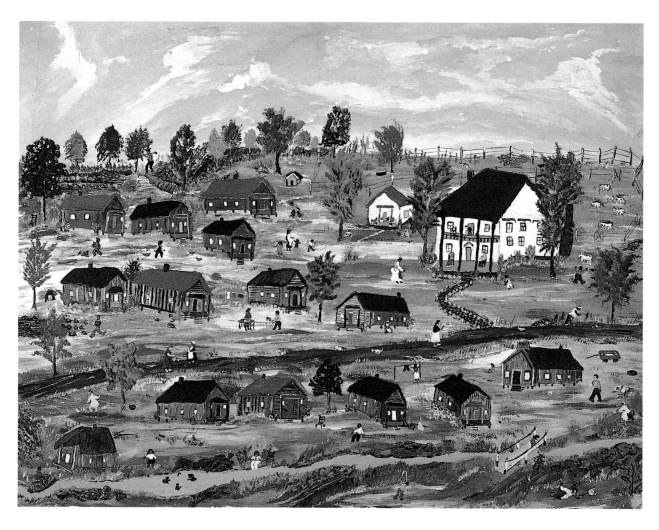

14. *Tarbor Quarters*, 22 x 30, Acrylic on watercolor paper, On loan from Louisiana State University Museum of Art, Baton Rouge. Gift of the Friends of the LSU Museum of Art (Accession no. 97.1)

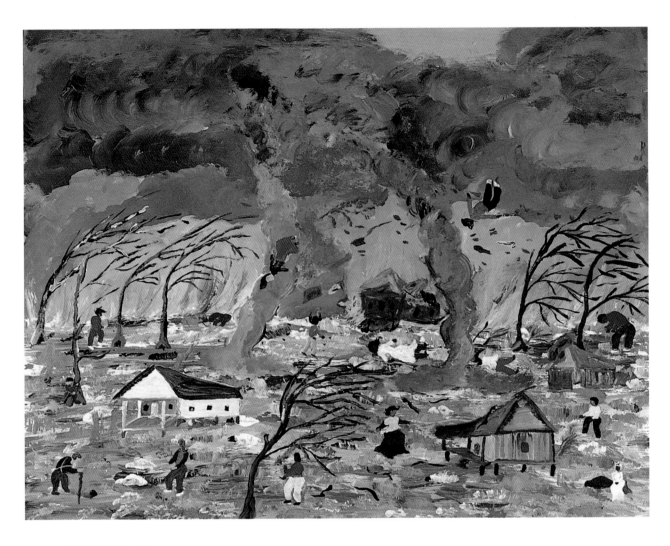

15. *Tornado*, 18 x 24, Acrylic on paper

Tornado

We were out playing; we had gone down the [railroad] track playing (you played down the tracks). There is a story down the tracks. When I was a little girl and would go down the track, there were some hoboes . . . It was a lot of trees there, and it was hoboes, and they lived there, I guess; they were always there. I had gone down track to the hobo camp. And I used to go and eat with the hoboes, and they would feed me. And the train would come through, and each day I would sit on the bank, and he [the conductor] would throw me a Baby Ruth everyday. . . . This day I had gone to the track, and the tornado came. I came on home through the wind. The tornado didn't harm me; nothing have ever harmed me. God has been protecting me all the way through. I've never been harmed; I don't care what I have been through, I have never ever been harmed, so it'd have to be my guardian angel looking over me. This day two of the Lewis's children were killed in the tornado. Two of my little friends were killed. It wrecked the houses around there, but just two were killed; they were the only two hurt, killed. So it was a terrible tornado. Dr. Tarbor did put the houses back there . . . I was five or six when this happened. [Age 6; December 14, 1995]

Hoboes

When I was a little girl, . . . I was hungry . . . every day, not one day, every day. So what we would do, we would go down the tracks, and there was some hoboes that come in, and they would go under this trestle, and that's where they would stay. They might be there two or three weeks. I don't know why they stayed so long. . . . And we would go under there, and we would eat with them. And they cooked in cans; they didn't have pots and pans. . . . We ate there with them. They were real nice, never said anything out of the way to us; I never heard one cuss. And I would sit on the track in the afternoons, on the bank; we had some high banks. And the conductor came by every day, and he threw me a Baby Ruth as long as we lived there. [Age 6-8; December 17, 1996]

16. *Hoboes*, 32 x 40, Acrylic on paper

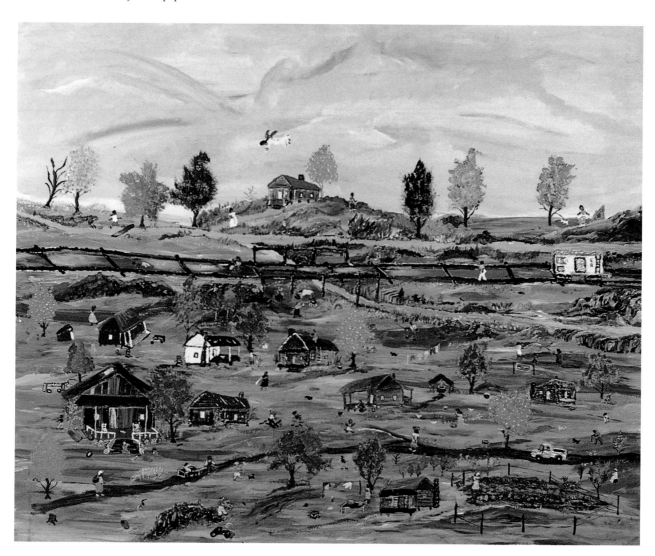

Crawfishing

We were in Tarbor Quarters, and the Jenkins boys and I decided that we would go down to the cesspool branch and hunt crawfish. And what we would do—we would take a string, a fishing pole—a stick, not fishing pole—and a cord string and a safety pin, and we'd catch crawfish with them and make a little fire and cook them, roast them. We'd stick a stick in them and hold them over a fire . . . They taste better roasted. [Age 7; March 1, 1996]

17. *Crawfishing*, 18 x 24, Acrylic on watercolor paper, On loan from Amos and Vaughan B. Simpson

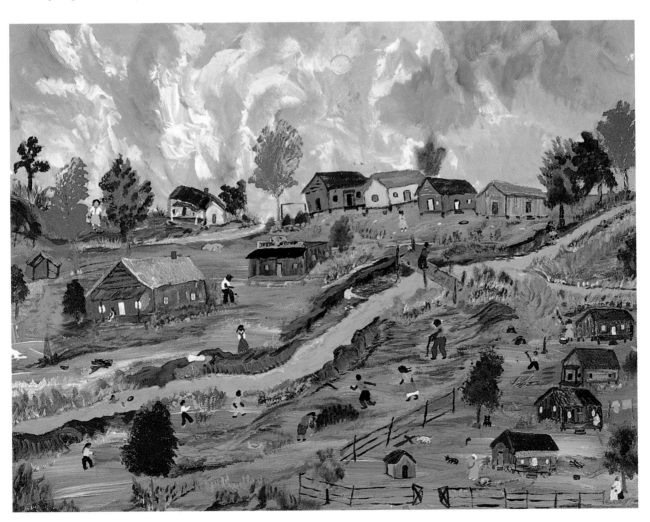

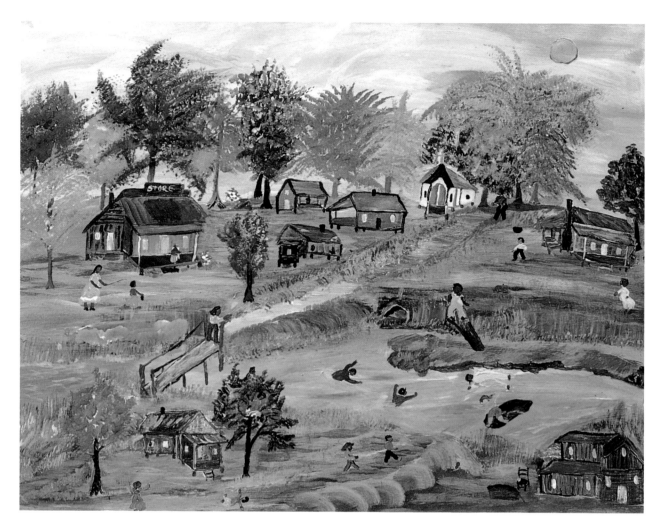

18. *The Swimming Hole*, 18 x 24, Acrylic on paper

The Swimming Hole

It was the cesspool branch, but it was our swimming hole; we didn't have no other place to swim but the cesspool branch. . . . Alvin [a friend] had stole some gum for all us, so Miss Savannah [store owner] got after him with a switch to whip him. They would bring the candy out from the store; they would swipe the candy—I know she didn't give it to him—and bring it out for us to eat . . . We don't have anything but little boys swimming, and we have a white child swimming with us . . . They lived right across the street from us, and we always played with them, and they always jumped in the creek with us, or we would go to their house, or they would come to our house. And Alvin—he was shy—he would always go up a tree and look out: he was scared to get in the water, so he would go in the tree and look out because he knew we was going to throw him in there anyway. . . . We did have a good time playing in the water. That hole was not deep; we used to call it mud crawling. We called it our swimming hole. [Age 6-8; March 3, 1996]

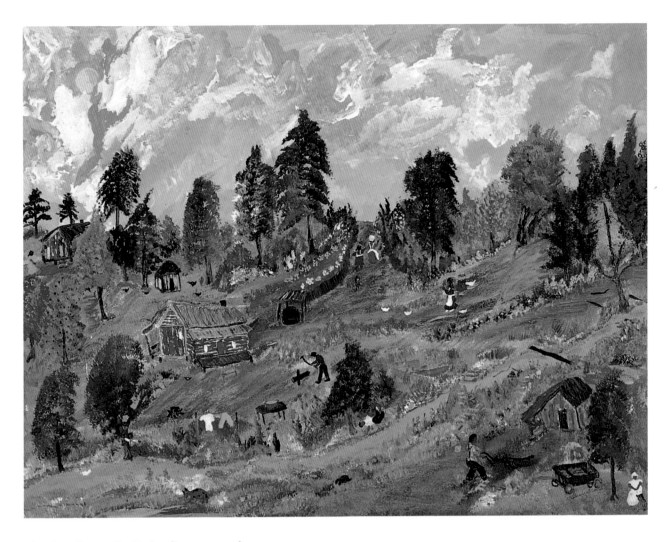

19. *Money Hunting*, 18 x 24, Acrylic on watercolor paper

Money Hunting

At Cassie's place, we were all working, and once the work was finished, Mrs. Willie Dean, who was Cassie's mother, would get me, and she'd say, "Let's go money hunting." She would take a silver teaspoon, and a red cord string and we would go in the woods, along the banks and creeks, and she would swing the spoon, looking for money. I don't know if she ever found any; she didn't tell me about it. [Age 6; March 1, 1996]

Learning My Prayers

I went to live with Cassie [on Cassie and Thomas Lewis's place near Vienna] when I was five [or seven], and her mother lived with her, Mrs. Willie Dean, and Fred and James, her two brothers, and Thomas. Miss Willie asked me if I knew how to say the Lord's Prayer, and I told her no, I didn't. And she say, "You're going to learn it today." She took me down by the little branch, and she broke some switches, and she whipped me until I learned the Lord's Prayer, and I hated her. She was real mean. And Cassie didn't like it; she told her if she hit me one more time, she would have to leave there. And she did leave there later on; she was mean to me again, and Cassie took her away. [March 3, 1996]

20. *Learning My Prayers*, 18 x 24, Acrylic on paper

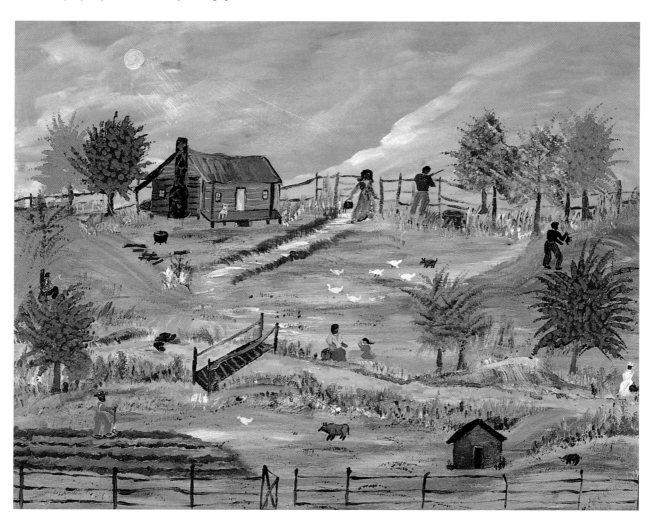

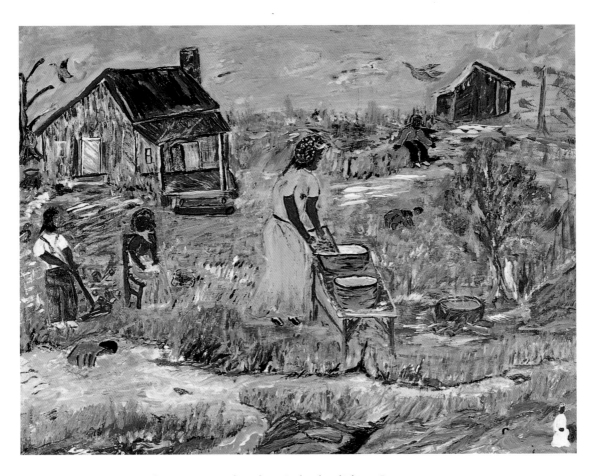

21. *Tall Woman*, 18 x 24, Acrylic on paper, On loan from Richard and Thetis Cusimano

Tall Woman

No woman in the world would stand taller than Cassie [Lewis] in my life . . . And she washed for all five of us, plus worked in the field and took care of the house, too. This is the one I lived with when I went out there [in the country] when I was five. And Mrs. Willie Dean, the one I told you that whipped me until I learned my prayers, and Fred and James and Thomas—they were good to me. I even got drunk out there. Thomas made some home brew, and he had some in Coke bottles capped up. I didn't know it was home brew; I thought it was cold drink. I got me two or three of those bottles of that beer and drank it. I knew it wasn't Coke. When they got back, I was drunk as I could be . . . Cassie bought me my first ribbon to go in my hair and my first pretty dresses. She took me to the beautician the first time . . . , and I had plenty of food. Actually, she spoiled me, to tell you the truth. They couldn't have children, so I got a little spoiled while I was out there. I stayed out there a year, and they asked me out of all the things what I would want most, and I told them a loaf of bread. They didn't have bread in the country; they had biscuits and cornbread. They didn't have white bread. . . .

And I remember we came back home that night, and we saw a bright light in the back of the house, and Fred said, "It must be a ghost." So we got flashlights and went up there, and the closer we got to the light, the more it moved back in the woods, and they said it was a spirit. And a black woman will stand tall when she has to raise her children by herself. [Age 7-8; March 3, 1996]

Lying

Cassie sent me over to Mrs. Cooper's [in the country near Vienna] . . . She wanted to make a cake and she told me to go over and get a teaspoon of vanilla flavor. So I did, and I loved to make mud cakes, and I stopped on the way back and made some mud cakes. And I told a lie; I told Cassie Miss Babe didn't have no vanilla. She says, "What is it I smell?"

I said, "Nothing."

She said, "What did you do with the flavoring?"

So I finally said, "I made mud cakes." And I got a good whipping over that about lying.

[Age 6-7; March 3, 1996]

22. *Lying*, 18 x24, Acrylic on canvas board

23. *Working on the Farm*, 18 x 24, Acrylic on watercolor paper, Collection of Joe and Jody Brotherston

Working on the Farm

During the summer, I would go out in the country and spend six weeks in the country, two with Elouise, two with Uncle Clem, and two with Cousin Quemine and Cousin Will. When I got out there, I thought I was going to get to run around and play with Ella May. I hadn't seen her in almost a year, and they were dropping corn [planting]. They were all working. Ella May and Pete was a-dropping corn, and Uncle Will said, "Girl, get that bucket and get some corn and drop it." So I filled the bucket up with corn and was going down the row, and I was dropping a few, and then I decided just to pour the whole bucket in. He asked me, "Why did you pour all the corn in?" He said, "Don't you know how to drop corn?"

I said, "Naw, Sir."

He said, "I'm going to give you a good whipping for that." So he took me home, and Cousin Quemine told me to get out of my clothes; she didn't want to beat my dress out. So I told her I didn't know how to drop corn. I said I was out on the farm yesterday—that was over at my cousin Sue's, yesterday.

And she said, "Don't you say that word to me no more."

I said, "Well, I was yesterday." She called it a bad word; she wanted me to say *yestiddy*, rather than *yesterday*, and I didn't know about *yestiddy*. So I got a good whipping about that.

And they really worked hard, constantly all day long, till night. [Age 7; March 3, 1998]

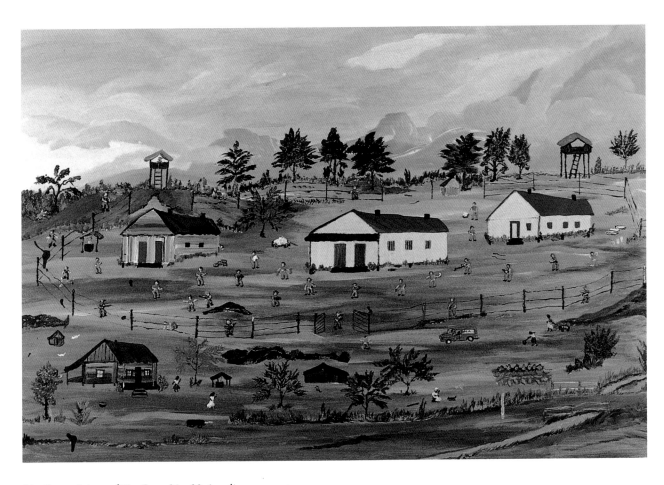

24. *German Prisoner of War Camp*, 24 x 36, Acrylic on canvas

German Prisoner of War Camp

When I was out in the country living with Thomas and Cassie, Thomas would give me a nickel every day. And I would walk the six miles to Vienna. And on my way to Vienna, just as you cross Cypress Creek . . . , was the German prisoner of war camp. And I did not talk to them because they didn't understand me. And I surely didn't understand them; They would wave, and they would smile and come to the fence and look at us. So all I really got to do was stop and look at them and wave; they'd wave back. You could tell they was friendly; well, they acted friendly; I don't know if they were friendly or not, but they acted friendly, and I probably would have talked to them if I could have understood German. . . . Uncle Clem worked there; he worked on the yard, and he cooked; he was a cook first. He cooked there for the camp there, and then they had a camp here in town [Ruston] over by the park—Cook Park—and he cooked over there. And he would walk to work from out at his place. . . .

After he [Thomas] explained to me what it [the prison camp] was, I still didn't think anything. I was just thinking they was prisoners, just regular people. I didn't see nothing bad about them even though he told me, but I still didn't think nothing about it. And I probably would have gone up and talked with them and gone in the prison if they would have opened the gate or something because I liked—always did like to rattle off with my mouth. [Age 7-8; May 13, 1998]

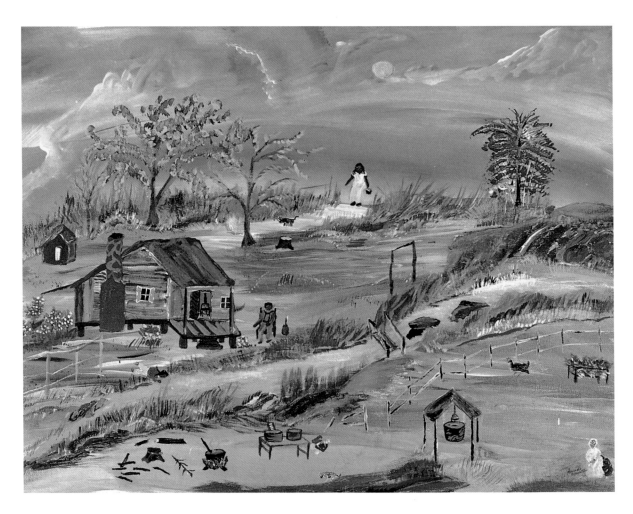

25. *Aunt Mary's Place*, 18 x 24, Acrylic on canvas board

Aunt Mary's Place

I had met Aunt Mary and Uncle Sam McGuire out to Mount Harmony during a revival, and they asked me if I wanted some food; I could eat out of their box. That was my first time meeting them. They lived about four miles from Cassie and Thomas. So I ate with them, and we went home, and the next day Thomas gave me a nickel to go to Mr. Delony's store up to Vienna; that was about six mile [miles away]. On the way at Aunt Mary's place, which is owned by Bob Levy now, I stopped and ate and played around with Mr. Sam; he made me a sling shot—I was a tomboy, so he made me a sling shot. I went on to the store and got my all-day sucker and come back, and I was thirsty, and I lay down to get me a drink of water (the creek is still there, by the way). And Aunt Mary invited me in for tea cakes. She always had something to give you; she was the most kindest person in the world, and she would take me with her to the hog pen and to feed the chickens. And I was allowed to go there and stay, but I had to be back home before night. So it was a beautiful place; it's on a hill. [Age 8; March 3, 1996]

Learning Her Lesson

Uncle Clem was one of my greater teachers who taught me right from wrong; he taught me to work. I would follow Uncle Clem as he plowed, and he always had a little saying: "Sister, if a man won't work, he'll steal," so he said, "I want you to stay in your books, get you a job, buy you a little piece of land, and save a quarter." During any time I lived there, I had a little job on the farm too. I would go out; I liked to chase the guineas, and I would go out and hunt for their nests, and when I found them, I would take the eggs out with my hands. Sometimes it would be as many eggs as twenty-four and twenty-five and twenty-six eggs in the nests. But Uncle Clem taught me never to put your hands in a guinea's nest; you always take a spoon and take the eggs out. So those were my eggs; all the eggs I collected he would let me have even though I couldn't eat them all, but I had fun owning a lot of eggs. He would also let me slop the hogs and make up the shorts [mixed grains] for the pigs, and my job was to make the dog bread. And when I say dog bread, he would let me take meal and water and make it up, and he would feed the dogs with that. So that kind of got me on the move to making hot water bread. So we all had to work; we were trained to work.

I loved to go to Uncle Clem's place better than any place I knew because he would let me go to the smokehouse; he would let me select any meat in there I wanted to eat. And I always wanted the ham, and he would take me over to the syrup mill to Mr. Mayfield and let me see them make the syrup. And then he would buy syrup and bring it back. I had a wonderful time at Uncle Clem's place. And Uncle Clem—I have been with him all of my life, and when he died four years ago, he was a 104 years old. And he came and lived with me, so we exchanged: he babysitted with me, and I babysitted with him until the end. [Age 7-10; December 14, 1995]

26. *Learning Her Lesson*, 18 x 24, Acrylic on paper

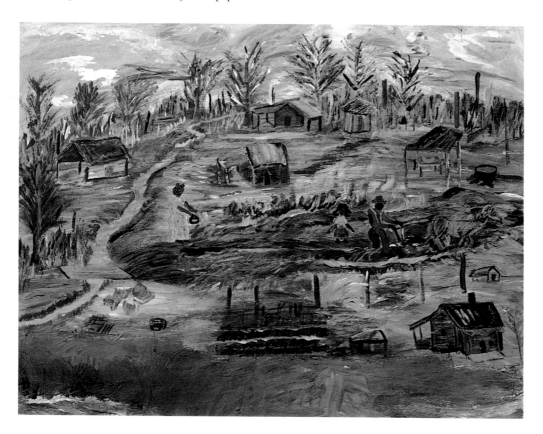

Fighting the Chickens

We were out on the farm; now you've got to realize that when I was out on the farm, I was in a four mile radius from Ruston; I never was far. I was either in Vienna . . . or on Farmerville Highway. The community is Mount Harmony, . . . and all the families was relatives that lived out there in the two communities. . . . This is out on the farm, out to Uncle Clem's with some of the children that he kept there. It was Matt and Bill [Mrs. Wright's niece and nephew] and Felt there, and myself, Doug, and Teenachie [nephew]. We would all go and visit the country. Most lived with them, and they would like take in—you might want to call them orphans, but they were relatives; they would take us in. And on the next farm over we have Quilla—Quilla was kind of slow; we call it slow today, but she was crazy about me, and she was always wanting to ride me in that wagon, to get me in trouble, and we always got in trouble; I'll tell you that. I got the whipping; she was too old to get a whipping because she was like in her fifties. But she still had a childish mind, and we would play. In this particular setting, you see everybody working; during that time everybody worked. . . . Each one of us had a job out on the farm, but this particular day I was running the chickens. I always liked to run the animals, and I was very busy running the chickens. Now, I'm going to get a whipping for running them chickens. And it's a funny thing—out on this particular place, you wouldn't believe this—I don't know how they done it: John had chickens, Uncle Clem had chickens, Auntie had chickens, and each one of them took care of their own chickens, and their chickens went a separate way. In other words, they didn't keep company with each other. Now how they got them trained . . . like that, I don't know, but I do know that's the truth, so I guess that normally if you get your chickens and take them a certain way, they'll just go that certain way. . . . They had their eggs separate; everything in the house was separate. It was either John had his food; Uncle Clem had his food; Auntie had her food. They were married, but separate. That happens a lot now, not just then. . . , but it happens now. . . . Auntie is busy [washing], and Frank [in the upper left with dog] was my great-uncle; he was a little on the lazy side. If he could get away and not do any work, he would get his dog, and he'd head for the woods. And he'd stay there all day; he'd get back in time for supper. Uncle Clem let him have sixty dollars one year to raise a crop—when I say crop, I'm referring to cotton because that's all they raised for a cash crop. . . . He raised his cotton, but he was too sorry to pick it or get someone to pick his cotton, so he didn't get any more money from Uncle Clem. . . . And Doug [tried to plow]. . . . He was from Ruston; he could not plow, and he would get me in more trouble. Uncle Clem tried to teach him to plow, and he, in turn, let me try to plow and I would mess up, and a whipping always came.
[Age 8; December 17, 1996]

Fight after School

You'll notice all the little boys—they are the Jenkins boys, and I was a tomboy. So Esther May had been picking at me, and I told her, "I'm going to get you after school." So I did catch her, and the whole gang got involved in the fight. And Mr. Morelle Emmons caught us, and we were punished—every one of us—with a belt at Lincoln High School. [Elementary classes and high school classes were on the same campus then. Age 8; March 1, 1996]

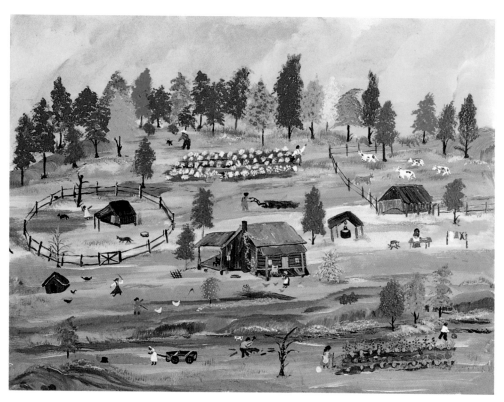

27. *Fighting the Chickens*, 18 x 24, Acrylic on watercolor paper, On loan from Susan Roach

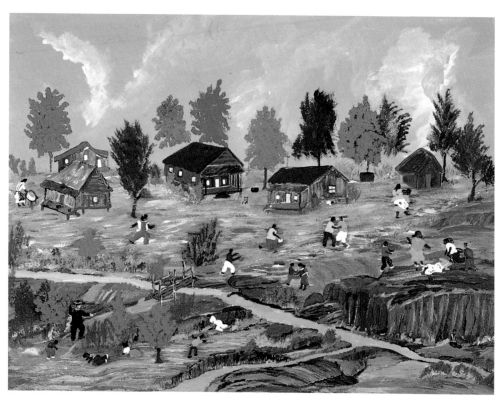

28. *Fight after School*, 18 x 24, Acrylic on paper

Neighbors Picking Cotton

In those days in the Vienna and Mount Harmony communities, neighbors would come together and help each other with anything they had to do. They would come and help you kill hogs, kill your beef or whatever, help you work the farm, help you plow, . . . or pick cotton. In Vienna, there was Aunt Mary and Uncle Sam McGuire, Thomas and Cassie [Lewis], Aunt Babe and Mr. Cooper, and Mr. Nels Mayfield and Aunt Gertie, and Brunner and Cousin Sue and Zola and Quilla—those was the neighbors there. And when you go to Mount Harmony—you could go through the woods to Mount Harmony then, over on the 167, there would be Uncle Clem, Auntie, Frank, Miss Lizzie Woodard, Mrs. Annie and John Mayfield, J. C. Lewis, and Cousin Ruth—they would all come together and pick each other out in cotton. And they would all bring their little syrup buckets—we called them syrup buckets because syrup did come in the buckets. And they would bring their lunch, and most time they would have some kind of piece of ham, salt meat, or baked potato, and some bread and some syrup in the syrup buckets. And when lunch time came, they would all sit out, and kind of like have a little party or a little family get together, and they would eat. And my job was to help bring the water to the field. So that's what we could do. And Quilla . . . we would bring the water.

And once they picked each other out, they would actually have a prayer meeting. They would have church and cotton picking. They would sing hymns and have a good time—wasn't no preaching, just hymns and praying. The greatest pray-er they thought—maybe I thought it too because I liked to hear him pray myself—it was, we called him Praying Amos. He was a deacon at the church at that time. And he could really pray, and he would pray from Ruston—now he lived in Ruston—he prayed from Ruston to Vienna and Mount Harmony. People called him everywhere to pray. And I mean he could pray! So just coming together, helping neighbors do anything needed to be done—if you wanted to fix fences, the men would come over and help each other fix fences or whatever.

And that's the way a neighbor should be, like they used to be, because we're a little selfish now. We just care about ourselves; we really don't care about helping out. The majority of us don't care about helping neighbors. Now we've done that same thing right here at the kitchen. This little group round here—Miss Mary Lou, Miss Tyler, and Miss Alma and Mac, and Ma Babe, Maggie, Miss Edna, and Lola—if we had peas, corn, whatever we had to shell out or do—we'd come together and shell each other out. And by the way, just about all those I named came from Mount Harmony too, the same community. It's funny, but they did. [Age 7-10; May 13, 1998]

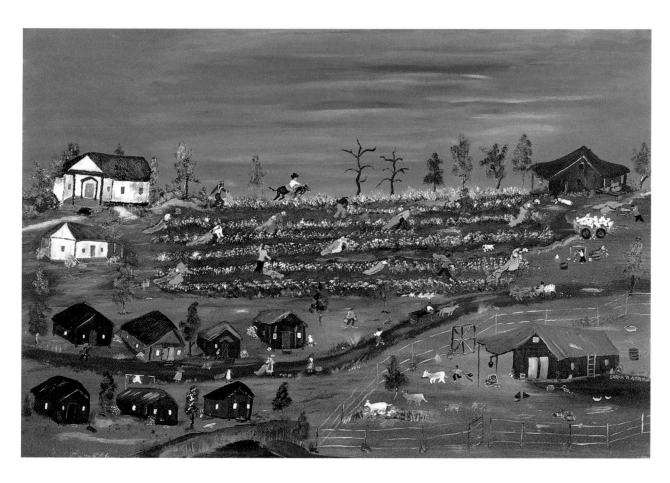

29. *Neighbors Picking Cotton*, 21 x 32, Acrylic on watercolor paper

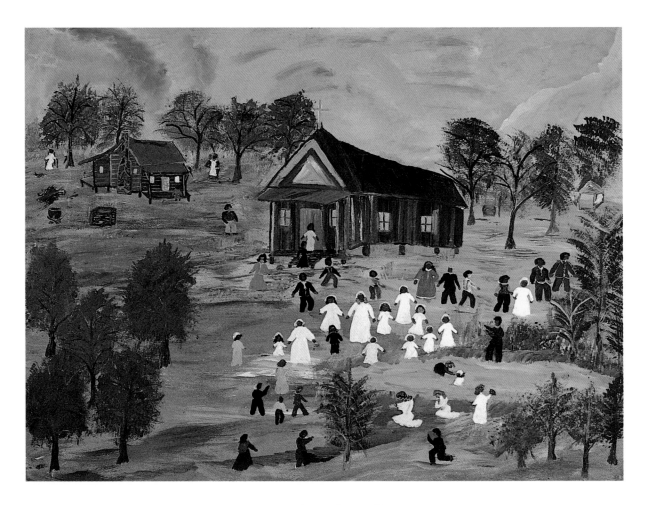

30. *Baptism*, 22x 30, Acrylic on watercolor paper, On loan from Judy F. Weller

Baptism

 In Tarbor [Talbot] Quarters, Joe Lewis, BeBee, and Lick—That was the three boys lived next door to me, and they were really cowards. Well, they were; I'd beat them up all the time; I beat all three of them up. I was bad about fighting. I didn't start nothing, but if you started something with me, you had to fight. Let me tell you something: I have a reason for that. I have had to fight for myself all of my life, and I guarantee you I would fight for myself, and I still would defend myself. I have to catch myself sometimes now, "Whoa there." Anyway, they had been picking on me, and I said, "Wherever I see you, I'm going to get you."

 They were having a revival that week. We always left town for country revival; don't ask me why. We had churches around here too; that was home church, though. I had ridden the bus out there. . . . The children that didn't belong to the church—the sisters would take to the left of the building, and the boys would go to the right with the deacon. They would take you out there and pray over you all day if necessary. So they prayed and prayed; they prayed on me all week. That's true. This Friday night was the last night of revival. My sister and Hazel—that's another girl that lived in the country—they called me behind the church and said "Tell you now, you want them to let you alone; just join the church, and we are going to tell you what to say. So they said you get up there when the preacher extends his hand; you get up there

and say, "I come to join the church, I feel like the Lord has forgiven me for my sins, and I want to be baptized." So there was about twenty of them children up there, and I started off, and we went down the line with that, and all those joined the church. That Sunday was baptizing; we went to church that morning. And this was late in the afternoon when we were baptized because we had dinner on the ground, and that was a lot of fun . . . and then the baptism. And it was a little hole that you was baptized in; the church didn't have nothing in it but the seats. And I was the first one in the pool, and when Reverend Pearlue Harris baptized me, I came out, and the sisters put a sheet over me.

And Joe Lewis and his brothers were there; they had been baptized. . . . I had a fight right there, still wet from the baptizing pool because I told them I was going to get them wherever I caught them. That was a good place to catch them, and I didn't know not to catch them there, so that was a good place. This was the one time—I don't know why—but I didn't get a whipping for fighting, and the Reverend didn't even take out one of them long talks because he could talk a long time. . . . They don't baptize in the pool any more, but the pool is still there; it's a little branch—that's what it is. The same branch from southside goes to Vienna, comes across Vienna to Highway 33 to the church and comes back. [Age 6; December 14, 1995]

31. *Baptism #2*, 23 x 34, Acrylic on watercolor paper

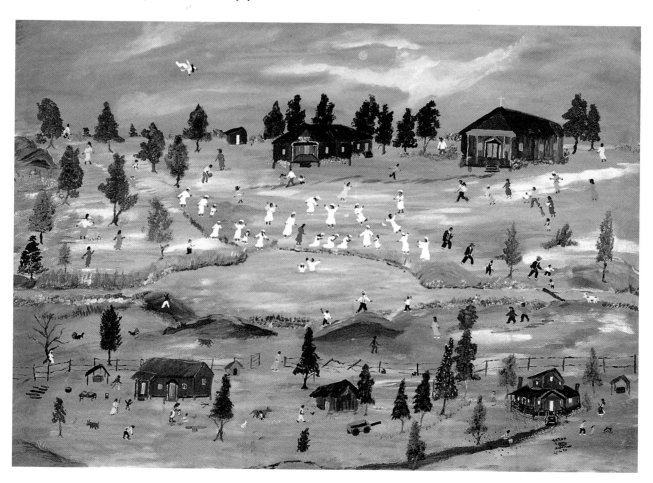

Funeral Procession

[My Aunt Willie Bell] was my mother's [only] sister . . . She lived with us in Tarbor Quarters; that was just over across the tracks from south side. . . . She liked to go to the cafe, and they had a Busy Bee, right there at the farmer's market and Martin Coffee House . . . She would go there every night. I remember this particular night Mother says to her, say, "You should stay at home; you shouldn't go up there; you need to stay at home some," but she was going anyway. And when she got up there, she ordered a bowl of chili, and . . . when she came home, and she got sick. They said she was ptomaine poisoned. And then she asked me to get in the bed with her that night. I didn't want to get in that bed now because she was sick, but anyway I got in there. When I woke up the next morning, she was dead. And Mother was crying, said she said she didn't have any money to bury her, and I said, "I can get some money." And I took a jar, and I solicited the money to bury her. That's when I was eight. Kings Funeral Home had the body and . . . her funeral was held at Mt. Harmony Baptist Church out on 133 [Highway 33]

When the preacher got up to preach, I told mother I had to go outside, so she said, "Go ahead." I went out there and found a hickory nut tree. I didn't know it was a hickory nut tree at that time. And I came back; I had a lap full [of hickory nuts], and I stood at the back of the church, and I said, "Mother, what's dem [them]?" I got a good whipping right there at the church about walking up there and asking what was the hickory nut, but I wanted to know. So that's the end of the story. She [Aunt Willie Bell] didn't have any children, and she was good to me; she loved me. I didn't want her to die; I just couldn't stop her from dying. I didn't know nothing to do. And the scary part was when they [the funeral home] came to pick her up, they put you [the body] in a basket, a little narrow basket. It was scary, and I never went back in that house, the one she died in. Now Mother had to move two doors down; she moved because I was scared to go back in that house. I wasn't going back in that house. [Age 8; December 14, 1995]

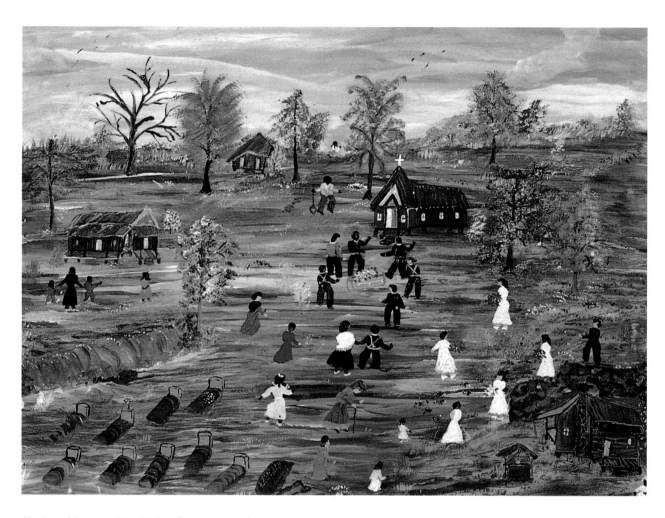

32. *Funeral Procession*, 22 x 30, Acrylic on watercolor paper

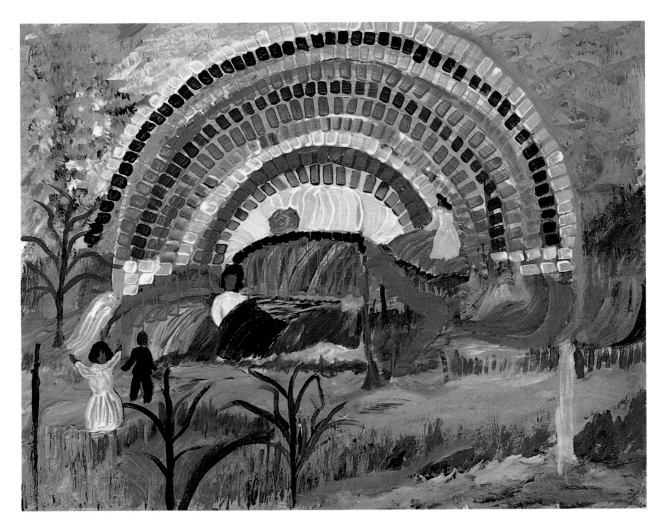

33. *Angels Watching Over Me,* 18 x 24, Acrylic on paper, On loan from Mr. and Mrs. James R. Owens.

Angels Watching Over Me

[After Aunt Willie Bell died] Mother moved us within a week. I remember I had a cold; mother said that I could have had pneumonia, and [my stepfather] said that I might die, so he went to the store and got some Black Draught and castor oil, and mother put it in some hot water. I had to drink that, and then I also had to take a tablespoon of castor oil and some soda. And I was real sick then; I really thought I was going to die. That's when after I had gone to bed that night, she [Aunt Willie Bell] appeared to me, . . . praying with an angel standing there, and she told me I'd be up in about three days, and I was. [Age 8]

It's not the first time angels have appeared to me. The second one I saw was when Robert Lee's sister died. She would always hide her money, and she called me, and I went to the back door. And she was standing there, and she says, "Go up to the house and look in the loft in a corner; you'll find my money." And that's where it was. So her children got the money. An angel can take any form. . . . I thought it was her calling me. [March 3, 1996]

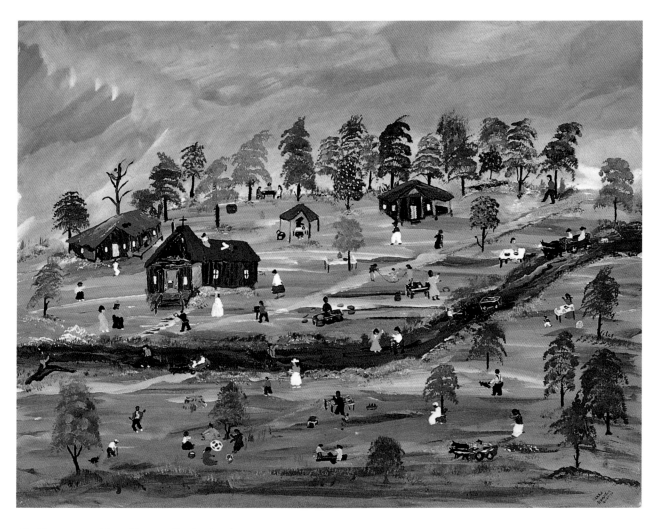

34. *Homecoming at Mount Harmony*, 18 x 24, Acrylic on watercolor paper

Homecoming at Mount Harmony

The first Sunday in August revival—I was back home with Mother, and we had to walk from South side to Mt. Harmony. Every first Sunday in August—I don't know why my mother did it—but she sent a jar of peanut butter and crackers to my two sisters out in the country. And I would eat just about all the peanut butter and crackers, so that would make us get into a big fight. As you turn off [Highway] 33, they had stands; they would sell ice cream, cakes—just about anything you can imagine from the road, Highway 33, to the church, and everyone bought a basket, and we would sit out—we didn't have a fellowship hall—so we'd sit out under the trees and eat and play and just really have a good homecoming at Mt. Harmony.
[Age 7-10; March 1, 1996]

Chunking Rocks

Mother worked from six o'clock in the morning until six o'clock at night. And when she got off from work, she'd go to the Busy Bee. Now the Busy Bee is a café . . . That's where everybody went was to the Busy Bee. That was the hottest place in town to go. And she would go there every night, and I didn't have a babysitter. I always stayed by myself, and I'd get in behind her hollering; I'd want to go to the Busy Bee, too. But I'd stayed back because she'd whipped me several times about following her. And she'd pick up gravels and throw them at me and run me back home. Now sometimes she thought I went back home, and I'd go up and peep up—they had a little box out there by the window; I'd stand up on it and peep in and see them dance. She don't know that, but I did. [Age 5-7; January 20, 1998]

35. *Chunking Rocks*, 22 x 30 , Acrylic on watercolor paper, Collection of Randy Laukhuff

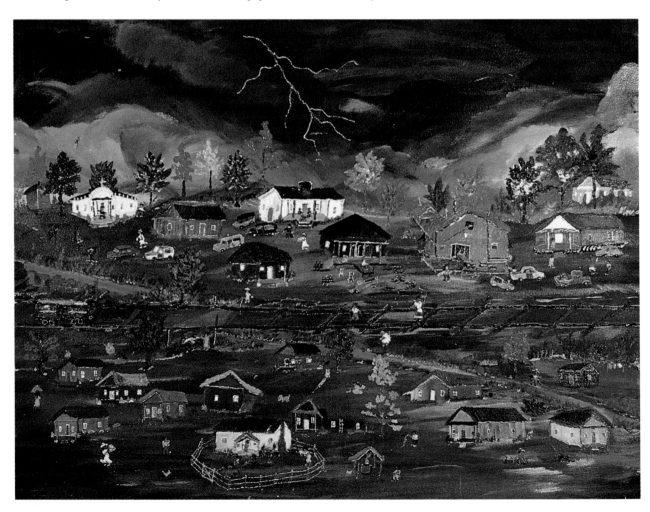

Lonely Road

We were out on the Lewis place, and during that week Thomas would take me down to the hog pen, and we would talk about farm life, and I would talk about Kavanaugh's Quarters and Tarbor Quarters. And we talked about that all the week, and Thomas said if I wanted to, he would take me home that Saturday, which he did. He had an A-model Ford, and they brought me back. They stopped at the doughnut shop first, and we got some around-the-worlds . . . actually it's just a big old cinnamon roll, but they called them around-the-worlds then. And then he took me to Mother's and when we got there and I got out and went in the house. Mother asked me what was I doing there. And I told her Thomas had brought me home, and I wanted to stay home. And she told me no, I could not stay; she didn't want me. And [my stepfather] say he didn't have time for no chaps and he didn't like no chaps anyway. So Mother called [out to] Thomas and told him to come back and get me. And [my stepfather] was cursing me, and Thomas told him he better not do that again. If he do, he was going to have him to deal with.

So Thomas left me there, and that Saturday night after Thomas had left, Mother told me I couldn't stay and told me to get out—get my little clothes and get out. So I got my little clothes, and I walked down to Miss Annie May's—Annie May Cullen; she always would let me come to her house, and she would feed me when things got rough at our house. So I went and stayed with Miss Annie May three days. And Mrs. Harmon, she had seven boys, and . . . I thought they were rich because they had everything, but all seven of them worked at the sawmill, and they bought me dresses and ribbons. And I stayed at Miss Annie May's for a while, and Mother told Miss Annie May that I couldn't stay with her; I had to go back out in the country because she didn't want me. So Mother sent word for Thomas to come back and get me, and it was back to the country. Until that night I just walked the lonely road. I call it the lonely road; it's Glover [Groveland] now. [Age 7; May 13, 1998]

36. *Lonely Road*, 22 x 30, Acrylic on watercolor paper

Mama, We're Cold

When I was a little girl, it snowed every year; it froze every year. But now the temperature has changed for some reason, because it's God's will, I say, is the reason. We had to go down to the Sterling-Nix Sawmill, which was about three miles from where we lived. And we would go down and catch slab. Now slab is a rejected piece of lumber. And they had a huge fire pit, and the slabs would come on chains, and they would fall over in the fire pit. And we had to go down there and catch wood. And we would bring it back. We did it in the summer; we did it in the winter, the same thing. It is very dangerous, which we didn't think about it at that particular time because we could have been burnt up in that pit. . . . It was enclosed; you had to go inside to catch the wood, and we would drag it back up the track. And when we got home, we had to cut it up. We was always responsible for cutting the wood and making the fire. Once that was done, then my stepfather would get out of bed, once the house was warm. And if you ever been in a raggedy house with holes everywhere and you make a fire with a wood heater, you're never really warm. You warm on the front side, and then you turn the backside. So you do that constantly. And people's legs used to be burnt up just from standing close to the fire. But I never was hot enough to burn up. I was always cold. And I'm cold now in the wintertime. And my mother said it was icicles everywhere and snow everywhere when I was born. I said, "Yeah, you froze me to death then." [Age 6–10; December 17, 1996]

37. *Mama, We're Cold*, 16 x 20, Acrylic on Crescent watercolor board

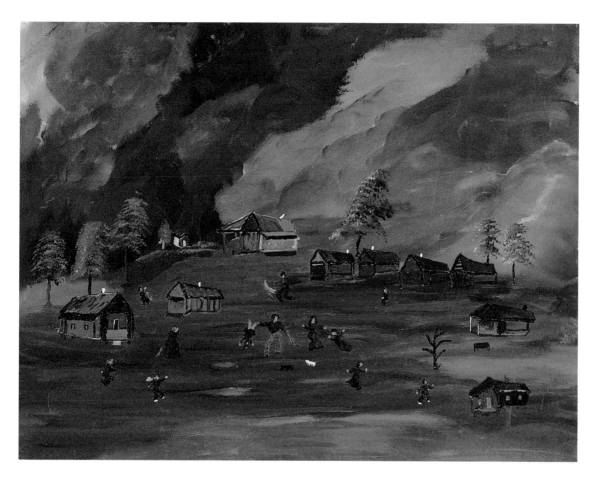

38. *The Beating*, 18 x 24, Acrylic on paper

The Beating

When my mother brought my stepfather home, I just hated him, and I hated him thirty-eight years, so you know I had to be grown thirty years. I hated him because he wouldn't give us any food; he would lie on [about] us, and he would beat us. So I didn't like him; I learned to like him before he died now, but I didn't like him then. And one night—there was a little café, . . . actually it was a store with a Seabird [jukebox] in it. It was right across from our house which was not far. And Mother had told us not to go there this particular night. Now my sisters was teenagers, but I was tagging and tattletale everything; if they said anything, I would tell it, so I was tagging. And mother told us not to go up there, and my stepfather and mother came up there. My stepfather had a gin strap. They used to have these big belts on the cotton gin; you could take those—it was a big, thick piece of leather—and he would bore holes in it, and this was what he whipped us with. And Mother came up and I was on the wrong side. The little children had to sit over where Mr. Bob and Annie was. The largest teenage children could go in the little room and dance. And every time the music would start, I'd be in there dancing, so Uncle Bob would whip me too; not only would your parents whip you in those days, but he would whip me also. So Mother came and got us out. . . . So he [her stepfather] whipped me [the girl being held by the legs], and Mother whipped Eloise, and Ella May is running, but she did get a whipping when we got home. [Age 8; December 17, 1996]

Dirty Old Man

This painting represents something that happened when I was in the second grade. At that time all the students if they could afford them was wearing black and white saddle oxfords. And I'd been begging Mother for a pair of shoes, but she didn't buy them; she got me some ballerina shoes. So my stepfather was a gambler, and he had money all time, so I asked him if he would buy me a pair of shoes. And he says, "Yes, I will if you'll get in this bed with me." So I ran out of the house. Mother had gone to work, and my sisters had already left the house. And the next day, I was in the back bedroom, and he came back there and say, "You still want those shoes?"

I say, "Yeah."

And he caught me by my hand and says, "Come on; you go to bed with me; I'll buy you the shoes, so he drug me through the kitchen (it was the back bedroom, [and] kitchen) to Mother's room (the front bedroom), and he tried to get me in that bed, but I got away from him. And he didn't only do that one time; he did that several times, only I was smart enough to get away from him. That's the only reason he didn't get me in that bed. And he didn't care; he definitely didn't care. He was a dirty old man. . . . I got away; I was a fighting little sucker. I scratched his face. And I told Mother what had happened, and she pulled my clothes off, and he got a belt, a piece of leather he had gotten from the gin. It had holes in it; he cut holes that would suck your flesh up when you [are] hit. And Mother held me, and they beat me until the blood ran out of me and said I was lying, but I was telling the truth. She didn't believe anything you said if it was about [my stepfather]. I don't care what. He could do anything he wanted to; she was always on his side. And you were going to get beat. It wasn't no if, and, but about it. So that represents that wrong there. Angels again protected me. That gulf there is a division there; I'm hoping he will fall in there; in other words, I'm hoping he will die there and be covered in the gulf. I'm wishing him dead, and I said I was going to kill him too. . . . This is what made me say, "when I get ten years old, I'm going to kill you." . . .

My sister Ella May, she had come from the country to live with us, and she was studying for a test; we had lamp light. And Mother was in the bed, and he came in and said, "Blow the damn lamp out." We didn't blow it out, so he came back and blowed it out. And he said, "Next time I come in here, if y'all light that lamp, I'm going to beat the hell out of both of you. I hate chaps anyhow." He called us chaps.

So I said, "Ella May, let's kill him." So she got up and got the yard rake; you know, I'm talking about the iron rakes, not what you call a yard broom now. And I had some RC bottles, and I put them behind the bed. I lit the lamp back. He came in with the strap, and he draws back to hit Ella May, and I cut all his eye a loose up with that bottle, and Ella May got the rake, and she split his back open.
And Mother was hollering, "Y'all better leave [him] alone; he going to kill y'all."

I said, "That's a God damn lie; we're going to kill him." That's true. . . . And I said, "If you come in here, we're going to kill you, too." We like to have killed him. So it was him or us, it seemed like him or us. And I can understand now when some children do something to their parents. We don't ever know. They might deserve it, because he beat us every chance he got; you didn't have to do nothing.
[Age 8; April 19, 1998]

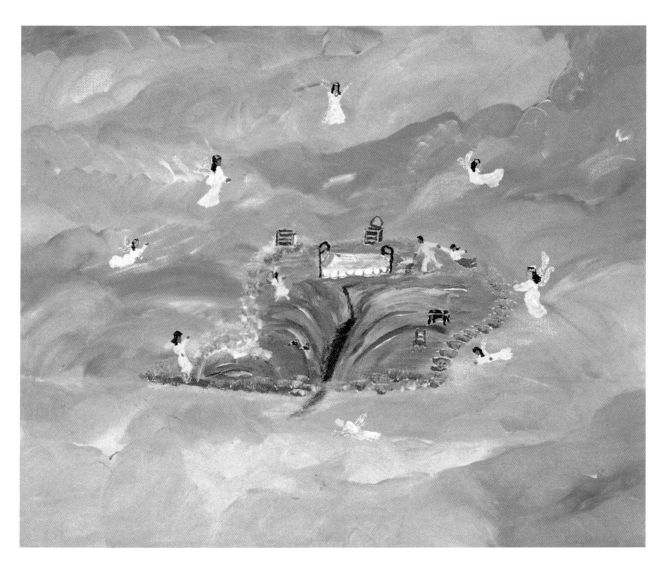

39. *Dirty Old Man*, 16 x 20, Acrylic on canvasette

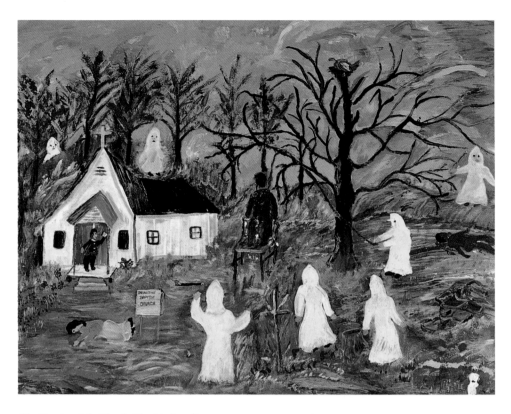

40. *Hanging at the Church*, 18 x 24, Acrylic on paper

Hanging at the Church

I used to be a runner to the store or wherever people wanted me to go when I was a little girl, and they would send me to get things for them uptown or to one of the stores on whatever side of town. We had black stores; these were black stores I was going to. . . . These were black stores in the community, but uptown they was all white. A lady was having a baby, and this [another] lady was a midwife, and I went up to get her, and news came about the hanging. And they put me in the car, and we went out to the church.

Now the story behind this painting [has] two sides of the story, the black and the white side. They [blacks] say the minister was at the church, and this [black] man and [white] lady was in lover's lane, behind the church; it's still there; it's a little road now. He [the minister] sent for the Ku Klux Klan. [To give the background of the tryst,] The black guy took the white woman the message that he [another black friend] wanted to see her [at the church], so that's where they met up at; that's where they had been meeting up at, as the story goes. So the Ku Klux Klan came and beat one [the messenger] and hung the other. Now the lady laying there—she's not dead; she's heartbroken. . . .

After this hanging was painted, and this [white] lady saw it [a photograph of the painting] in Baton Rouge, her mother came to visit me. Now the lady in Baton Rouge [said] her grandfather was at the hanging. . . . She said the black side of the story is the truth. She said this lady [white woman seeing the black man]—she ran with her, but she was a bad girl and her mother didn't want her to run with her. [She] said but she slipped off and was with the lady, said she would go with any man; she didn't care. That lady was her best friend.

[Other] whites told the story that they [a white couple] were parked out there, and this black guy came up, pulled the white man out of the car, and beat him up with a stick and raped the lady. They said the police could not find him. The next night another couple was out there, and he [the black man] pulled the man out of the car and raped the lady. But we know a black in those days would not be in the same spot if he had raped a white woman; we all know that, or even beat up a white man, because they would have caught him one way or another.

But the black story was they was in love, and these [white] people verify that she was courting him . . . [Another white man] tells the same story, and he told me who was at the hanging—the people that was not Klansmen, that was at the hanging—trying to stop the hanging. I don't know if that's true, but that's what they said. And then I added Christian Funeral Home [the hearse in the painting]; they picked up the body. . . . I didn't see them pick up the body. . . . I did not see the woman; they said she was laying there. . . . They was taking the body down when we got there, and all I saw was a crowd; I didn't even see the ambulance, so I don't know if it was there or not. [The Klan] was still there. They didn't burn a cross; they made a fire and stuck hot rods up him after they hung him and tarred and feathered him. I didn't see them do that. I just seen them taking the body down, and they wasn't black people either. . . . You wouldn't take a body down for meanness; that's what they normally do, leave them hanging. [Age 5-7; April 19, 1998]

41. *The Hanging*, 22 x 30, Acrylic on watercolor paper

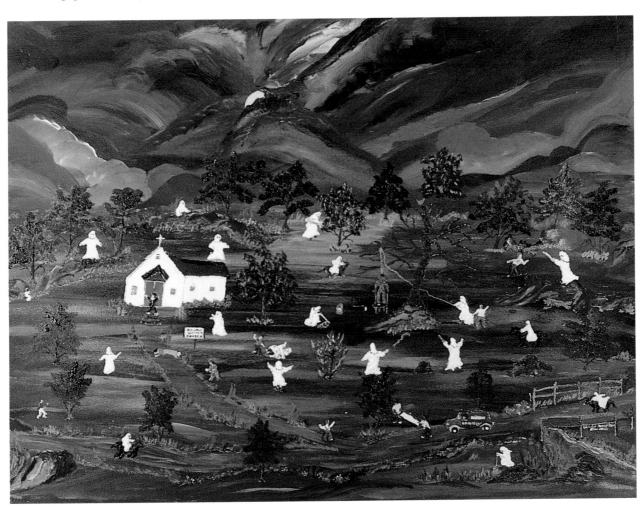

The Sun Is Gonna Shine

It's harvest time for cotton. . . . [The owner of the plantation] is waving good-by; the cook is on her way to the big house. . . . And the little black girl and the little white girl—you always have a little black girl to play with. Actually, she was just [like] a slave, so they having a good time. And these people [pointing]— they going to work in the house. These are all field hands here. And then we have two overseers there, one with the whip and he's on his horse, and he's making sure everybody come into the cotton fields, and everybody have their cotton sack, so they can pick cotton. And here, he's old, so he got tired of that sack; he throwed it down. She's tired, and she just fell down on her knees and dropped the cotton sack, even before she got to the field, she said. "I'm tired of working.". . . There were no horses; they pull the wagon into the field. This is based on . . . a place out on [Highway] 33. It's the same thing as sharecropping; share-cropping was a form of slavery too. After the slave was free, they was still under slavery. . . . They didn't have anything, and even in the thirties and forties, they didn't have anything. They sharecropped; they went to the store; they bought the seeds, and they got the groceries on credit, and then once their crop was in, they were still in the same shape. They never got a dime; they always owed the landowner, and this is not only true in slavery; this is true in the thirties and forties—the same thing, and some of it's still going on today in the Delta. . . .

[Name withheld] had a plantation, and he owned a lot of land, and people were sharecropping, and he had a little store there. My grandparents lived on his place. . . . Uncle Clem [Wright] told this story that he [Uncle Clem] was out there, and his father [Albritton's grandfather] was working on the place . . . and he [the owner] didn't think he'd done enough work, so the owner was going to have him whipped. So he [Uncle Clem's father] ran home to his wife; she locked the door, and one of the white guys on the . . . place—he kicked the door in, and his [Uncle Clem's] mother took the ax and cut his [the white man's] hand off, and they ran off [the Wright family moved] and came over here to Dr. Rutledge here on northside. Once you got on a person's place, nobody could come on that place and touch you, so actually Dr. Rut-ledge gave them shelter. . . . You would think nobody would whip a black person in those days, but that's not true; they was doing that in the sixties, so it's still a carry-over [from slavery]. [February 4, 1997]

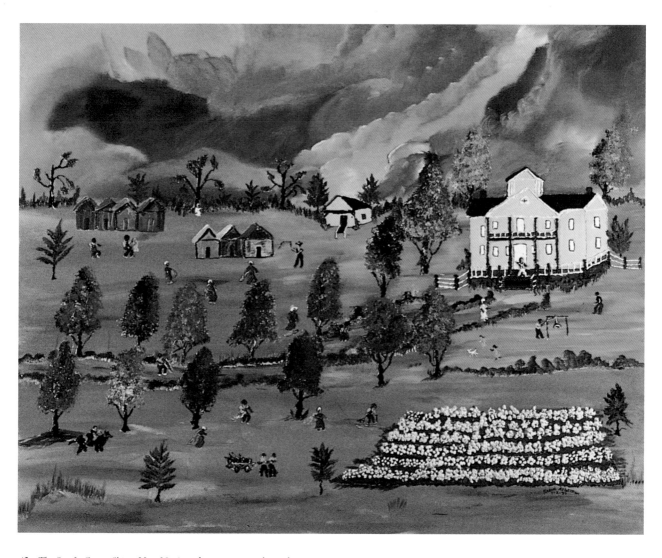

42. *The Sun Is Gonna Shine*, 22 x 28, Acrylic on canvas board

Bridge over Troubled Water

When I was little and when Mother worked for Mayor Beasley, Mrs. Fowler, and Mrs. Graham, I would get out of school, and I would go . . . to the Fowler house right up here. I thought Mrs. Fowler had the most beautiful house—I don't know how come, but it was beautiful to me. And Mother would always tell me not to come up there; she didn't want me coming on the job, but I guess you could call me stubborn, a nut, or whatever. I would always go where she was in the evening. And I don't know why I always wanted to be with my mother, other than I wanted her to love me. . . .

And I told her that I wanted to be a doctor, and she told me I didn't need to go to school; she didn't care too much for you going to school. She would tell me that you can't get in the white folks' world (she called it the "white folk's world"). And I guess what she meant by that was you actually can't go and live there with them because the only way you lived with whites at that time, you was a live-in maid. And Mother was not a live-in maid. Now sometime she would stay with Bill and Don when Mrs. Beasley and them were going out of town. So I always wondered about that: how come I can't go over there, over that bridge? There was a bridge, and there was a gulf, separating blacks and whites. Even though you could play with the whites—children, but when it come down to actually living with them and maybe getting some of the jobs and enjoy some of the finer things of life they were doing, there was always that bridge standing there: Mother on one end (she and [my stepfather]) telling me what I couldn't do and the whites on the other end said, "No, it's not for you. This is white only."

So that's why you see bridge over troubled water, and I made up my mind—I didn't care what Mother said, what the whites said, or what anyone said—I was going to do the best I could for myself, and if it meant crossing over, then I would cross over that bridge. If crossing over that bridge would keep me from being hungry, naked, and cold, I was going to cross that sucker, whether I was going to cross the bridge or swim the creek, one of the two. And I really don't know if Mother really told me the full truth about white people; she didn't say anything bad about them. She just tell me what I couldn't do and what was not allowed at that time. And I know it was some . . . good people; I knew that just by Dr. Tarbor and Mrs. Tarbor [Talbot]. . . . They was real nice, and he really cared about people, so I wanted to cross that bridge. I made up my mind, come hell or high water, I was not going to stay in Tarbor Quarters, be hungry, or go without food ever again, and I made myself a promise: my little crumb snatchers—you know what a crumb snatcher is?—my children would never have to go hungry and naked like I did. I was going to do my very best . . . to educate them so they would have good jobs so they would not have to suffer the same kind of consequences that I did.

And I crossed it, but the only way you going to cross it won't be nobody giving you nothing; you're going to have to work for it. I always had a job, never been without a job, just been fired two times: picking cotton and chopping cotton, and thank the Lord for that. So you must set a goal and you work towards that goal. Now a lot of times I worked, I knew I wasn't getting paid enough money, but now I always said, "A little something is better than nothing." So you have to be determined. And once you cross that bridge, there's a lot of whites that's not like people say they are, and there's a lot of them is, but I met a lot of good white people once I crossed it. If it wasn't for them, I don't know what I would have done. . . . I met a lot of good people; I met more good people than I did bad. I didn't run into but two or three bad ones. That didn't bother me at all because good outweigh bad, so you can't really judge one person by the next. That was a good lesson. Learn for yourself; learn people yourself, and then you will know. You don't have to believe all the lies—I call them lies—come to you. So that's it. [May 13, 1998]

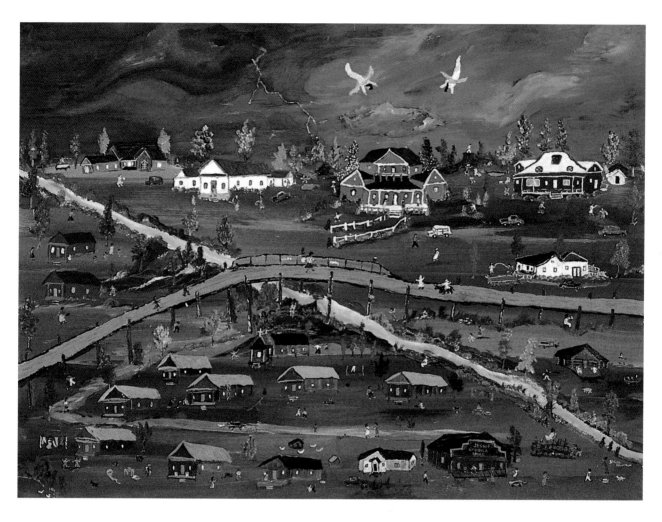

43. *Bridge over Troubled Water*, 23 x 31, Acrylic on watercolor paper

Trouble Quarters

When you look at the situation of the blacks now, we left the slaves' quarters, into white man's quarters (name one of the quarters—I say white man's quarters because the white man always owned the quarters), into the projects. It's just an endless cycle. We think we're moved up when we moved to the project, but the only thing different between the slave quarters and Tarbor Quarters or white man quarters is that they have some bricks and lights. [March 1, 1996]

44. *Trouble Quarters*, 18 x 24, Acrylic on watercolor paper, On loan from Kit Gilbert

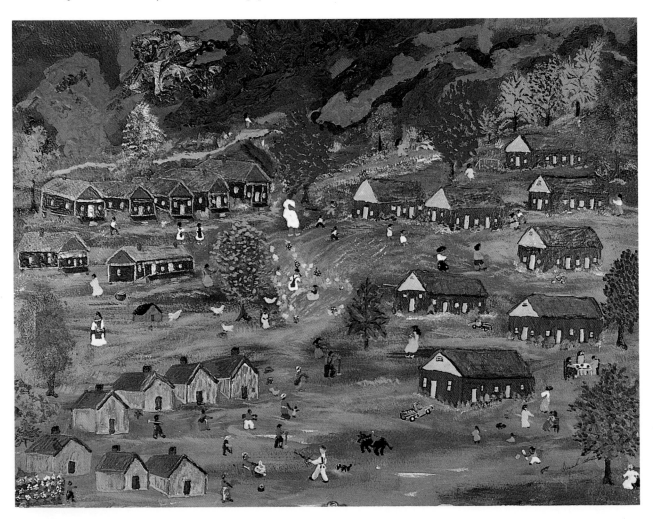

Wondering

We're always wondering about one another [blacks and whites] constantly until we get to know each other, and some will always wonder—black and white. . . . I transferred the babies, the white to the black side and the black to the white side. And the fathers of these children are standing up wondering if they should catch the black baby or they should catch the white baby. And Grandma and Grandpa—they love children; they don't care whose children, so they are going in to catch them. Mama's coming, but Grandma and Grandpa is going to beat them in. It goes to show you that we should not separate each other and wonder about each other. We should get to know each other and be more like grandmothers and grandfathers. [March 3, 1996]

45. *Wondering*, 18 x 24 , Acrylic on paper, On loan from Senator and Mrs. Randy L. Ewing

Breakthrough

Back when I was thirteen years old, I started working for the [white family name withheld]; they moved in from Colorado. . . . [Child's name withheld] was three years old when they moved here, and I took care of [her] because Mrs. [name] liked to go all the time. I remember driving up one morning, and she had a switch, running [the child] around the house to whip her. And I caught [the child] and told her [the mother] she better not touch her; if [she] do, I was going to whip her [the mother]. [The child] was a sweet, homely little child. And I baby-sit with [her] there, and I had to iron; that was my job: to iron and take care of [the child]. And Mr. [name] always wanted me to starch his underwear, so he wore starched underwear. . . . And once they became rich, they was on the go all the time; they were party goers. And they stayed gone weeks and sometime months, and I lived with them and took care of [the child]. Mrs. [name] was mean to [the child]; she didn't want her daddy to have any relationship with her, and she was just mistreated. And I was there to shelter [the child] because [she] seemed more like mine than she did Mrs. [name]. Now she was not neglected; she had all the clothes, anything she wanted, and we could go any place. They gave me a car to drive.

And [the child] hated drinking because when they got drunk, they would really abuse her. And some of the other people—they just came in to drink and eat. The house was open; if you wanted to come and eat, and they know you, it was free. You could drink and eat all you wanted to. And [the child] and I got like, made a little pact that when she graduated from high school or college, she was going to leave, and I was going to leave. So she said if they did not come to the graduation, she's going to leave, and they did not come to her graduation. I was there. At that time she had met [boyfriend's name withheld], and they were dating if I would let her go out with him. Sometimes I wouldn't even let her go, but she started dating him, and they got married right after high school and [her husband] went in service, and they moved He started dating [another woman], and he up and left [his wife] out there. She called me, and I sent a truck out there to move her; her parents were gone. . . .

Her mother down through the years has tried to keep her away from me because I'm the only one who know the story, what happened there in the house. Last year she [the young woman] came to visit me. And *Breakthrough* is catching her up on her past because for some reason she doesn't remember anything about it. She blocked it out of her mind, what happened. So for the last year, I've been bringing her up on things that happened in her life—break through the block she built around the bad things. . . . And I'm telling the story just like it happened to her, and she much better now since she knows the story.

[The child] and I are going through the dark tunnel [in the painting]. . . . She was rich, but she was in as bad a shape as I was; I was poor, so I didn't have any parent [that] cared about me; she didn't have any cared about her, even though she was rich. . . . And I'm taking [her] with the stories that she has blocked out; the tunnel represents the things she has blocked out. And I'm going to tell her the story and bring her to the light. [April 19, 1998]

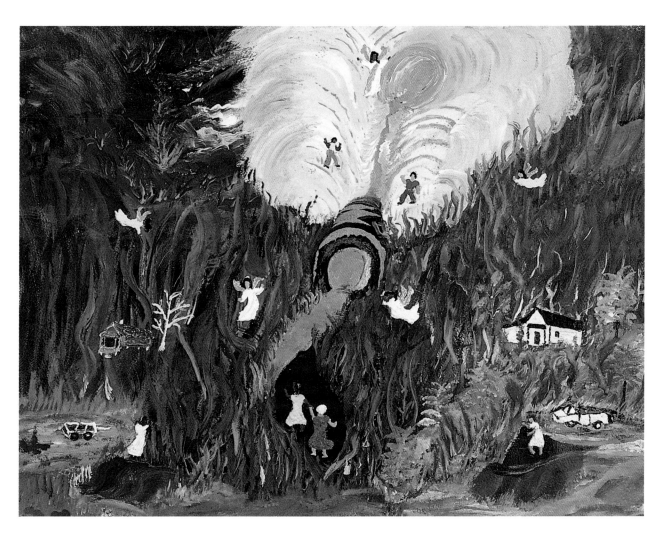

46. *Breakthrough*, 18 x 24, Acrylic on paper

Where Are you Going?

Where are you going? Are you going to heaven, or are you going to hell? Are you patterning your life after Christ, or are you patterning your life after Satan? In this painting on the left, we have people drinking, fighting, killing, stealing, and we have a lady that have three children out of wedlock and expecting another one. And it's got, "Make up your mind what path are you going to take; where are you going?" On the right side, we have a church, and we have angels representing Christ, and the road is wide in the beginning in our life, and it's going to narrow down. You'll come to the Satan side; you see the fire, and we have some of Satan's angels standing guard, and then we have a path leading to heaven. And some are choosing to follow after Satan, and some is choosing and being transformed, going into heaven. Some are falling in the fire now. Relating that to me, I was on the left side; I talked about when I was nineteen, I was on the left side: I gambled. . . . I didn't drink, and I had several fights. . . .

I'll tell this one story about one fight I had. I had gone out down to the Greasy Spoon . . . in Jackson Parish on my birthday. I didn't drink, but I was going to set everybody up and let them drink. I took two carloads down. And I told the bartender, "At twelve o'clock, set it up," so he set the counter up with whatever they wanted to drink. We was playing the Seabird [jukebox], and I was listening to the music, and Mr. Washington walked up and said, "You want to dance?"

I said, "No, I don't want to dance." I said, "If I did, I'd be dancing." So he asked me several times, and he walked away.

So his brother came up, and he said, "What's the matter with you? Do you think you're too good to dance with my brother?"

I said, "No, I'm not dancing tonight."

So Mr. Washington came up also, and he drawed his hand back. He said, "Well, I'll slap you"—he was going to say [that he would] slap me off that stool. And I took a switchblade knife, and when he drawed his hand back, I cut him up. And they took him, called the ambulance, and took him to the hospital. I went home. And [name withheld] was a rookie cop then. . . . And about four o' clock, he knocked on the door; I know it was [the cop]. "Open the door; I know you're in there."

I says, "What do you want?"

"I want that knife you cut Washington up with."

I says, "Okay." So I opened the door, and I gave him a little knife, small knife, real small knife.

He say, "Now, you know that's not the knife you cut him up with."

"I know that," I said, "but that's the only knife I have."

He say, "You got that switchblade; it's against the law to take a switchblade."

I say, "No, I don't." I said, "If you get a knife, you'll take this one."

He said, "Tell you what, I'm going to take this knife, but if he dies, I'll be back at you tomorrow."

He [the stabbed man] stayed in the hospital about six weeks. And I guess about three or four months later, I went to church down at Pilgrim Rest, and he was preaching . . . after he like to have died. For years, we get outside among ourselves, and we'll laugh about me cutting him up and the Lord calling him to preach; he thought he was going to die. That was one incident of my sinning and my fighting.

Now when I was gambling, I played pitapat and sometimes cooncan, and they called me the pitapat queen. I didn't play after a little money; I ran a gambling house, and all the money I didn't cut, when one or two people got it, that's when I gambled. Now I'd break them all, and I would always feed them and let them have something. But I didn't lose my money now. Once I got my money, wasn't no winning my money back. No, I kept my money. . . . I did not do dice, and I didn't steal, and I never had a gun to carry, but if you pushed the wrong button, you would get a good fight out of me, anytime, anywhere. [April 19, 1998]

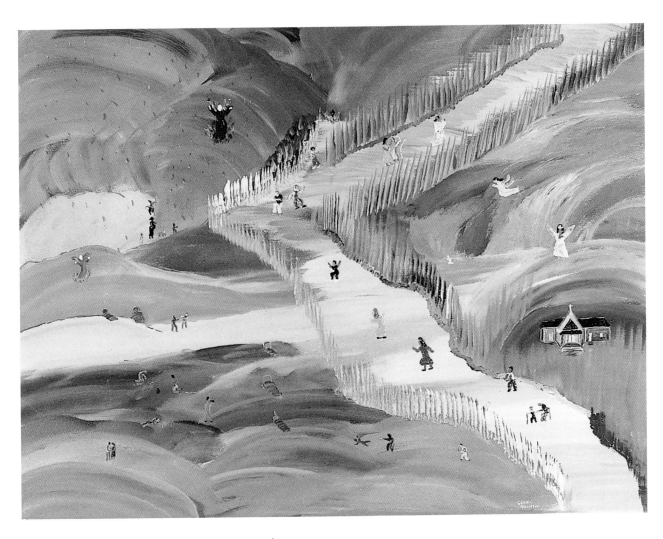

47. *Where Are You Going?* 22 x 30, Acrylic on water color paper

Crucifixion

I went to church on Easter Sunday and came back and started painting the Crucifixion; I thought I had to paint the crucifixion . . . because He died for me. He died for us all, but I want to say He died for me.

When I was nineteen—now, I told the story about [how] I joined the church when I was six—when I was nineteen, I was saved; I wasn't saved the first time. . . . I had moved over here. Robert Lee's sister—all sinners want to go to revival; that's the only time they're going, at revival time; they had two weeks revival, and Reverend Jones ran our revival—Lula May, she wanted to go to revival, and I told her I wasn't going to go to revival because I wasn't going to do right. I know I wasn't going to do right, wasn't ready to do right. So after [her] begging for two nights, I told her, yes, I would go one night. So on this particular Wednesday night, I did go with her, and Reverend Jones preached about hell fire. Well, I got a little uneasy there, and Ma Babe, Mama Babe—her name is Nola Jones, but we called her Ma Babe—she started singing, "Run, Sinner, Run and hunt you a hiding place." And you know how other sisters—you sing a part, and another sister picks it up. And Mrs. Donie Bisick started singing, "Oh my Lord, oh my Lord, what you going to do when the world's on fire?" So I thought I had to go to the bathroom [laughs]—I really did—I told Lula May, "I'm going to the bathroom," and I went straight to the mourning bench (they called it the mourning bench then; you know, where you sit on the first seat). So I went up there and I accepted Christ.

After then just sitting up thinking about what the Lord had done—you know, out of one condition into another one, because I was in good shape when I was nineteen because the [white family she worked for] gave me anything my heart desired, anything I wanted they gave me. And I started working for Christ. That's the story. And during that, then the sisters of the church, if a new member joined the church, then they would take the young ladies, and they would watch over them. And they drug me to every meeting, everything they had. They wouldn't say come on and go; they came and got me and took me; I didn't want to go, but they did. And I thank them now for doing that, and they taught me a lot—those women So He died for me, and I know that. He died for us all, but He died for me. And He gave me a new life And I been running ever since; that means I've been working for Christ ever since. And I wouldn't trade that day or that night for anything in the world, when I accepted Christ, my second baptism.

[In reference to the painting] The hill—he was crucified on a hill with the two thieves. You have some soldiers and the onlookers. . . . And it's two soldiers gambling for Jesus's coat. . . . And when Christ died, you know, they had a terrible earthquake and storm, and the sun refused to shine, and they said [the sun] dripped away in blood. And the dead walked around, and the graves was open, . . . which, according to scripture, is going to happen again. The temple [building at left] was rent, and the curtains was torn, bringing together—you know, before then, the men and women was separate in different parts of the temple, and the Gentiles—we're the Gentiles now—they was separate, and Jesus brought everyone together. . . .

And everybody knows the story about the thieves. One asked Jesus if he be a God, to come down and save himself, and the other asked to forgive him. And God says that, "Today, you'll be with me in paradise." Now, what does that mean? If I die today, and Jesus says, "You're going to be with me today," that mean I'm going on to heaven with him, not a wait station, a stop-off station, like people say you're going to go somewhere, stop off somewhere and wait until Judgment Day. So I'll immediately go with God; it's people up there. [April 19, 1998]

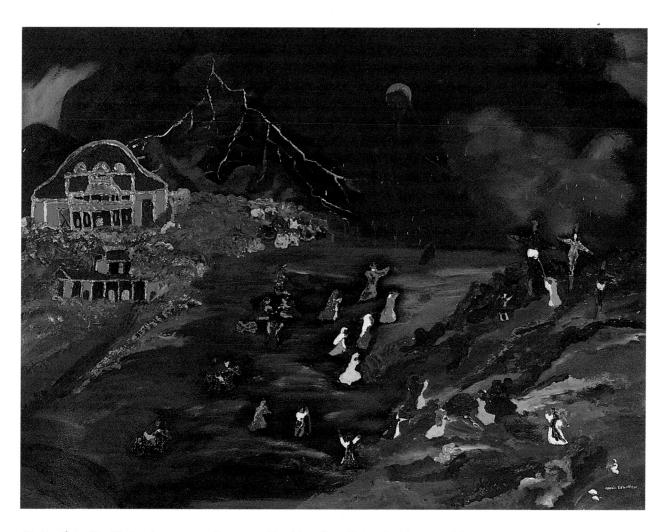

48. *Crucifixion*, 18 x 24, Acrylic on paper, Courtesy of Louisiana State University Museum of Art.
Promised gift of Mr. and Mrs. A.B. Cronan, Jr.

Pay Day

Pay day simply means that those persons who were mean and hateful to me is paying; time has come for them to pay for what they have done. . . . We have some of the good people going up the stairway, to the angel of life. And the people who were mean and hateful to me is paying by falling into hell. Everything is being destroyed, even the little shotgun house too, where everything just about it took place because most things that took place was around that house or maybe a couple of houses away from there in Tarbor quarters. . . . [The stairs] are representing Pay Day; you have to travel; Pay Day can be right here on Earth; you can suffer here on Earth, or you pay the price for what you do. The stairway is just representing when we die, we're going two places: heaven or hell. The Millenium—Christ is coming back; some of us are going to die. . . .

And like in the twinkling of an eye when Jesus comes, everybody won't die; some live peoples will be caught up. They made a choice to be mean and hateful to me, and when you're mean and hateful to anyone, you're going to pay; there's a pay day. Most people don't believe that, but it's true. They call it reaping what you're sowing. [April 19, 1998]

49. *Pay Day*, 23 x 31, Acrylic on watercolor paper

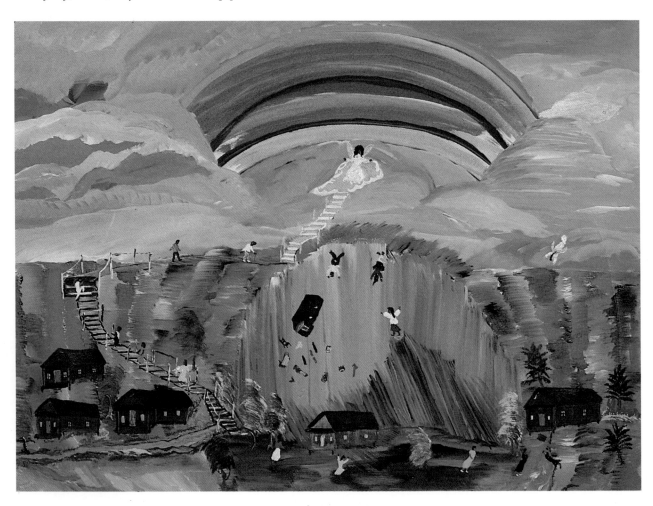

50. *In the Twinkling of an Eye*, 14x18, Acrylic on canvas board

In the Twinkling of an Eye

Miss Mary Lou and them died—two years ago and like Cindy [Laster] and Mr. Laster, and then Auntie and Uncle Clem, and Auntie joined them this year, about two months ago. . . If you go back and look at it, I was taught by Uncle Clem and Aunt Annie, and Miss Mary Lou, and Mr. Laster and Cindy was good friends of mine, so three of them would be connected with the past. . . . I loved them and I believed they were all going to heaven. . . . Cindy died from an unknown cause. . . , and then they had the funeral, and Howard [Laster] went back overseas; he was a ship captain and he died—had a heart attack. . . . I love them, and they'll do everything in the world they can for me. Cindy was a nurse, and she was a beautiful person; she'd help anybody, and Howard was too, so angels keep watch over them now in heaven. [These deaths were in recent years. March 3, 1996]

Wrapped in the Wings of Angels

We have the shotgun house in Tarbor quarters, and it's burning down. All the mean people out of my life—they're all dead. During that time when I was growing up, angels was protecting me; I've got a guardian angel because if it had not been for angels protecting me—I've never been hurt physically in my life, which sometimes I should have been hurt probably. And the angels kept me from all hurt, harm, and danger even though my life was hell. . . . Those people won't bother me any more; I don't have to deal with that any more. . . . All of this is over, and I was protected in the arms of angels.

Now when you look at going from hungry, no clothes, no shoes, nobody loving you, nobody caring, and then I grow up. The Lord has blessed me, always blessed me with a job, never been without a job in my life. And then I have my three businesses, so He blessed me with that. And then He give me the talent to paint; He give me the talent to write; He gave me the talent to sing; can't sing no more though. He gave me children. None of my children ever been in trouble; they were all 4.0's in college and high school. So my grandchildren are fine. I have a good business that takes care of us. . . . So I'm wrapped in the wings of angels. That's a blessing; that's a good story. And it goes to show you, if I had listened to Mother when she said I would never amount to nothing or listened to some of the other people and believed that, I'd probably still be sitting in Tarbor quarters somewhere, but I'm a fighter. I don't give up easy on nothing. The harder it gets, the more I fight and try to accomplish it if I can. And then when I find out I can't, well, I start me something else. [April 19, 1998]

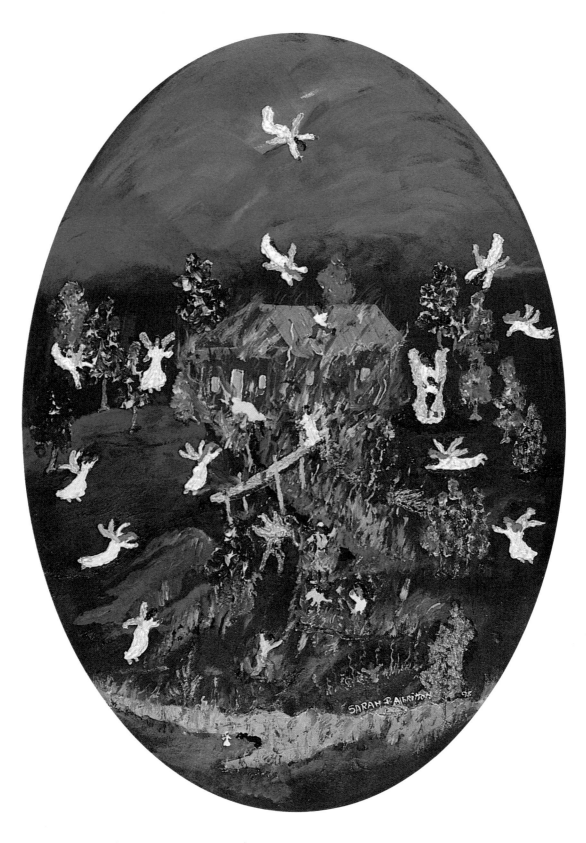

51. *Wrapped in the Wings of Angels*, 23 x 16, Acrylic on watercolor paper

Checklist of the Exhibition

Dimensions are in inches, height by width. The curators have determined approximate dates, based on style, consultation with Albritton, and photography and documentation dates. Photographing began in late 1995; works before 1995 are more difficult to date. Inclusive dates such as 1993-94 indicate a possible range of dates rather than a work produced over two years.

On My Way, 1994
18 x 24
Acrylic on canvas board
On loan from Edward and Karen Jacobs
Plate 1 (Frontispiece)

Working in the Kitchen, 1995
16 x 20
Acrylic on masonite
Plate 6

The Kitchen, 1993-94
18 x 24
Acrylic on paper
On loan from Mr. and Mrs. Alex Hunt, Jr.
Plate 7

Hell, 1995-96
18 x 24
Acrylic on watercolor paper
Collection of Michael Sartisky, Ph.D.
Plate 8

Angels Watching Over Me, 1996-97
Acrylic on watercolor paper
Collection of Dr. and Mrs. A. B. Cronan Jr.
Plate 9

Bastard Baby, 1998
22 x 30
Acrylic on watercolor paper
Plate 10

Mama, Don't Send Me Away, 1995
18 x 24
Acrylic on watercolor paper
Plate 11

Lord, Help Me, 1994-95
18 x 24
Acrylic on canvas
Collection of Robert and Melba Barham
Plate 12

I'll Fly Away, 1997
24 x 30
Acrylic on canvas
Collection of Sallie and Doug Wood
Plate 13

Tarbor Quarters, 1995
22 x 30
Acrylic on watercolor paper
On loan from Louisiana State University Museum of Art, Baton Rouge
Gift of the Friends of the LSU Museum of Art (Accession no. 97.1)
Plate 14

Tornado, 1993-94
18 x 24
Acrylic on paper
Plate 15

Hoboes, 1996
32 x 40
Acrylic on mat board
Plate 16

Crawfishing, 1995
18 x 24
Acrylic on watercolor paper
On loan from Amos and Vaughan B. Simpson
Plate 17

The Swimming Hole, 1993-94
18 x 24
Acrylic on paper
Plate 18

Money Hunting, 1995-96
18 x 24
Acrylic on watercolor paper
Plate 19

Learning My Prayers, 1993-94
18 x 24
Acrylic on paper
Plate 20

Tall Woman, 1993
18 x 24
Acrylic on paper
Collection of Richard and Thetis Cusimano
Plate 21

Lying, 1994-95
18 x 24
Acrylic on canvas board
Plate 22

Working on the Farm, 1995
18 x 24
Acrylic on watercolor paper
Collection of Joe and Jody Brotherston
Plate 23

German Prisoner of War Camp, 1997
24 x 36
Acrylic on canvas
Plate 24

Aunt Mary's Place, 1993-94
18 x 24
Acrylic on canvas board
Plate 25

Learning Her Lesson, 1993
18 x 24
Acrylic on paper
Plate 26

Fighting the Chickens, 1996
18 x 24
Acrylic on watercolor paper
Collection of Susan Roach
Plate 27

Fight After School, 1995
18 x 24
Acrylic on paper
Plate 28

Neighbors Picking Cotton, 1998
21 x 32
Acrylic on watercolor paper
Plate 29

Baptism, 1993-94
22 x 30
Acrylic on watercolor paper
On loan from Judy F. Weller
Plate 30

Baptism #2, 1998
3 x 34
Acrylic on watercolor paper
Plate 31

Funeral Procession, 1994
2 x 30
Acrylic on watercolor paper
Plate 32

Angels Watching Over Me, 1993-94
18 x 24, Acrylic on paper
On loan from Mr. and
Mrs. James R. Owens
Plate 33

Homecoming at Mount Harmony, 1995
18 x 24
Acrylic on watercolor paper
Plate 34

Chunking Rocks, 1998
22 x 30
Acrylic on watercolor paper
Collection of Randy Laukhuff
Plate 35

Lonely Road, 1997-98
22 x 30
Acrylic on watercolor paper
Plate 36

Mama, We're Cold, 1996
16 x 20
Acrylic on Crescent watercolor board
Plate 37

The Beating, 1996
18 x 24
Acrylic on paper
Plate 38

Dirty Old Man, 1998
16 x 20
Acrylic on canvasette
Plate 39

Hanging at the Church, 1993-94
18 x 24
Acrylic on paper
Plate 40

The Hanging, 1998
22 x 30
Acrylic on watercolor paper
Plate 41

The Sun Is Gonna Shine, 1997
22 x 28
Acrylic on canvas board
Plate 42

Bridge Over Troubled Water, 1998
23 x 31
Acrylic on watercolor paper
Plate 43

Trouble Quarters, 1995
18 x 24
Acrylic on watercolor paper
On loan from Kit Gilbert
Plate 44

Wondering, 1993-94
18 x 24
Acrylic on paper
On loan from Senator and
Mrs. Randy L. Ewing
Plate 45

Breakthrough, 1996
18 x 24
Acrylic on paper
Plate 46

Where Are You Going? 1997
22 x 30
Acrylic on watercolor paper
Plate 47

Crucifixion, 1996-97
18 x 24
Acrylic on paper
Courtesy of the Louisiana State
University Museum of Art
Promised Gift of
Dr. and Mrs. A. B. Cronan, Jr.
Plate 48

Pay Day, 1998
23 x 31
Acrylic on watercolor paper
Plate 49

In the Twinkling of an Eye, 1996
14 x18
Acrylic on canvas board
Plate 50

Wrapped in the Wings of Angels, 1998
23 x 16
Acrylic on watercolor paper
Plate 51

Christmas Lights Display by Sarah Albritton, 1996
16 x 20
Color photographic print by Peter Jones
Plate 2

Sarah's Kitchen, Christmas 1996
16 x 20
Color photographic print by Peter Jones
Plate 5

Contributors

Dr. John Michael Vlach is professor of American Studies and Anthropology at George Washington University. His publications on folk art and African-American art include *The Afro-American Tradition in Decorative Arts, Charleston Blacksmith, Plain Painters: Making Sense of American Folk Art, By the Work of Their Hands: Studies in Afro-American Folklife,* and *Back of the Big House: The Architecture of Plantation Slavery.*

Dr. Susan Roach, Associate professor of English at Louisiana Tech University, currently chairs the Louisiana Folklife Commission. She received her Ph. D. in Anthropology (Folklore) from the University of Texas at Austin, and her M. A. and Ph. A. in English from the University of Arkansas. She has curated folklife exhibitions and festival presentations; her publications include "The Journey of David Allen" in *Public Folklore* by Baron and Spitzer and "The Kinship Quilt" in *Women's Folklore, Women's Culture* by Jordan and Kalcik.

Peter Jones, painter and Professor of Art at Louisiana Tech University, received his M. F. A. in painting from University of Iowa and B. A. in Fine Arts from Amherst College. He did graduate work in Art History at New York University Institute of Fine Arts. He was art director for *Vermont Magazine* from 1973-1980, and has exhibited his paintings widely, with two one-man exhibitions at A. M. Adler Fine Arts in New York.

Sarah Albritton owns and operates Sarah's Kitchen, a restaurant and catering business in Ruston, Louisiana. She worked as a nutritional aide for the Louisiana State University Cooperative Extension Service and ran a home canning business. She graduated from Lincoln High School and later studied carpentry, welding, and theology.

References

Albritton, Sarah. Personal Interviews. 15 May 1984; 14 Dec. 1995; 1, 3, 6 March 1996; 2 Feb. 1997; 1 Aug. 1997; 20 Jan. 1998; 4 April 1998; 13 May 1998.

---. *Living from Day to Day.* Unpublished manuscript.

---. *Poor Black Girl.* Unpublished manuscript.

Bauman, Richard. "Ed Bell, Texas Storyteller: The Framing and Reframing of Life Experience." *Journal of Folklore Research* 24.3 (Sept.-Dec. 1987): 197-222.

Braid, Donald. "Personal Narrative and Experiential Meaning." *Journal of American Folklore* 109 (Winter 1996): 5-30.

Cullum, Jerry. "Vernacular Art in the Age of Globalization." *Art Papers* 22 (Jan.-Feb. 1998): 10-15.

Davis, Gerald L. *I Got the Word in Me and I Can Sing It, You Know: A Study of the Performed African-American Sermon.* Philadelphia: U of Pennsylvania P, 1985.

Goins, Charles Robert, and John Michael Caldwell. *Historical Atlas of Louisiana.* Norman: U of Oklahoma P, 1995.

Hays, John. "40 Years Ago: A History Lesson?" *Morning Paper.* 12 Oct. 1978, 1+.

Highsmith, Richard M. "Natchitoches Parish: A Microcosm of Trends and Processes in Southern Land Use." *Louisiana Studies* 3 (Spring 1964): 9-45.

Hollis, Susan Tower, Linda Pershing, and M. Jane Young. *Feminist Theory and the Study of Folklore.* Urbana: U of Illinois P, 1993.

Hopkins, Henry T. "Selecting Works for the Exhibition." *Philip Guston.* New York: George Braziller; San Francisco Museum of Modern Art, 1980.

Hufford, David. "Beings without Bodies: An Experience-Centered Theory of the Belief in Spirits." *Out of the Ordinary: Folklore and the Supernatural.* Ed. Barbara Walker. Logan: Utah State U P, 1995. 11-45.

Hughes, Robert. "Close Encounters." *Time* 13 April 1998: 209-210.

Kapchan, Deborah. "Performance." *Journal of American Folklore* 108 (1995): 479-508

Kirlin, Katherine S., and Thomas M. Kirlin. *Smithsonian Folklife Cookbook.* Washington: Smithsonian Institution Press, 1991.

Kirschenblatt-Gimblett, Barbara. "Objects of Memory: Material Culture as Life Review." *Folk Groups and Folklore Genres.* Ed. Elliott Oring. Logan: Utah State University Press, 1989. 329-338.

Kniffen, Fred. *Louisiana: The Land and Its People.* Baton Rouge: La. State U. P, 1968.

Lawless, Elaine. "Women's Life Stories and Reciprocal Ethnography as Feminist and Emergent." *Journal of Folklore Research* 28 (1991): 35-60.

Levi-Strauss, Claude. *The Savage Mind.* Chicago: U of Chicago P, 1969.

Lindahl, Carl, Maida Owens, and Renee Harvison, eds. *Swapping Stories: Folktales of Louisiana.* Jackson: U P of Mississippi, 1997.

Lynton, Norbert. "An Obverse Decorum." *Philip Guston: Paintings 1969-80.* London: Whitechapel Art Gallery, 1982.

Percy, Walker. *The Message in the Bottle.* New York: Farrar, Straus, and Giroux, 1975.

Personal Narratives Group, ed. *Interpreting Women's Lives.* Bloomington: Indiana U P, 1989.

Roof, Judith, and Robyn Wiegman, eds. *Who Can Speak? Authority and Critical Identity.* Urbana: U of Illinois P, 1995.

Preston, Dennis. "Ritin' Fowklower Daun 'Rong." *Journal of American Folklore* 95 (1982): 305-26.

Roach, Susan. "The Journey of David Allen, Cane Carver: Transformations through Public Folklore." *Public Folklore.* Eds. Robert Baron and Nicholas Spitzer. Washington, D.C.: Smithsonian Press, 1992.

Roach-Lankford, Susan, ed. *Gifts from the Hills: North Central Louisiana Folk Traditions.* Ruston: Louisiana Tech University Art Gallery, 1984.

Rosenberg, Bruce. *The Art of the American Folk Preacher.* New York: Oxford U P, 1970.

Siren, Osvald. *The Chinese on the Art of Painting.* New York: Schocken, 1963.

Stann, Kap, Diane Marshal, and John T. Edge. *The Lonely Planet Guide to the Deep South: Louisiana, Mississippi, Alabama.* Oakland: Lonely Planet Publications, 1998.

Thompson, Robert Farris. "The Song that Named the Land: The Visionary Presence of African-American Art." *Black Art Ancestral Legacy: The African Impulse in African-American Art.* Eds. Robert V. Rozell, Alvia Wardlaw, and Maureen A. McKenna. Dallas: Dallas Museum of Art, 1989. 97-141.

Trechsel, Gail, ed. *Pictured in My Mind: Contemporary American Self-Taught Art.* Birmingham: Birmingham Museum of Art, 1995.

Tucker, Lori. "Painting Her Life: Childhood, Faith Muses for Ruston's Albritton." *The News-Star.* 10 November 1996, D1, D5.

Vlach, John Michael. *Behind the Big House: The Architecture of Plantation Slavery.* Chapel Hill: U of North Carolina P, 1993.

---. *By the Work of Their Hands: Studies in Afro-American Folklife.* Charlottesville: U of Virginia P, 1991.

---. *Plain Painters: Making Sense of American Folk Art.* Washington: Smithsonian Institution Press, 1988.

---. and Simon J. Bronner, eds. *Folk Art and Art Worlds.* Ann Arbor: UMI Research P, 1986.

Weatherford, Claudine. *The Art of Queena Stovall.* Ann Arbor: UMI Research P, 1986.

Wright, Martin. *Log Culture.* Diss. Louisiana State University, Baton Rouge, 1956.

Yelen, Alice Rae. *Passionate Visions of the American South: Self-Taught Artists from 1940 to the Present.* New Orleans: New Orleans Museum of Art, 1993.